HADDINGTON: ROYAL BURGH

This book is dedicated
to the people of Haddington,
past and present,
who have made our town
unique

HADDINGTON: ROYAL BURGH

A History and a Guide

Tuckwell Press

First published in Great Britain in 1997 by
Tuckwell Press Ltd
The Mill House
Phantassie
East Linton
East Lothian EH40 3DG

ISBN 1 86232 000 4

British Library Cataloguing-in-Publication Data
A catalogue record for this book is available
from the British Library

Typeset by Carnegie Publishing, Lancaster
Printed and bound by Cromwell Press, Trowbridge, Wilts

Contents

Photographs in Part 1

Introduction and Acknowledgements

This is a book for everyone interested in Haddington. It has long been thought that a popular, up-to-date guide to the town, together with a brief glimpse of its past, should be made available for the benefit of residents, visitors and 'old Haddingtonians' alike.

Accordingly a committee was formed from the two local history societies – Haddington's History Society, and Haddington Remembered Group – with the aim of producing such a volume, not too detailed in content, and of a convenient size, which would indicate some of the interesting features of the town and its environs in the wider context of history.

Such a task, researching, compiling and collating information, cannot be undertaken without help from many and various sources. The committee gratefully acknowledges all such help.

In particular it would like to thank the following:
David Dick, OBE for his material on the origins of Haddington place-names.
Harry Dietrich (artist, Musselburgh) for his drawings.
For their help with the historical section: Mr and Mrs William Ferguson; Haddington Twinning Association Committee; Jack Tully Jackson (Haddington's History Society); Susanna Kerr (Scottish National Portrait Gallery [SNPG]); the Lamp of Lothian Trust; John McVie (former Town Clerk); the late Mrs O'Connor (Jane Welsh Carlyle House); and Chris Roberts and Veronica Wallace (Local History Centre of Haddington Library).
Sir Alistair Grant, for kindly contributing the Foreword.

Members of the Book Committee: George Angus, Victoria Fletcher, Nessie Gell, Shirley Middlemass, Patricia Moncrieff (Chair), Bill Rarity, Arthur Reid.

Foreword

Haddington is one of the semi-secret jewels of Scotland. The fertile East Lothian countryside lies between the romantic Border country and the many attractions of Edinburgh and for many visitors our county can mean principally golf and the seaside. Yet, in his excellent guide to East Lothian published in 1907 Charles Green's opening sentence reads: 'Haddington is the most delightful old county town in Scotland'. Ninety years later we can still support this affectionate description, and those of us who may have lived much of our lives miles from our native town return to find it even more rewarding than we remember it.

The very heart of Haddington is to be found where the East Haugh runs towards the Nungate Bridge. Many times I have stood with visitors, whether from the South or further abroad, gazing westwards from the old bridge over the Tyne, to the great church of St Mary, Lamp of Lothian. I shall never tire of this, one of the most beautiful townscapes in Britain, and it never fails to astonish my guests with its grandeur and unspoiled beauty.

Haddington is compact, bounded by the sweep of the Tyne to the South and by the lower slope of the Garleton Hills to the North. The countryside is always in view and though, from the town, the sea cannot be seen, the sky above the Firth of Forth is somehow recognisable as the upper half of the seascape that becomes visible as you come to the crest of the road to Gullane or Aberlady. Not only is the countryside constantly in view, it comes close to the town along the banks of the Tyne. If you walk from the Nungate upstream, particularly in the early morning, you have an excellent chance of seeing swans, herons, moorhens, ducks, dippers and occasionally a kingfisher. I have high hopes that otters which are already evident in some parts of the county will return to the Tyne before too long.

Haddington has been a Royal Burgh since the twelfth century and in medieval times it was one of Scotland's more important towns. Kings and Queens from William the Lion, Alexander II (who was born in Haddington), Henry IV of England, Mary of

Guise and Mary Queen of Scots have associations with the town. Wars and sieges took a heavy toll of Haddington's medieval buildings, leaving only the great church which was itself partly ruined until its restoration in 1973.

Although not much of pre-Reformation architecture remains, the people of Haddington have been fortunate that their handsome streets and public buildings have been preserved and protected so that very few of the unsightly developments which disfigure so many British urban areas are to be found.

The Lamp of Lothian Trust has played a key part in raising the funds and public support for the restoration of St Mary's, Haddington House, the home of Jane Welsh Carlyle and the unique community centre of Poldrate Mill. These are among the key attractions of Haddington, but for anyone who is prepared to get to know the area on foot there are innumerable interesting historical and topographical features to be found throughout the town and its surrounding countryside.

We who live in or near Haddington may take for granted our rich heritage and perhaps undervalue the privilege which we share from our close association with our town. For us and for the many visitors who are drawn to visit our town, this book will be an invaluable guide to our history and to the many pleasures which can be found within the town boundaries, in the county of East Lothian and along the shores of the Forth.

Sir Alistair Grant
October 1997

❦ 1 ❧

Haddington in History
ARTHUR REID

Beginnings

'Ada the Countess, Mother of the King of Scots'

In this way Ada announces herself in the preamble to a charter confirming the rights of Alexander of St Martin to the marches of Athelstaneford, the lands of Baro, Duncanlaw and Banglaw and to a mill on the Tyne. The document was drawn up some time between 1153 and 1178 and all of the places listed are familiar place names still. But before we look more closely at the connection between Haddington and this niece of the king of France, we will try to step back in time just a little further.

Embraced in a meander of the river Tyne and at the heart of a fertile plain, Haddington occupies a site that must have been an attractive one for early settlers intent on exploiting the rich countryside; the river would give some defence against unwelcome visitors as well as being a convenient provider of both food and water. The name of the town first appears as Hadynton in 1098 during the reign of King Edgar, and its origin has been a fruitful source of conjecture and debate over many of the succeeding 900 years. However, Hadda was the mythical founder of the Danish kingdom whose name also occurs in Old English, leaving us with the reasonable assumption that Haddington was founded by one Hadda, thus Hadda's tun or village.

With the accession of David I in 1124 Haddington entered a golden period of royal patronage. David instituted a system of charters giving certain burghs privileges in trade along with added fiscal responsibilities, including the levying of customs. Haddington was among the first of these royal burghs but the date of its creation has been lost along with much of the burgh records during the years of English hostility. In 1139 David's heir, Prince Henry, married the Countess Ada de Warenne and the young bride received Haddington and its lands as a wedding gift from her father-in-law. The princess took a great interest in her burgh and

in 1178 she founded an abbey of Cistercian nuns by the river about a mile to the east of the town. Nothing of this abbey survives but a chapel associated with it and dedicated to St Martin still stands, semi-ruined, on the edge of the Nungate and is thought to be the oldest surviving church in Scotland. The abbey was an important establishment, and must have been well appointed, as it frequently received high-ranking guests; the fourteen-year-old Princess Margaret Tudor, being borne on a litter to her marriage in 1503 with James IV, was lodged in the Abbey along with her considerable retinue. It housed one of the most important sittings of Parliament in our history, as we shall see.

Ada lived to see both her sons, first Malcolm and then William, crowned King of Scots. The latter continued the royal link with Haddington, building a palace in the town on a site now occupied by the Council Buildings. One of the King's daughters was married in the palace, no doubt amidst scenes of rejoicing, and even more joyful must have been the celebrations when the son who was to become King Alexander II was born there in 1198.

William I, the Lion, was in residence at Haddington for long periods. He held court there and petitioners made their way to King (now Court) Street for the privilege of an audience. It was not far to the south, at Alnwick in 1174, that he carelessly allowed himself to be taken prisoner when trying to assert sovereignty over Northumberland. He did not remain long a prisoner but his freedom had to be bought by submitting to the authority of Henry II of England. He founded the Abbey of Arbroath and dedicated it to the murdered St Thomas à Becket, probably to annoy Henry II. He re-established Scottish independence in a deal with Richard the Lionheart to subsidise a Crusade, and the church in Scotland had its claim to independence from Canterbury sustained by the Pope.

Haddington became a less desirable royal residence as English incursions increased, and the town, in the direct line of march between Berwick and Edinburgh, was put to the sword and torch so often that it was nicknamed Scotland's Wall. In 1242 the palace was destroyed by fire, not by the enemy but at the instigation of one William de Bisset, to conceal the murder therein of Patrick, sixth Earl of Atholl. His stratagem failed and the story goes that de Bisset was banished and obliged to take part in the Crusades.

Even then the lands of Hadintunschira were famed for their rich produce and this fruitful and pleasant country, so described

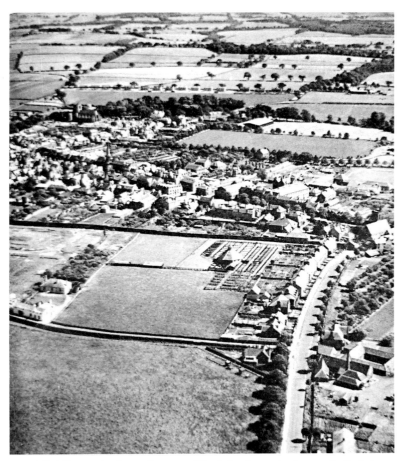

1. Haddington in the early 1950s. The belt of trees in the top half of the picture follows the curve of the Tyne round St Mary's. The Town House steeple, left of centre, indicates the start of the High Street and Market Street, whilst the strips of land behind both streets are the surviving riggs, once worked by the feudal peasants. The dark line running from Hope Park is the Black Palings, following the line of the old town wall. The riggs and the Mart (conical building, right of centre) have now been given over to housing or car parking.

by one French visitor, was a tempting prize to the invader, whose aggressive policy gained fresh impetus with the outbreak of war between England and France in 1338 (the Hundred Years' War). Edward III chose to fight the war on two fronts rather than seeking

an accommodation with Scotland, which would have left him free to concentrate on his French campaign. In 1356 he crossed the border in force, laying waste much of the border country and as far as Edinburgh.

Haddington was not spared: the Abbey and a famed Franciscan church were among the casualties, as well as the parish church. So beautiful was the church of the friars and so strong its spiritual influence that it was known as the Lamp of Lothian; its site in Church Street was near the present Episcopal church of Holy Trinity.

The Lamp Shines Anew

The loss of the church of the friars and the Abbey in the flames of the Burnt Candlemas, as this incursion came to be called, was a grievous one, but from the ashes of the parish church there rose a fine new Gothic kirk, larger than Edinburgh's St Giles, which still stands today in a place that seems to have been created for a building as beautiful as St Mary's; so beautiful indeed that it has inherited the title of Lamp of Lothian.

The building of the new St Mary's took place during the adolescence of Walter Bower, born in Haddington in 1385. He

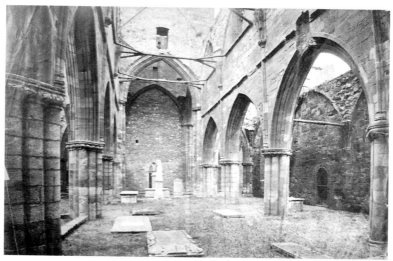

2. *The ruined choir of St Mary's looking west to the wall erected to separate the nave, restored to serve as the Parish Kirk, from the ruins. Note the braces supporting the inner walls of the aisles.*

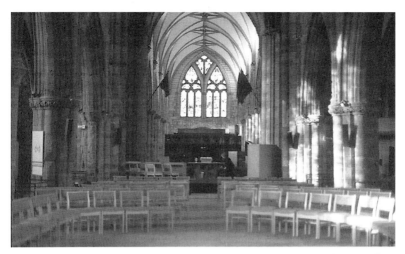

3. *St Mary's Collegiate Church today from the same point as the preceding photograph. (J. Tully Jackson)*

became Abbot of Inchcolm at the age of 32, having been among the first graduates from St Andrews University. But his energy and talents were not fully absorbed by his duties as abbot. He was one of two commissioners appointed by James I to raise the ransom demanded by the English for the King's release and he acted as a diplomat at peace talks in Perth where he vigorously upheld the right and the necessity for Scotland to maintain the Auld Alliance with France. Bower is still important today for his work in continuing the first chronological history of Scotland started by John of Fordun, taking up the narrative at the year 1153 and ending at 1437. His contribution is less detached than Fordun's and it may be that his views on the English had been soured by his childhood experiences in Haddington. Certainly the last line of his *Scotichronicon* is unequivocal: 'Christ! He is not a Scot to whom this book is displeasing'.

The importance to Haddington of its religious establishments is illustrated by the Bishop of St Andrews' authorisation of so grand a church in such a relatively small burgh. From its consecration around 1400, St Mary's attracted pilgrims, as is indicated by the relief of a scallop shell on one of its columns, the shell being the badge of the pilgrim way to the shrine of St James at Compostella in northern Spain, and it can still be seen today on hostelries along

the historic route. We know that pilgrims from St Andrews made
this journey.

The local economy would also benefit from the conferring of
collegiate status on St Mary's. The students of theology and
religious music, as well as their tutors, would be a welcome addition
to the demand for goods and services. Indeed, at this time
Haddington must have been a colourful place with its monks and
its nuns, its prelates and its priests mingling with the peasants and
the traders and the knights and lairds and, from time to time, the
presence of the royal court.

Alongside the religious activities the trades of the burgh
flourished, in times of peace at least, most of them established
under royal charter. These included wool and the processing of
hides. Weaving and tanning survived into recent times; the last
commercial weaver, James Mitchell, who made quality cloth on a
hand loom, died in harness in 1994, and the last tannery closed
in the '60s after a disastrous fire, but its site is still identified by
Tannery Lane in the Nungate. Markets were also authorised
by charter and the Haddington grain market was said to be one
of the largest in Scotland.

But the Auld Enemy threatened so frequently that turmoil and
peace seemed to be Haddington's lot in equal measure. The
incursions were so damaging that the town frequently had to
petition the crown for relief from their tax obligations as a royal
burgh. And worse was to come.

In 1542 the relationship between Scotland and France, the Auld
Alliance which had existed since 1296, was at a high point. James
V was married to a French queen, Mary of Guise. Henry VIII
ruled in England and, as ever, sought to extend his dominion over
France, but first he must subdue the Lion in the North in case it
came to the aid of its traditional ally. He resorted to a mixture of
force which was resisted and negotiation which was distrusted.
With the birth of Mary, who became Queen of Scots as an infant,
Henry set his heart on securing Scotland by contracting a marriage
between his six-year-old son, Edward, and the baby Mary. When
this was rejected he returned to the diplomacy of the sword. The
Scots were crushed at Pinkie near Musselburgh and the English
overran the south. They then established strong points from which
to control their conquest. One of these was Haddington.

'Most men think keeping Haddington ye win Scotland'

So said Sir Thomas Palmer, one of the English commanders, and the high value the English placed on their prize can be gauged from the effort that was put into keeping it.

Strangely, Haddington had never been a stronghold but the invaders now set about making it into one. Under the capable command of Sir James Wilsford, within six weeks earthworks were thrown up, which were to prove very effective in repelling the direct assaults mounted against them in the succeeding weeks and months. St Mary's lay outside the defences and, in an attempt to render it useless to the Scots and their French ally, the English demolished the roof and undermined the foundations.

The siege became a stalemate as the allies failed to make any impact on the defences, while the English were unable to exercise the control over the south-east of the country as planned, but they were in a position 'fit to annoy and insult the whole Kingdom'. They were sustained by occasional relief columns, strongly guarded, which had to run the gauntlet as the Franco-Scottish army obstructed and harried their progress.

Since Henry VIII had intended, by force, to bring about the betrothal of his son with the infant Mary, Queen of Scots this campaign became known as the Rough Wooing. In Scotland it was felt that if this was the manner of the courtship, the resulting marriage, which would be a union of nations, looked like being a troubled one. The situation was critical, and the safety of the young queen must be assured, so Parliament was convened to consider the way forward. It met, on 7 July, 1548, in the Franciscan abbey on the banks of the Tyne, within earshot of the guns, which no doubt helped to concentrate minds. So in that ancient abbey, with the French ambassador acting on behalf on Henry II of France, the Treaty of Haddington was signed committing Scotland to even closer ties with France in

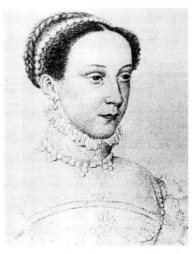

4. Queen Mary in 1557, aged 15, by Clouet, four years before her return to Scotland. (Bibliothèque Nationale)

the face of the 'crudelities, depredatiounis and intollerabill injuris done by our auld enemis of Ingland'. The treaty also committed the young Queen Mary to marriage with the Dauphin François, and it was further agreed that she should immediately be sent to France for safety, setting her on the first steps of the tragic path that led to Fotheringhay. On 13 August, 1548 her ship sailed from Dumbarton. She was six years old, and in her retinue were four little friends to keep her company in a foreign land; they were from the noble families of Beaton, Fleming, Livingstone and Seton, and they were all called Mary. Henry II received her with great joy, making her a favourite and nicknamed her his *Reinette*.

Still the siege of Haddington continued. Six cannons were brought to bear on the fortifications; in one day, at intervals of one every two minutes, they fired 340 balls into them with negligible effect.

The Queen Mother, Mary of Guise, took an active interest in the conduct of operations, even to the extent of climbing the tower of St Mary's to get a better view of the English positions. She and her party were observed and came under fire, from 'chayne and haile shot', killing and wounding several of her entourage.

Eventually the tactic of frontal assaults gave way to one of blockade: Aberlady was fortified to prevent seaborne supply and the ring around the town tightened; then a dreaded ally came to the aid of the besiegers: plague broke out among the starving garrison. The English had also lost their resourceful leader, Wilsford, taken prisoner leading a diversionary attack on Dunbar.

With conditions so bad for the occupying force, even the weather had turned against them, continuous rain and strong winds adding to their woes, so an army was assembled at Berwick to bring out the survivors. It reached Haddington about 15 September, 1549 and by the 20th relievers and relieved were heading for the border. Their first act on taking Haddington had been to destroy the Kirk of St Mary, their last was to set fire to the town. And so they went, taking with them the kirk bells (do they grace Durham cathedral as many believe?), strangely unhindered in their retreat, which may in part have been due to the weather: the continuous rain which so demoralised the English was equally a hindrance to their opponents. The Tyne in flood has been a fearsome event even into recent times.

The Siege of Haddington had lasted one and a half years, the longest siege in our history.

Religious turmoil

The Reformation came late to Scotland and even more tardily to Haddington, in spite of having given to the world one of the most famous of the reformers, John Knox. His place of birth is not recorded but it is known to have been in or near Haddington and he was certainly educated in the town; the *Encyclopedia of Scotland* has no doubts, placing the event firmly in Haddington *c.* 1513.

Although Knox trained as a priest, he never held a parish, becoming instead a notary and then a tutor. It was in this latter capacity that he met the reformer George Wishart who was being supported by some of the lairds to whose families Knox acted as a tutor. Knox seems to have been made a guardian or guide to Wishart and accompanied him on his travels in Lothian. In January 1547, the two came to Haddington where Wishart addressed sparsely attended services in St Mary's. Knox, bearing a great two-handed sword, stood guard in front of the pulpit. He would have defended the reformer against Cardinal Beaton, but Wishart sent Knox away, saying, 'One is enough for a sacrifice', and went on alone to his eventual martyrdom at St Andrews.

In time Haddington had to accept the new religion and, indeed, the people became as fervent in the new faith as they had been in the old. The abbey which not many years before had hosted Parliament lost its last abbess when she married, the buildings were abandoned and were soon ruinous, and no trace of it survives apart from some masonry which was probably used for improvements to the Nungate Bridge. By 1561 Presbyterianism was well established and in that year work was started on the ruined St Mary's to re-roof the nave and wall it off from the choir and transepts. The nave thus became a satisfactory venue for the new forms of worship, and the rest of the church, open to the skies and the elements, soon bore the air of a romantic ruin, and so it remained for over 400 years, awaiting perhaps a miracle.

'Keip traist'

– or Keep Trust – was the motto of James Hepburn, 4th Earl of Bothwell, and he was faithful to it throughout his turbulent life. He stood out as a colourful figure in an age not lacking in striking characters. He was probably born in 1535 into a family that dominated the eastern borders, with castles at Hailes, Hermitage and Crichton, and he held the post of Keeper of Dunbar Castle. Bothwell was a born soldier, a master of surprise and the

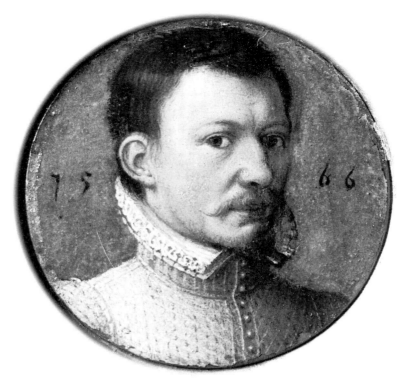

5. *James Hepburn, 4th Earl of Bothwell. From a miniature, the only
known portrait. (SNPG)*

unexpected but lacking the patience and subtlety needed for suc-
cess in the labyrinthine politics of the day. In his short life – he
died at the age of 43 – he experienced both exile and imprisonment,
but he was a player in acts of high drama in the history of the
nation, and he married a queen in what was, unusually for those
days of dynastic alliances, a love match.

In the absence of the young Queen Mary in France her mother,
Mary of Guise, acted as Queen Regent. The reformed religion
was rapidly replacing the old, and there were those who opposed
the Queen Regent because of her adherence to the Roman Catholic
rites. Also resented was the increasing influence of France in
political matters: the French Ambassador even attended meetings
of the Privy Council, and another Frenchman had charge of the
Great Seal.

The nobles acting against the Queen Regent were known as the Lords of the Congregation and, egged on by John Knox, they were soon in open rebellion. England, never slow to exploit division, became involved, but not to the extent of sending troops, as this could have led to war with France. However, they could finance the rebellion and this they did, provoking the gallus Bothwell to one of his most daring coups.

In October, 1559 a consignment of 3,157 French crowns arrived at Berwick upon Tweed for onward conveyance to the rebels. French coinage was to be used because it was legal tender in Scotland and would not arouse the suspicion that would greet the sudden appearance of a large amount of English cash. A reliable courier had to be found to bring the subvention to the plotters. They chose a local man, a new recruit to the cause, John Cockburn of Ormiston, who knew the country well.

So it was that in the gloom of Hallowe'en the trusted courier, confident that he was safe against attack with his escort of seven hand-picked and well-armed men, guided his band past Hailes towards Haddington. He had little to fear: he was on home ground and Traprain, that mysterious mount, haunt of witches and other fearsome, supernatural beings, was safely behind them. It was all plain sailing now.

Then out of the darkness loomed shadowy figures, a hand took his bridle and fear took his guards. Were these men or were they the agents of the devil? Cockburn drew his sword and struck at the hand which was now separating his precious burden from his saddle, there was the hiss of a blade through the night air and John Cockburn, blood coursing down his face, fell from his saddle. There was the clink of coins as the booty passed out of the custody of the agent of the Lords of the Congregation and the band – supernatural or mortal they outnumbered the escort three to one – were gathered into the embrace of friendly night.

As a Protestant, Bothwell had been under pressure from the Lords that he should join them. He had shown an interest in their proposals, indicating that, if he could be given a safe conduct he would go to Edinburgh to discuss his defection. But Bothwell had his informants within the rebel camp and while, on the face of it, he was considering changing sides, he was really planning to win the English gold for his Sovereign Lady the Queen Regent. So the hapless John Cockburn felt safe passing through Hepburn territory, so safe that he did not even bother to wear his helmet

which might have saved him from the slight wound that temporarily rendered him *hors de combat.*

In one daring swoop Bothwell had deprived the plotters of desperately needed funds and revealed the duplicity behind England's pretensions of neutrality. This proved the turning point in the rebellion and the fortunes of the rebel lords declined as their support withered.

The news of the loss of the money reached the Lords of the Congregation far quicker than Bothwell had reckoned. They were outraged, and had two objectives, to recover the subsidy and to punish Bothwell. Quickly they assembled a large force. One estimate put it at two thousand men, and two cannons.

Bothwell had taken refuge at Crichton when news of the large force mustered against him arrived. A siege or a pitched battle seemed inevitable and Bothwell was prepared for neither. Indeed, the massive reaction of the Lords is an indication of the damage done to their cause and the subsequent desperation of their attempt to recover the loss. Quick-witted as ever, Bothwell took to horse and was gone, a bare fifteen minutes before his enemies arrived.

Tradition has it that he led the detachment pursuing him to Haddington where he abandoned his horse. He was soon alerted that the pursuit had entered at the West Port so he ran down

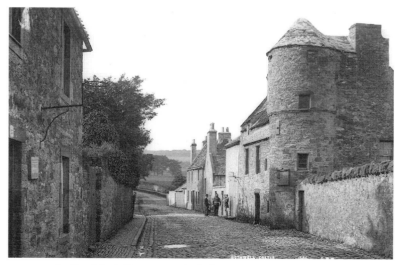

6. *Sandybed House, popularly known as 'Bothwell Castle'.*

Gouls Close to the river; wading downstream through the shallows for about a hundred or so metres, he came to the back of Sandybed House and entered. Coming to the kitchen, he found a serving girl turning a spit. His appearance and manner alone would arouse a pity which would be reinforced by his pleas and the disclosure of his identity. After a swift exchange of clothes, a not very attractive serving maid took over the task of turning the spit. The story goes that Bothwell performed his homely tasks for several days until the heat was off.

What is certain is that Bothwell, in gratitude, settled a yearly grant of four bolls (one boll approx. 63.5 kg) of wheat, barley and oats annually on Sandybed, a commitment that was honoured for the next two hundred years, and Sandybed itself became popularly known as Bothwell Castle until its demolition in the 1960s.

'Nane of Edinburgh, Leith na otheris suspic place be let in ye toune'

The bubonic plague is spread by infected fleas which live on rodents. It came from Asia as a by-product of increased trade and broke out in southern Europe in 1347. Spreading rapidly, it reached England in 1348, acquiring the grim nickname of the Black Death from the black blotches which appear on the skin of its victims. Other symptoms include headaches, a high temperature and spitting blood. The most obvious symptom is the suppurating swellings which appear in the armpits and the groin after as little as two days, soon after which the patient dies. The mortality rate was about seventy per cent, but where the agent combined with the germs of respiratory ailments to cause the pneumonic variety of the plague, the outcome, almost invariably, was fatal.

Some Scots looked upon the outbreak in England as a judgement from God, but the rat flea respects neither individuals nor nations and within a year it was devastating Scotland's population. Lacking statistical records, we cannot tell exactly what the plague did to society, but a study of rents can give some indication. There was a trend to lower rents, showing that there were fewer people but the same number of homes were available. The size of farms is another guide; acreages increased because the land was divided amongst fewer farmers. From this sort of evidence it is believed that the Black Death reduced Scotland's population by about one sixth. This is rather less than the rest of Europe, where the figure is put at between a quarter and a third, and for this meagre blessing

it seems we must thank our much maligned climate, which was not quite so hospitable to the rodent flea as more southerly climes. Even on this reduced scale the epidemic was a horrific event for Scotland, with fatalities in the region of 200,000. Haddington, being astride a major highway, may well have suffered rather more than her proportionate share of the horror. A steady flow of travellers brought welcome trade but they could also bring less desirable side-effects during epidemics, and there were others – the gangrel buddies, tinkers, beggars and drifters – who were not very welcome visitors at the best of times and certainly undesirable in times of pestilence. These were all possible carriers of the infection, and a potential burden on the burgh's charity, and had to be kept out.

We know little of how Haddington coped with the dreadful epidemic of 1349, but the plague recurred several times in the succeeding centuries and the outbreak of 1603 tested the resources of the town to the limit.

In 1597 work had started on the building of a town wall, not as a defence against the English but as a hindrance to those who crept out at night to 'steal horses and other geir' and, more importantly, as a means of controlling entry to the town.

Six years on and the wall was still incomplete, and the crisis it was intended to control arrived. The outbreak lasted six years, probably receding in the winter and erupting anew with the return of warmer weather. Ignorant of even the basics of good sanitation and refuse disposal, the burgh fathers struggled to cope with the menace.

Orders were issued forbidding anyone except the residents to enter any house where the disease had broken out, and deaths were not to be marked with a wake which would have involved a gathering of mourners. Infringement of these orders brought fifteen days' imprisonment followed by banishment. Another order banned the importation of foodstuffs from infected areas, and this offence was serious enough to carry the death penalty, no doubt the sentence to be carried out using the hook on the west arch of the Nungate Bridge, long since redundant, but still to be seen.

The poor of the town were a cause for concern in the crisis and were a great strain on the burgh finances. Strangers were only admitted to the town if they could give a surety that they would not become a liability; they were also required to produce a certificate, signed by a reputable person, to the effect that they were free from infection by the plague. Watchmen at the town

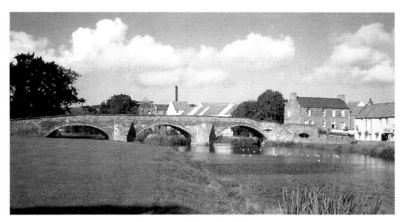

7. Nungate Bridge looking north.

ports (gates) who failed to apply these regulations were liable to fifteen days in the stocks.

In 1603 the burgh lands extended as far as Gladsmuir in the west. The name means the moor of the hawk and it evokes the lonely, dank and inhospitable place it must have been at that time. There it was, at the furthest extent of the burgh's authority, that those of the poor who showed signs of recovery were sent to convalesce. Housed in tents, their chances of surviving the elements could not have been much better than those of recovering from the plague, especially in winter. To feed these wretched exiles the town ordered for each patient one pound of bread and a chopin of ale (a half-pint Scots, about 0.85 of a litre) per day.

The town wall was never properly finished. It seems to have been a shared project involving private property owners and the council. The council records over the years carry several references to failures by landlords to maintain their heid roumes, i.e. where private property merged with the wall. Demonstrating that the wall was as much about keeping in as keeping out, an entry from 1619 orders that those possessing 'dykes or yaird heids' must maintain them, as well as all 'yetts or passages to and from either thair awne yairds that no swine pass out or through the dykes, yetts or sloppes either to thair awne or thair neighbours corn or skaith'.

Very little remains of the town wall, and the line it took is, in places, a matter of conjecture but the sites of the ports or gates

give a good idea of the bounds of the burgh in the Middle Ages. The West Port was on the south side of Court Street near the traffic lights, and a house there is still called the West Port. Clockwise from the West Port we come to the North West or Newton Port which was originally near the town library but was later moved up the hill to a site near the parish church hall. The North East Port was in Hardgate near Old Bank House where a section of the wall survives. The garden of Elm House in Church Street was the site of the East Port and, finally, we come to the South Port in Sidegate on a site opposite the Maitlandfield.

'To promote a woman to bear rule ... is contumely to God'

Mary of Guise died in 1560 and with her loss Scotland was slipping into chaos and anarchy. In France her daughter Mary had grown into a young woman as much French as she was Scottish since her flight in 1548. She had reigned briefly as queen of both countries, but the death of her husband, François II, had left her isolated at the French court, where the other Queen Dowager, Catherine de Medici, who had never cared for her Scottish daughter-in-law, promoted the interests of her second son, Charles IX.

It was time to go home.

Mary landed at Leith on 19 August 1561. She was just eighteen years old.

The first years of her return went well as she dealt even-handedly with the conflicting religious factions. This was the policy known as *politique* in which the monarch regarded him or herself as looking after the interests of all his or her subjects, and not just those of one particular persuasion. It worked well and Mary visited many corners of her realm, showing herself to all her subjects, and not just those of one particular persuasion. But, as we shall see, all her gains were put at risk by her ill-judged marriage to Henry Stewart, Lord Darnley. The brilliance of her court, which reflected the Queen's love of music, dancing, literature and the arts in general, as well as her pleasure in pastimes such as cards, archery, golf and riding, began to attract the displeasure of the Kirk which was taking on a puritanical character. John Knox took every opportunity to revile her: perhaps the fact that Mary had proved equal to him in debate prejudiced him. But his *The First Blast of the Trumpet Against the Monstrous Regiment of Women*, that is, rule by women, declared that for a woman 'to bear rule ... above any

realm, nation or city, is repugnant to nature, contumely to God, a thing most contrarious to His revealed will and approved ordinances'. A clever woman was bad enough, but a clever woman who did not conceal her ability behind a screen of deference to the superior male must have been especially galling.

'Ye haven of Aberlady'

The first reference to the haven at Aberlady comes in a charter of Robert II who ruled from 1371 to 1390, and who gave Haddington free transit to 'our said harbour'. If there was indeed a harbour at that time, it could only have been because ships were small and therefore had a shallow enough draught to come alongside a jetty at high tide. As ships increased in size, the harbour would be a sheltered anchorage.

During the siege of Haddington in 1548–49 control of Aberlady was vital as the English sought to supply their garrison by this route, and it was by eventually denying the invaders access to Aberlady, as part of their blockade, that the allies were able at last to bring them to abandon their prize.

The town had a property at Aberlady from which the harbour was administered, known as Haddington House, and there the officials recorded the comings and goings of shipping from Edinburgh and the Fife ports, with cargoes of timber, manure and linseed cake. This was probably the easiest way of transporting big loads, and was quicker as well as safer than by land. It was only with the coming of the railway to Haddington that the town's own harbour became redundant and the anchorage and Haddington House were sold to the Earl of Wemyss in 1848 for £375.

Market days

Some of the goods landed at Aberlady would, no doubt, come to the weekly market in the burgh. These were sanctioned by royal charter and at first were held on Saturdays, but this was later changed to Fridays. A second market was granted by Charles I in 1633, to be held on Wednesdays, but this did not last.

The layout of the town was ideal for markets. The original town centre consisted of one very wide street on the line of the south side of the present High Street and the north side of today's Market Street. The expanse between the two rows of houses was probably grassed and used for grazing by domestic livestock as well as for sport, fairs and markets. The buildings would be of wood, wattle,

mud and thatch. Only the most important structures such as the church and the royal palace would be stone-built. Some time before 1426, a further row of buildings, known as the Middle Raw, was created down the centre of the open grassed area, creating the town centre plan as it exists to this day.

Most of the buildings date from the seventeenth and eighteenth centuries, being built on the foundations of much older structures. Very little from earlier times survives but mention must be made of Mitchell's Close in Market Street, which dates from the sixteenth century. The entrance to the close is through a pend which has, on either side, the entrances to the houses above the shops which flank the pend on the street frontage. The shops are a later addition, the original frontage having consisted of pillars supporting the first floor of the house above, as at Gladstone's Land in Edinburgh. This created a colonnade effect, and within these roofed but open-fronted areas booths would be set up for the sale of goods, particularly on market days. In Edinburgh these booths could be secured and so were known as luckenbooths.

The burgh council went to a great deal of trouble over the years regulating both what could be sold, and when, as well as by whom. The social order of the Middle Ages was very clearly defined, and in the burghs the division between merchants and craftsmen was strictly maintained. A merchant was usually a burgess, who had to live in the burgh, pay local taxes, sit on courts and perform any other duties the law imposed. In return merchants had the right to engage in commerce generally both at home and abroad. Moreover, they alone had the right to vote in the election of magistrates.

The craftsmen were restricted to their particular trade and they controlled entry to their craft through guilds which in Haddington

8. High Street seen from the spire of the Town House in 1976.

were known as Incorporations. Non-members setting up a business could be, and were, closed down. On market days, however, they allowed chapmen (peddlers) to sell the same goods as craftsmen on payment of a boxpenny. One member only of the craft collected this due from the chapmen, having bid the highest among his colleagues for the privilege. He then had to hope that enough chapmen turned up at the market to leave him a profit after paying the sum he had bid to the Incorporation.

The lower class of citizens were called unfreemen. This group was not allowed, by law, to infringe upon the rights and privileges of the freemen. They included the chapmen who, as we have seen, could buy a temporary licence to sell craft goods at markets. Unfreemen could only buy wool, hides or skins from merchants and only on market days before 11.00 am, thus restricting their access to raw materials. Another law decreed that skins and hides could be bought only at booths, thus ensuring that the merchants retained their monopoly.

On market days the merchants could supplement their booths by setting up a crame. This was a stall in the street, but again certain types of goods could not be sold from crames. The merchants must have severely abused the crame system when, in 1554, they were forbidden to set them up on the 'hiegate or in kirk doors', or in common passages except on a Saturday, the market day. They must have been abusing their rights by maintaining the crames between markets.

A privileged few merchants had trading links with the Low Countries, and this connection would bring to the markets luxuries for those who could afford them. There were silks, fine woollens, velvets and satins, not just for the seamstress, but also for the tailor: the upper-class men were no less colourful in their attire than

9. Market Street seen from the spire of the Town House in 1976.

the women. To complement the fashionable outfit, there were French or Flemish lace collars and cuffs, delicate gloves, fine hose, belts and the sixteenth-century version of the bum bag.

Gourmets, also, were well served with wines from France and Spain, and from the Mediterranean and Near East would come spices, dates, raisins and figs; and sweetmeats, including liquorice and treacle, which would serve also as medicines.

'I rencountred Her Majesty coming ... to Haddington'

Sir James Melville (1535–1617) left an account of his meeting with Mary, Queen of Scots in his *Memoirs*. The story of how she came to be in Haddington is the very stuff of drama, one that led inexorably to tragedy. The murder of the Queen's secretary, David Riccio, by disaffected nobles, jealous of his influence with the Queen, was accomplished with the complicity of the King Consort, Darnley, who wanted to take power to himself.

The wretched victim was attacked in the Queen's Chamber at Holyrood Palace, where his grip had to be prised from the skirts of the horrified Queen before the first blow could be struck. Darnley himself took no part in the killing but his dagger was used whilst he restrained Mary. Riccio's body was flung down the Palace stairs, still carrying Darnley's dagger in one of the fifty-six wounds found on the body, such was the ferocity of the attack.

These events took place on Saturday 9 March 1566. The plotters intended removing the Queen to Stirling Castle and she had every reason to fear for her life. However, by Monday she had weaned the irresolute Darnley from his co-conspirators and, with the aid of the captain of the palace guard, they escaped from Holyrood by a back stair. Horses were waiting and they were soon making their escape towards East Lothian. At one point in their night ride to safety Darnley took fright and urged his mount to a faster gallop, at the same time flogging the Queen's horse to greater effort. Mary was in the seventh month of pregnancy with the future James VI and she cried out for the safety of her child. 'Come on', cried her gallant husband, 'if this one dies we can have more.'

At Seton they were met by a group of loyal nobles, including the Earl of Bothwell, who escorted them to Dunbar. They arrived at daybreak, a fire was lit and, despite all she had been through, the Queen cooked breakfast!

By the end of the week a large army had rallied to the side of

the Queen and her nobles. They set off for Edinburgh on 17 March, 1566, and that evening they stopped at Haddington. It was a short stay, only one night, but where did she find accommodation? The Abbey would seem the obvious place, for it had housed royal visitors in the past, but Sir James Melville says Haddington, and the Abbey was about a mile to the east. David Croal, in his *Sketches of East Lothian*, intriguingly suggests Mitchell's Close as the site of the Queen's lodging, pointing out that it was owned by Bothwell's family, the Hepburns, and as such would be a secure haven.

There may well have been other occasions for the Queen to be in the burgh. For example, a letter to Lord Cecil, dated 4 April, 1566, from one of his spies in Scotland, tells of Mary investing a nun 'solemnly, and with all the old unwonted toys', which places her in the Abbey of Haddington. That was less than a month after the events just described.

The next day Mary returned in triumph to Edinburgh and the people turned out to welcome her, but the drama was not yet played out. The following February, Darnley was convalescing at Kirk o' Fields in the capital when there was an explosion and the uninjured body of the Queen's consort was found in the garden, unmarked but strangled. Theories there are in plenty as to who was responsible, and they continue to be produced. The Queen appeared unaffected by her sad loss, and she provoked adverse comment when she played golf in the days following the murder. Indeed, on the Sunday after she was widowed for the second time, Mary was in East Lothian with Bothwell, where they engaged the lords Seton and Huntly in an archery match. The two lords lost, and they had to entertain the winners to dinner at a Tranent inn.

'Examplar terrificatioun to all Godles harlottis'

Under the feudal system, the administration of justice was in the power of the baron or feudal lord. He had the power of life and death in all cases, even including murder if guilt was clear. These powers were also held by the magistrates of the burghs. At various times a variety of courts sat in Haddington, the Burgh Court, the Head Burgh Court, the Court of Council and the Assize among others. Some courts dealt with civil matters: weights and measures was a serious matter and could lead to expulsion from the burgh. The trade incorporations were also strict in protecting their privileges, and could have a business closed down if it transgressed.

The jougs, an iron collar and chain fixed to a wall, was a popular method of punishment in Scottish burghs, at least with the courts (a set still hangs from the wall outside Duddingston Kirk) but Haddington seems also to have favoured the stocks, though it is recorded that a set of jougs, attached to the east end of the Nungate Bridge, was removed in 1672. Both the jougs and the stocks seem rather a merciful form of retribution when compared with some of the more gruesome penalties of the day: in 1555 a James Hume was sentenced to be nailed by the ear to the tron for stealing a cow, and sentences as long as two weeks in the stocks must have been a severe ordeal, particularly in winter.

But the stocks or jougs were not always considered a sufficient punishment. One of the last times that the jougs were prescribed, for what we would consider a petty misdemeanour, was in 1785 when a servant to William Gourlay, distiller, was found guilty of helping himself from his master's cellar. He was sentenced to one hour in the jougs with a sign attached saying: 'Infamous Thief Of His Master's Property'. He was then to be returned to the jail and the sentence repeated the following Friday. Two weeks later on a fair day, when there would be the maximum audience to be either instructed or entertained, he was to be whipped through town, then banished, never to return on pain of a repeat of the whipping.

The seventeenth century was the century of the witch. In that period over 3,000 cases of witch-hunting are recorded. More than a thousand were found guilty, of whom over 800 were women. Sadly, this witch mania was not a manifestation of the ignorant, simple or ill-educated but was led by the King himself. The Duc de Sully's comment, that James VI was the wisest fool in Christendom, seems fair in this context.

The craze for witch-hunting began in Europe as a campaign against heresy originated by two Dominican friars who produced a treatise called *Witches Hammer* in 1486. This was seized upon by the church authorities as a means of countering the growing opposition to established order which was to culminate in the Reformation. The craze spread across the Continent, but by the time it reached Scotland the Reformation was an established fact, and it seems strange that this movement, founded on irrational and incredible evidence, should take such a hold in a country which had so recently embraced a more rational form of religion. Even that most sensible of states, Switzerland, had one of the worst records in the persecution of witches.

Inevitably, Haddington parish had its witch hunts but they have not achieved the notoriety of those at North Berwick, where the witch hunt was by Royal Warrant, as King James VI took a personal interest in the investigations and in the torture that was inflicted to secure confessions. A number of witches were tried in Haddington. In 1649, Margaret Dickson, Agnes Hunter and Isabel Murray, all of Penston, were suspected of witchcraft. The case was submitted to Parliament by the magistrates, ministers and elders. The instructions they received were that, if found guilty, the magistrates were to strangle them and burn their bodies. This was a merciful punishment: at the beginning of the witch hysteria the guilty had been burnt alive.

In 1661 the tenants of the Earl of Haddington's Samuelston estates were so concerned by the number of witches in the area that they persuaded their laird to petition the Parliamentary commissioner to authorise an investigation. This was granted, four women subsequently confessing and naming eleven others of both sexes. In view of the tests inflicted on suspects, it is not surprising that so many confessed and incriminated others.

On of these tests was pricking with a needle. This was in the belief that witches had marks on their bodies which, if pricked, would not bleed. There were professional prickers who were skilled at exposing witches by finding these telltale points. In the Lizzie Mudie case of 1677 the accused named five other women and a man. The tests on the latter were described by a witness: 'I did see the man's body searched and pricked in 2 sundry places ... he seemed to find pain, but no blood followed, tho the pins were the length of ones finger, and one of them was thrust into the head'.

Records survive of a trial about 1620 which demonstrates the seemingly pitiless cruelty suffered by those found guilty. the case came before a court in Haddington, described as an assize. It was heard before fourteen men of the parish under one David Forrest with the title of Chancellor; like the others on the assize, he was a layman, the merchant of Gimmer's Mill, and there was no legally trained person involved. Only capital cases, when the accused had been caught red handed, were tried by such local courts. Other cases had to be referred to a higher court.

The accused was Margaret Alexander of Aberlady (three of the assize were Aberlady men), and she was alleged to have committed adultery and incest and, in an effort to conceal her crimes,

infanticide. The man involved was a Patrick Learmonth, and since no other man is mentioned, Learmonth must have been a relation.

There were two babies in the case. Margaret claimed that the first had died of natural causes. In the case of the second, in her desperation she had resorted to practices all too familiar, even in recent times. She had tried to induce miscarriages, there was a visit to Agnes Cowstiane in Nungait, said to be 'ane witche', for drinks that would procure an abortion and, when her condition became too obvious to be denied, she said she was suffering from hydropsy. Finally, she named another man as the father, in a desperate attempt to escape the incest charge.

The second child was born in the brewhouse of William Lawder, her brother-in-law in Haddington. She wrapped the infant in rough cloth and hid it behind a malt sack. That night she went out with her niece, Christiane Lawder, whom she sent on an errand, giving herself time to scoop out a hole in the river bank, and there buried the baby. It was found quite soon and laid at the Mercat Cross whilst a search was made for the mother. Margaret lay low until she could escape, fleeing as far as Fife before she was caught and brought to trial.

David Forrest announced a unanimous verdict of guilty and William Sinclair, the court officer or dempster, pronounced the doom. She was to be taken to the waterside where the bairn was hidden, and there testify to her unworthy behaviour and present repentance, and from there to the grave of the infant in the churchyard, 'with the same hands that first scrappit the hoill at the watter ayde ... to skraip out her said murthurit bairne out of the grave ...', as further testimony of her ignominy. Finally, Margaret Alexander was to be taken to a scaffold erected beside the Mercat Cross, there to make an open confession of her guilt, before being hanged to the death. Thereafter, her arms to be severed at the elbow, one to be displayed at the North East Port, the nearest to where the baby was concealed, and the other to be attached to a wooden stake in Aberlady, all this as an 'examplar terrificatioun to all Godles harlottis to flie and abhorre the lyk mair nor beastlie behaviour'.

The Handing of Earth and Stone

When James VI succeeded Elizabeth as James I of England in 1603, he took away the court and its power to influence through

patronage and example. No more were there to be royal progresses to the palaces and castles of the ancient kingdom, no more the royal hunt, no more the sports of kings and queens. Before he moved to London, James did occasionally visit Haddington, but as far as we know he never stayed in the burgh. On one visit he came to hunt, not game, but the Earl of Bothwell. This was Francis the fifth of the title and the nephew of the third husband of Mary, Queen of Scots.

This earl seems to have caused his sovereign a lot of worry, even apparently attacking Holyrood. James feared that the rebel coveted the throne, so he put a price on his head and personally led a search for him across the Borders and East Lothian. Hearing that his prey was near Haddington, the King set out to trap him and put a stop to his outrageous behaviour. But the best-laid schemes of kings ... his horse slipped on the bank of the Tyne and mount and rider fell into the river. The king was rescued with difficulty by a 'yeaman', probably a farmer. The King's entourage were unable to do much to help him as they, like their master, would have been heavily armed and armoured, in preparation for the expected engagement. As it was, Bothwell was not caught but, for a moment, the future of Scotland and England lay in the ability of a humble agriculturist to haul his accoutred and sodden sovereign to the bank of the Tyne.

When James left for London he took with him his two sons, the younger eventually reigning as Charles I. He was born in 1600 at Dunfermline and was the last king to be born in Scotland, while his son, Charles II, was the last king to be crowned in Scotland. The reigns of both these monarchs were marked by continuing religious strife and civil war.

In 1617 James VI made his one return visit to Scotland, but his progress did not take in Haddington. Nevertheless the council entered with enthusiasm into the spirit of the occasion when they were told to be prepared to welcome some of the royal retinue. Some of the restrictions on trade were lifted, both by the council and the trades incorporations. The bakers promised sufficient extra bread and the butchers plied their trade for the week of the celebrations without impediment.

Although he ignored Haddington on that regal occasion, James more than compensated for it when, towards the end of his reign, he confirmed Haddington's royal charter. The document, dated 13 January, 1625, defines the burgh's lands as Gladsmuir, Ralph

Eglins Acres and Hangmans Acres as well as two mills, the haughs and the port of Aberlady.

The ceremony defining the boundaries of lands granted in a charter is set out in a charter of 1543. After the reading and understanding of this 'Precept . . . the said Henry Cockburne, Sheriff Depute, went to the above-mentioned Moor of Glasmoor, and upon the ground and land of the same, according to the said Precept by the handing of earth and stone, gave and granted state, heritable sasine, and real, true, and corporeal possession of, all and whole, the said moor and its pertinents to Master William Brown, Provost of the said Burgh, in name of the Baillies, burgesses and Council of the Burgh of Haddington'.

And so it goes on, with every part of the lands mentioned in the charter being visited and the ceremony of earth and stone being performed. This same ceremony takes place annually in several Border towns where it is known as the Riding of the Marches and is the heart of a week-long festival of sport and entertainment, binding the townspeople together in a commem-oration of their past and in their present identity.

It was Charles I who, in trying to introduce the English Book of Common Prayer without reference to the General Assembly of the Church of Scotland, provoked the backlash which found its focus in the National Covenants. The Covenants presumed that Scots, a priesthood of all believers, had a direct relationship with God, without the intervention of papacy or king. The movement started in Greyfriars Churchyard, Edinburgh in 1638 and the Covenant and its copies were eventually signed by some 300,000 of the faithful. Many in the Haddington parish signed including Sir Archibald Sydserf and the Earl of Wemyss.

Not only was the covenant enthusiastically endorsed by the Haddington Presbytery, but they entered their own petition to the Moderator of the General Assembly, setting out their objections to the adoption of the Book of Common Prayer:

That where we have all conceived ane great fear to be pressed, baith minister and people, to prectice in our churches a late book, entitled a Book of Common Prayer for the Church of Scotland, and we foreseeing ... the great evil and hurt which will inevitably ensue by the fearfull disturbances and rent that will follow ... be reason that the foresaid book being styled a book for a settled form of divyne worship, which in no nation

nor kirk ... was ever receiveit in a Christian estait under a Christian king but by a nationall Assemblie and ratified by Act of Parliament of a Christian prince and estait and that same estait wherein the kirk was established, which was not in this.

Secundlie, that both pastors and people, altho that they were [to be] pressed with the highest authority may well some of them be induced to practice the aforesaid book, it is impossible that ever in this kingdome there can be a liking of it, by reasone that there is into the book sundry points that toucheth the fundamentall points of our reformed profession [of faith] where-unto we have been all sworne of all estates in sundry actes of Parliament. And that [if] we do not speak of particulars it is because the remonstrance thereof is onlie competent to be disputit in a nationall Assemblie. (Some of the spelling has been modified)

Haddington is here taking a firm and principled stand from the outset, asserting the primacy of the General Assembly in deciding matters of faith. Towards the end it is also emphasising that the fundamentals of the reformed religion have been endorsed by the Parliamentary estates. The three estates were the constituent parts of Parliament and they were: the clergy, the nobles and the bur-gesses. It would seem from this that the Presbytery of Haddington was also saying that the will of the Scottish Parliament in this matter was not to be vetoed by a king in London.

'There may be a covenant made with death and hell'

The Presbytery of Haddington in this submission summed up the aims of Scotland throughout the succeeding war-torn years. But as always, there were divided loyalties. When in 1639 the King moved against Scotland because of the rejection of the Prayer Book, he sent a fleet to control the Forth, commanded by the Marquis of Hamilton whose mother was leading a cavalry unit on the Covenant side!

The Scots were victorious in this campaign, even occupying the North of England down to Newcastle and forcing the King to come to Edinburgh. There he agreed to the independence of the Church of Scotland and of Parliament as well as the abolition of bishops. Scotland had achieved civil rule with a constitutional monarchy, but it was not to last. These were known as the Bishops' Wars.

The King's situation in England deteriorated. The Scots had shown that he could be brought to heel and this led to rebellion in Ireland and then civil war in England as those who opposed him for widely differing reasons sought to benefit from his weakness.

The ensuing Civil War established Cromwell as the leading figure in England and the Scots expected him to make Presbyterianism the established form throughout the whole of the British Isles in return for Scottish support, as they believed had been agreed by the English Parliament in the Solemn League and Covenant of 1643. The English were not only ignoring the religious terms of the League, they now executed the King although the agreement allowed for the rights of Parliament and the King.

The Scots were appalled by the execution of Charles and immediately proclaimed his son as Charles II of both countries. The following year, after signing both Covenants, he was crowned at Scone. But it was too late. Cromwell had already subdued Ireland and now he turned his attention to Scotland.

In July 1650 he crossed the Border with 16,000 men. He was opposed by an army commanded by Alexander Leslie, Earl of Leven, an able general who led the Scots with great skill in the Bishops' Wars, but he was ageing and the effective command was in the hands of his nephew, David Leslie. Their tactics were successful, and after a rebuff at well fortified Leith and outmanoeuvred at Corstorphine, the Cromwellian force was ushered back in the direction of the Border, through land which had been laid waste.

The demoralised force retreated by way of Musselburgh, harried on its way by the Scots who carefully avoided a full-scale engagement. On 31 August, Cromwell arrived at Haddington. The advance guard of the Scots caught up with him by nightfall. Cromwell seems to have been unaware that his enemies were so close, and his rearguard were harried and hounded right up to the ports of the burgh, and even into the streets. There was a good moon and Leslie made full use of it until it clouded over. The Cromwellian forces took up defensive positions until daylight when they withdrew to a field to the south of the burgh. There on the ground where he had chosen to make a stand, Cromwell drew up his troops in battle order but, again, Leslie was not to be drawn. The English continued to retreat and two days later they were south of Dunbar. Leslie still had the tactical advantage, holding

Doon Hill, and with a force to the south at Cockburnspath, Cromwell was trapped with the sea at his back and no room to manoeuvre. That night the Scots descended the hill, partly because the weather was causing them problems. It was raining heavily and the cavalry were having difficulties, and the ministers accompanying the force insisted that it was the will of God that the enemy be defeated at this place. It was expected that the English would break in the face of the Scottish charge but they did not. The English now had the advantage of the terrain and the Scots army, weakened by religious purges of its most experienced men and officers, suffered a crushing defeat: 4,000 Scots died and 10,000 were taken prisoner, and were treated most cruelly, the few survivors being transported to the plantations. Cromwell, a master of the *mot juste*, remarked, 'There may be a covenant made with death and hell'.

The Cromwellian forces turned back into East Lothian and, by bombarding the fortresses of Tantallon and Dirleton, rendered them useless in the event of further resistance. Enough remains of Tantallon, however, still to give sense to the old saying that 'you might as well try tae ding doon Tantallon and build a brig tae the Bass', as an expression of the impossible.

For the first time in its history Scotland had been conquered. To the populace it seemed that God had abandoned His people.

The country was put under military rule, English troops were stationed in every town and the country was ruled by eight commissioners sent from England. The administration was not oppressive but opposition was ruthlessly suppressed. Dundee was the only burgh to show any opposition to the military occupation but it was put down with great cruelty; it is said that only Drogheda's suffering exceeded that of Dundee at the hands of the Roundheads. In the light of this and, even nearer to home, the massacre after Dunbar, it is little wonder that Haddington fell into line, as did the rest of the burghs; their provosts were just as submissive as Haddington's:

I, George Brown, being deputed by the Burgh of Haddington do, on the behalf of myself and those represented by me, declare our free and willing acceptance of and consent unto the Tender made by the Parliament of England that Scotland be Incorporated into and made one Commonwealth with England, that thereby the same Government that is established and enjoyed

without a King or House of Lords under the free State And
Commonwealth of England, and We desire that the people of
England and Scotland may be represented by one Parliament
as the supreme authority of the whole Island.

Acceptance of military rule brought assurances of good behav-
iour on the part of the military garrisons and, on the whole, the
occupying troops were well disciplined and obeyed the injunction
that they should offer 'no violence nor injury unto the person or
goods of any of the inhabitants of the same', i.e. those burghs
which had undertaken to live peaceably under, and yield obedience
to, the Authority of Parliament of the Commonwealth of England
exercised in Scotland.

No doubt the acceptance of the joint Parliament was a bit less
enthusiastic when Scotland was granted only five seats out of 140
and, later, 30 out of 460, under the constitution drawn up by
Cromwell when he took office as Lord Protector. The English
mocked the Scottish representatives and treated them as a con-
quered people, so that even the small numbers required were not
always forthcoming. As one minister put it, 'As for the embodying
of Scotland with England, it will be as when the poor bird is
embodied in the hawk that hath eaten it up'. However, the country
had been in a virtual state of war for twelve years, and now there
was peace, most of the nobles who might have been a focus for
opposition having fled. There was religious tolerance, although the
fervent Presbyterians regarded that as sinful, and there was an
unprecedented observance of the rule of law, due to the garrisons
imposing military rule, but this was paid for in heavy taxes.

The first detachment of Cromwellian troops in Haddington was
led by Captain Roger Legge, and one of his first demands on the
burgh council was for a piece of linen large enough for a table
cloth, a dozen napkins and a poster bed: evidently he intended
filling his post with some style.

In late July 1663 the council and the trades paraded in their
finest apparel to the Mercat Cross to hear the proclamation of the
powers of his Highness, Cromwell and of Parliament. The pa-
geantry was enlivened by trumpet fanfares from Captain Legge's
troop. The councillors used the occasion to further good relations
with their guests by making both the captain and his quartermaster
burgesses.

The taxes imposed to pay for the occupation must have borne

heavily on Haddington and, not for the first time in the history of the burgh, the council petitioned the authorities for some relief. The provost, William Seton, was delegated to make representation to the Privy Council.

It was proving difficult to find politicians willing to sit in the English parliament, and the number attending was usually well below the allotted quota, small as it was. Haddington Burgh was one of those having difficulty in finding a volunteer to take up the vacancy. The provost was able to approach General Monck, the military governor in Scotland, directly. The general readily recommended his brother-in-law, Thomas Clarges. This was not an entirely altruistic nomination as, apart from being a relative, Clarges had been acting as a go-between, carrying information from London to Monck. The general now had a trusted informant close to the seat of power.

When Cromwell died in 1658, he was succeeded by his son, Richard, as Lord Protector. He was not a capable administrator, and it soon became clear that a change was needed in order to avert chaos. Monck assembled his army in Scotland ready to march on London. Before leaving, he addressed the burghs and shires in

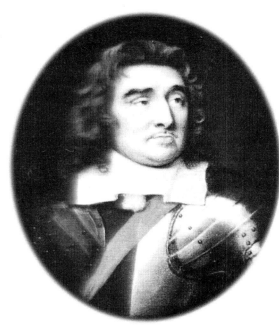

10. General George Monck, virtual Governor of Scotland during the Protectorate. He 'suggested' his brother-in-law, Thomas Clarges, as MP for Haddington.

Edinburgh, telling them that they must maintain order while he was away, and that he was going to restore the liberties of the three nations. Meanwhile Thomas Clarges, Haddington's MP and Cromwell's courier, was sent to the continent with a message for Charles II at Breda, inviting him to return and to restore the monarchy. This message so pleased the king that Thomas was immediately made Sir Thomas.

'The great mercie to this land be his majesties return'

In spite of the order that marked the rule of the Lord Protector, there was no great regret at his passing; indeed with the restoration of the monarchy there were wild and extravagant celebrations. In Haddington, the council declared that 'upon consideration of the great mercie to this land be his majesties return', bonfires be lit, and the whole population was to join with the magistrates at the Cross in 'testimonie of their joy'. It was further decreed that the King's birthday should be celebrated in succeeding years. In the following year, the Restoration was again celebrated by the Estates. Not wishing to be left out, the councillors decided to erect a platform at the Cross, and at two tables thereon, with a party of five or six score guests, would sit down to a feast to sweetmeats, weighing twenty pounds, to be washed down by wine from a large cask, and the King's health would be drunk. The platform was to be decorated with flags of white and blue taffeta emblazoned with the burgh arms and inscribed 'Haddington'.

The councillors of Haddington now developed a severe case of collective amnesia, pledging their loyalty to the Stewart dynasty, not only in the present and the future but also retrospectively, conveniently forgetting their effusive welcome of rule from London without a King! It was ordained that every household was to light a bonfire on November 5 to mark 'that great mercie & delyverance manifested to those kingdomes be discoverie of the Gunpowder treason plotted and intended against his majestie King James the saxt of ever blessed memorie and his parliament of England'. This was cried throughout the town by the town drummer and it was also announced that this would be an annual event and failure to observe it would incur a fine of £5 Scots.

One of the officers in the army of Cromwell who elected to stay in Scotland after the occupation was Colonel James Stanfield who settled in Edinburgh, where he proved himself a shrewd business-man. He was trusted in the community, 'having many transactions

with noblemen'. He owned land in Leith but his home was in Edinburgh, in what was then called Stanfield's Close, now World's End Close. He seems to have suffered from a form of depression, having once tried to dive headfirst from a window but his feet were seized and he was pulled to safety.

His malady did not affect his business reputation, however; so, when in 1681 Parliament passed laws for the promotion of trade, Stanfield was in a position to gain support for the setting up of a major clothmaking enterprise. He had acquired a property by the Tyne, then called New Mills but now known as Amisfield, where there was an existing woollen mill. It was there that the new manufactory was to be set up with Stanfield and Robert Blackwood, who was Master of Edinburgh's Merchant Company, holding most of the shares.

The prospectus envisaged 20 looms with a workforce of 233 producing close on 56,000 yards of material annually. This proved rather optimistic when difficulties were experienced in finding experienced weavers. The best source of recruitment was England, but weavers there were reluctant to make the move. Nevertheless, by October 1681 two looms were operating, producing coarse cloth, and in the following January production of fine cloth commenced. By 1684 the company was able to pay some interest to stockholders.

New Mills was constantly being undercut by cloth illegally imported from England, and government contracts for cloth, to outfit the military, were regularly lost to suppliers of contraband material. Eventually Sir James Stanfield ran into financial difficulties and he was found dead in the Tyne. He had been knighted, probably for his services to industry and to Parliament where he served as representative for East Lothian. At first he was thought to have committed suicide, a reasonable assumption in the light of his earlier attempt and his current money problems. However, suspicions were aroused by a hasty funeral, and the lifestyle of Sir James' son, Philip. In fact, the father's financial problems stemmed, not from his business interests but from Philip's spendthrift ways. There was sufficient concern for the Privy Council to authorise the exhumation of the body. The examination of the remains, which took place in Morham Church, pointed to death from strangulation, not drowning. There then took place a bizarre ceremony in which Philip Stanfield was confronted with the body and told to touch it. It was reported that the corpse bled when touched by the suspect, and this was taken as proof of his guilt.

Philip was found guilty and hanged at the Cross in Edinburgh. After death his tongue was cut out and his head was sent to Haddington to be displayed at the East Port. His right hand was also cut off but enough of his body was left to allow it to be hung in chains at the Gallowlee between Edinburgh and Leith.

Stanfield's interests were taken over by his fellow directors, and the reconstructed enterprise was launched in 1693 as the Incorporation of the Woollen Manufactory at New Mills in the shire of Haddington. The affairs of the company gradually improved and by the Union of the Parliaments in 1707 good profits were being made, but the Union brought about the end of the enterprise. Free trade was established between England and Scotland which allowed cheaper English cloth free access to Scottish markets, and by 1711 the business was being wound up. In 1713 the estate was sold to Colonel Charteris.

The Divine Right of Kings

Harsh reality soon followed the spontaneous outburst of goodwill that welcomed the restoration of the monarchy. Charles II, like his father, was a firm believer in the Divine Right of Kings and now sought to impose his will. He created a Privy Council composed of people sympathetic to his aims. The most powerful of these was the Earl of Lauderdale, a grand-nephew of the Maitland of Lethington who had been Secretary to Queen Mary.

When in exile Charles had taken an oath to honour the Covenants but this was a cynical move, as he was prepared to do or say anything to recover the throne. The post of secretary to the Privy Council was made a London appointment, and all Charles had to do was to dictate his wishes to the secretary who then passed them to the Privy Council, whence they were presented to Parliament for rubber stamping. One of the first measures to go through this process was the rescinding of all the laws, no matter how good or just, that had been passed since 1633. The King now had the power of decreeing what was to be the religion of Scotland and he declared Episcopacy the only lawful religion.

Whereas Presbyterian ministers had been chosen by the congregations, they now had to get the support of the local laird and then get consent from a bishop. It was thought that, rather than lose their livelihood, most ministers would conform. They did not, nor did their congregations, and this led to the conventicles, gatherings of Covenanters in remote places for services led by

ministers with a price on their heads. Warnings of the dangers involved in attending were proclaimed throughout the land. Haddingtonians were told from the Cross to avoid these meetings addressed by 'vagrant, intercommuned, or rebellious preachers', as they would be severely punished because the Government held such gatherings 'in just horrour and detestation'. In spite of cruel repression and even pitched battles, the Covenanters persisted in their resistance to the end of Charles' reign in 1685.

During the last few years of the reign, Charles' brother, James, was Commissioner to the Scottish Parliament. When he arrived to take up his appointment, Lauderdale organised an East Lothian reception for His Royal Highness, and the royal party was duly, and dutifully, welcomed to Haddington by the Magistrates. The royal party then proceeded to Lethington, now known as Lennoxlove, to be entertained with splendour. The party totalled about two thousand and included most of the Borders gentry and nobility.

James used his position to further his plan to make Scotland a Roman Catholic country, arousing the anger of Presbyterians and Episcopalians alike. Once he became James VII, he tried to impose this policy on the whole of Britain, but all he succeeded in doing was to provoke the Revolution of 1688 which drove him into exile and brought about the joint rule of William and Mary. James had ruled for less than four years and his going brought to an end, after more than three hundred years, the direct line of the Scottish royal house of Stewart.

The Revolution of 1688 established William of Orange, a grandson of Charles I, and his wife Mary, a daughter of James VII, as joint monarchs of the United Kingdom. The new regime agreed that Presbyterianism should be the recognised religion of Scotland and that ministers should be called by the congregation, thus ending patronage, at least until 1712 when it was reintroduced by the United Kingdom Parliament.

Haddington's two Episcopalian ministers, James Forman and George Dunbar, continued to minister to their flocks. Although the people of Haddington were strong supporters of the Covenants and opponents of patronage, they remained in their posts after 1688, which indicates that, as pastors, they were liked and, presumably, had bowed to the inevitable by accepting the new regime. Nevertheless, when Forman died in 1702 he was replaced by John Currie, whose Presbyterian credentials were impeccable; indeed

he was appointed Moderator of the General Assembly seven years later. George Dunbar died in 1713, and from then on the Parish of Haddington has never wavered from the path beaten by John Knox.

One Haddington minister who must have regarded this tolerance of Episcopal ministers somewhat wryly was the Rev. John Gray. He was born in the burgh in 1646 and entered the ministry in 1667, when the Episcopal system was dominant. He first went to Tulliallan and then to Glasgow. In 1684 he was appointed to Aberlady, but in 1689 he refused to pray for William and Mary, and was dismissed. He retired to Haddington, preaching occasionally at an Episcopalian meeting house in Poldrate.

John Gray died in 1717, leaving his extensive library to his native town. He also left three thousand merks Scots, the interest of which was to be devoted to charitable causes, apart from twenty-five merks Scots (around £1.38 today) for the maintenance of the library. In 1807 the council allowed a further £2.50 for maintenance.

For its day the library was an extensive one comprising some 1,500 volumes, many of them valuable examples of the art of the early printers. There are theological works, early prayer books and some thirty volumes of political and ecclesiastical pamphlets and manuscripts, the latter including some of Gray's lecture notes and sermons in his own hand. Of great interest to researchers are the loan registers listing borrowers in the years 1732–96 and 1805–16; there are only three other examples of surviving loan registers. Sadly the gift was something of an embarrassment to the council as the books, many in Latin, Greek and Hebrew, while being a memorial to the great learning of their donor, were far too erudite for the general reader. As a consequence the library suffered from neglect. This neglect extended to the administration of the collection, and poor control over those books that were borrowed meant that many were never returned. In a revealing move, the council withdrew from the Presbytery the privilege of holding their meetings in the library! James Miller, in his *Reminiscences of Old Haddington*, singles out country ministers for special mention: 'Doctor Laing got his hands among this valuable collection ... and got away with some rare copies which were never returned'. Initially the library was kept in the old school house in Church Street; later it was placed in the present Public Library building in Newton Port where it was shamefully neglected. It was not until

1929 that the Council faced up to its responsibilities by building an annexe to the Public Library to house and care for this precious inheritance. In 1961 the collection was transferred to the National Library of Scotland, on loan to the body best equipped to care for it and, just as important, able to make it known to a wider audience. In 1983 the new District Council surrendered trusteeship of the Gray Library and it is now in the permanent care of the National Library of Scotland, accessible to students and researchers and safe from forgetful rural pastors.

'Wilful Willie, Wilt Thou Be Wilful Still?'

At the turn of the seventeenth century the economy of Scotland was in a poor state. As we have seen, illegal imports from England were undercutting local products and the other half of the United Kingdom was now acquiring overseas possessions, giving it more trading opportunities. It was thought that Scotland should be able to join in the trade to Africa and the Indies, and an Act was passed in 1693 setting up a company for that purpose.

Haddington was a trading burgh and the new trading company looked like a good way to restore prosperity. Merchants such as George Cockburn and George Anderson subscribed £200 and £100 respectively, from among the landed gentry Sir John Baird of Newbyth subscribed £500, an official, Postmaster William Johnston, £100, and a widow, Isabel Yeaman or Robertson, £100.

English traders, however, were having none of it, the scheme was denounced in the English Parliament and foreign backers withdrew. The new company looked like being a failure before it had even begun to trade.

It was now that William Paterson came to the fore. Regarded as one of the cleverest Scots of his day, he had travelled widely, making a fortune in the West Indies and in London. He had advanced the idea of a national bank, funded by the Government, and the Bank of England was born. Now he proposed that, rather than trying to compete for trade in the English colonies, Scotland should set up her own colony. He had long had his own idea of where to found such a colony on the narrow isthmus, now called Panama, which joins the north and south continents of America. There would be no need for merchantmen to brave the dangers of Cape Horn, and the dream of a north-west passage north of Canada could remain a dream, because the two oceans would be joined by a road and Scotland would control it.

It was a brave scheme, an imaginative scheme, but it was an impossible dream. No one in Scotland had any conception of the conditions in the rain forests of Central America: there were tropical rains and violent storms, and festering swamps that bred diseases unknown in Europe. Finally there was the hostility of those who wanted the enterprise to fail, the Spaniards and the English.

This was the Darien Scheme, and Haddington's council added to the wealth already committed by its citizens by investing £400.

A small fleet of three ships and two tenders left Leith in July 1698. This was followed by a further expedition in 1699 to find that the first settlers had abandoned the collection of huts optimistically christened New Edinburgh. This second wave, after an initial success against the Spaniards, were also forced to abandon the colony in the face of the overwhelming military superiority of the Spaniards. On 1 April, 1700 the colony was again abandoned, the survivors carrying off their sick and wounded. The Spaniards were chivalrous in observing military courtesy; they granted the soldiers the honour of embarking with their arms, drums and colours. This contrasts with the reception received by the little fleet, with its burden of sick and wounded men, women and children, when aid was sought from their fellow Britons in the colonies of the West Indies. All help was refused, even fresh water. They had to put to sea and, one by one, the ships were lost in storms while trying to reach New York.

The loss to Scotland was enormous: 2,000 dead and over £200,000, a vast sum for a small nation. There was scarcely an aspect of life untouched by the fiasco, whether it was the grieving families, the exchequer or the investors. Haddington's long-standing continental trade had suffered because of wars in Europe and the Darien Scheme had offered hope of a guaranteed trading area. But even with the coming of peace, economic conditions did not improve. And now the news filtering through from the troubled colony indicated that hope in that direction was misplaced. The Council petitioned Parliament: 'We find our trade abroad seriously decayed and our coin carried out of the country by the importation of commodities from places where ours are prohibited, our Woollen and other manufactures at home by the same means ...' Today we would say that the town had a trade deficit and a balance of payments problem. The Council went on to highlight the social problems arising from the economic crisis: '... whereby our poor

are neither maintained nor employed as they might otherwise be and Parliament should take some effectual course for the curbing of vice and putting in execution the many laudable laws for the maintaining and employing the poor'.

When the full scale of the Darien débâcle became known it provoked discontent and disorder across the land, for the disaster affected virtually the whole population. Haddington has been described as seething with discontent but this did not descend into serious disorder as happened in Edinburgh where riots broke out. (Edinburghers of former times seem to have been more passionate and volatile beings than their counterparts today, with their reputation for douce rectitude!) Those of the rioters who were brought to trial were sentenced to be whipped by the public hangman. However, whether from sympathy for the accused or fear of the mob, the hangman applied his scourge most gently. The councillors accordingly imprisoned him and also sentenced him to be whipped. They had, however, to borrow a hangman to carry out the sentence, presumably to give an object lesson in how the punishment should be inflicted, and sought the loan of the Haddington executioner, who turned out to be the brother of the Edinburgh hangman. This official duly arrived in Edinburgh to carry out the sentence but was confronted by a threatening mob. Doubtless relieved to be given such a good excuse, he made his escape back to Haddington.

The Edinburgh rioters blamed William II (III in England) and his merchants for the troubles that now beset Scotland, and they broke the windows of those known to be friendly to the government, whilst the bells of St Giles' carillon played the tune, 'Wilful Willie, Wilt Thou Be Wilful Still?'

William II died in 1702 and was succeeded by his sister in law, Anne the second daughter of James VII who had died in exile.

'Now There's Ane End Tae Ane Auld Sang'

With these words Chancellor Seafield handed the signed document of Union to the Clerk of Parliament on 19 March, 1707, when Parliament adjourned. It never met again and on 1 May the Treaty of Union came into force. On that day the carillon of St Giles played the tune 'Why Should I Be So Sad On My Wedding Day?' The High Kirk of Edinburgh evidently boasted a musician with a tune to fit every occasion. Rioting broke out in many towns and a copy of the treaty was burnt in Dumfries.

Few in Parliament stood out against the Treaty of Union, the

most prominent of these being the Member for Haddington, Andrew Fletcher of Saltoun. He was born in the village, the eldest son of the laird, in 1653 and he was buried in East Saltoun kirkyard when he died in 1716. His mother traced her family tree back to King Robert the Bruce and Fletcher was just as single-minded in his struggle for Scotland's independence as was illustrious ancestor. Every September the life of the man remembered as The Patriot is commemorated at the kirk of East Saltoun, with an address by a prominent Scot.

In 1708 the Council voted an address expressing their attachment to the Government and their loyalty to the Queen. This outburst of affection may have been prompted by two events. The first was the Act of Union, the second was the arrival off the Forth of a French fleet intending to land 4,000 men at Leith, with the object of restoring the Stewart dynasty in the person of James, only son of James VII and brother of Queen Anne.

Haddington was heavily dependent on the wool trade and the Treaty of Union provided for a subsidy of £2,000 per annum for seven years to help the wool, fishing and other basic industries to make the transition. This would afford some relief to the town, in the bleak aftermath of the Darien tragedy.

As for the French fleet, war was averted by a navigational error, the fleet missed the mouth of the Firth in the dark, and by the time the mistake was realised and rectified, a British fleet had taken up position between the French and their objective. There was nothing for it but to return to France. This they did, suffering grievous losses in storms on the way. The later Stewarts seemed destined to fail, either through bad luck or bad planning.

Nevertheless, another attempt to restore James was made in 1715. On 6 September the Earl of Mar raised the Royal Standard at Braemar. Scotland was disillusioned with the Union which, many hoped, would be dissolved under a Stewart king, and support for the rising was widespread, but not deep. The underlying sentiment throughout the country was fear of Popery. It was this that made many draw back, who would otherwise have welcomed change.

This feared threat to Presbyterianism would, no doubt, be a factor in the attitude of the authorities in Haddington, that town of strong support for the Covenants. We can presume, therefore, that the news of Jacobite landing along the coast, the nearest at Aberlady, must have occasioned some apprehension.

A group numbering around a thousand men, led by the capable

Mackintosh of Borlum, marched on Haddington where they camped for a few hours. The Chevalier de St George was proclaimed James VIII at the Cross before the little army moved on to eventual surrender at Preston. Mar had raised an army three times larger than the Government forces in Scotland but procrastination and caution negated this advantage. Mackintosh surrendered on 13 November on the same day Mar's forces at last confronted the smaller Government army under the command of the Duke of Argyll, a very fine general. They met at Sheriffmuir by Dunblane. At the close of the day neither side had forced a conclusive victory:

> There's some say that we wan,
> Some say that they wan,
> Some say that nane wan at a' man:
> But one thing I'm sure,
> That at Sheriffmuir
> A battle was, which I saw, man.

With the dawn, Mar had left the field to Argyll, and the rising had failed.

The Disputed Council

Queen Anne had died in 1714. The Treaty of Union had stipulated that the succession should go to Sophia her second cousin, who had married the Elector of Hanover. Sophia was related to the Stewarts through her mother who was the daughter of James VI. However, Sophia died shortly before Anne and her son George was offered the crown instead. The Jacobites had expected James to be chosen and their disappointment was one of the factors that led to the '15. George was a German who spoke no English, but he was a Protestant and he was descended from a Stewart so, on 5 August, 1714 he was proclaimed King in Edinburgh and a grand ball was held in Holyrood House and, on 19 October, Haddington's councillors announced that the coronation would be celebrated.

Bitter conflict is not restricted to the military, and changing conditions – economic, social and political – combined to put a strain on the institutions of the country, many of which had scarcely changed for decades, if not centuries. Local government was one area that was showing signs of strain. Royal Burghs still had their privileged trading status but some of them were in decline whilst

other unprivileged towns, such as Paisley, were increasing in size and economic importance.

There were the early signs of groups of people with similar philosophies and aims coalescing into political parties as we know them today. It is ironic that, of the two main parties, one took its name, Tory, from Ireland where it meant a robber (Toerag), and the other, Whig, from Scotland from Whiggamore, a low kind of horse drover (more = mare), a term used as an insult. Little wonder they eventually adopted the more respectable terms Conservative and Liberal.

Local government elections, if that is not too generous a term for what went on, were still in the hands of self-perpetuating cliques, namely the merchants and the incorporations or crafts. Since 1552 the retiring council, by custom, appointed its successors. At one time labourers of ground had contributed members to Haddington council, giving freemen a majority over the merchants, but in 1566 the Convention of Royal Burghs had excluded this group, reducing the council to twenty-five members: sixteen merchants and nine craftsmen. Only one craftsman magistrate was allowed, the remainder coming from the merchant councillors. There were appointments to the posts of Dean of Guild, Baron Bailies of Nungate and Gladsmuir and two Burlaw Bailies, the bailies settling minor cases and disputes.

Each year the full council reappointed themselves for a further year, but would invite four merchants and two craftsmen to join them. This brought the council up to thirty-one members. Six must now be removed to bring the number back to twenty-five. This was called 'the purging' and was a good excuse to settle old scores. In 1761 the Provost, Treasurer and Dean of Guild were all purged after only a year in office, yet they must have been acceptable as councillors to have been appointed in the first place. Was this the outcome of a factional feud or does a scandal lurk behind the bare facts? Sadly, we are not told.

A service in the parish church followed the purging. Then, led by the town piper and the town officers dressed in their burgh uniforms and with shouldered halberds, the councillors, wearing their chains of office, went in procession to the Cross where the Town Clerk proclaimed the election of the Provost and Magistrates.

That evening there was an election dinner and the following Sunday another service with the Kirking of the Council. This time

the procession left from the Library where cake, wine and spirits were served during the forenoon and afternoon.

1734 was a Parliamentary election year and the confused out-come, to put it mildly, of the Haddington council elections cannot have been unconnected with that event. Thirteen of the serving councillors banded together to form a group committed to voting solidly together; they called themselves the Congress. The sixteen merchant councillors selected their four nominees to the new Council as usual. Meanwhile the craftsmen members of the Congress were hard at work targeting those crafts where the vote would be close. They used procedural tactics and the fine print of constitutions to get opponents out and supporters in.

The Congress now had enough merchant and craft backing to attend the election, protested that it was invalid, and withdrew to the Cross where they proclaimed themselves the new Council. They then proceeded to force an entry to the Council and started to debate council business. They were interrupted by the arrival of the retiring magistrates, councillors and their nominees. These magistrates ordered the Congress to leave, but they refused. The burgh officers were then ordered to remove the usurpers, but they too refused. The magistrates then issued a warrant authorising the burgesses present to remove the burgh officers' badges of office. This is where things got nasty – a burgh officer's badge of office was his coat! A fracas now developed as the burgesses struggled with the coats of the officers, and the Congress tried to defend them. Eventually the chamber was cleared of ex-burgh officers and Congress, and the victors assumed their duties, for the present.

It took the Congress sixteen days to concoct a pseudo-legal document listing their grievances. These were that 'they did in a tumultuary mobbish order enter the Courthouse where the Magistrates were sitting in judgement; and having cried to the Burgesses to give help, did attack the four Town Officers, threaten to strip, and stripping them of the town's livery coats', that in doing this 'they did drag and twist the officers' bodies and arms, and invaded them with their staves and fists. That they did leap upon the council table, and shaking staves over the Magistrates heads, threatened and menaced them ... That they particularly menaced the Dean of Guild, with stripping off his cloaths, beat him on the breast, squeezed him by the throat, and twisted his body and arms ... that they jostled and beat another magistrate and pulled off his hat and wig ... and that they invaded a third by fixing their

thumbs and fingers about his throat'. The complaint was laid by
James Erskine, John Cluddel, Andrew Wilson and others, describ-
ing themselves as Magistrates, and came before Andrew Fletcher
of Milton, a Judge of the Court of Justiciary. Lord Milton issued
a warrant for the imprisonment of those named in the complaint
and authorised the Provost of Edinburgh, Patrick Lindsay, to give
directions on the manner of execution of the warrant. So on 25
October the Provost, Magistrates and Burgesses of Haddington,
forty men in all, were arrested with the support of the military
and imprisoned at Dunbar, this in spite of there being room for
them in the Haddington jail or, failing that, the nearer alternative
at North Berwick.

Bail was refused, and they lay there for two nights, by which
time their supporters had gained their release through another
Judge, the Hon. David Erskine of Dun. This came through at four
in the morning on Sunday, happily allowing the ex-prisoners to
attend church on their return to Haddington.

The status quo was restored on the Council, but the matter
was not finished: the wronged Provost and Magistrates now
petitioned Parliament for redress with regard to their wrongful
imprisonment. The petition setting out the events that had taken
place around the Council election was read to the House, after
which a motion that the matter be referred to a committee of the
two Houses was put to the vote and failed. The Honourable
Members perhaps sensed that, considering the means by
which most of them obtained their seats, sleeping dogs should be
let lie.

This was all reported by a correspondent to an Edinburgh
journal entitled *The Thistle*. It is clear from the tone of his report
that he was opposed to the Congress. On 30 July, 1735 *The Thistle*
was moved to verse:

> On the Faithful Town of Haddington:
>
> The Congress then, like that of Soissons broke
> Shall, after all their farce, dissolve in smoke
> Still may thou flourish, Haddington, and thrive,
> And all thy honest sons in plenty live;
> May wealth within your walls forever wait,
> And Peace and Freedom guard your hospitable gate;
> Long may true patriots rule your happy town,
> Long keep the chastity of fair renown,

Long boast the prize of faith and virtue won,
And give a title to a HAMILTON.

A few weeks earlier, on 8 July, Provost Heriot and Robert Forrest were allowed £2:13:6 by way of expenses incurred by their short stay in Dunbar prison.

A parliamentary election was due in 1734. The sitting member for Haddington Burghs was Sir James Dalrymple of Hailes who, in spite of having held a Government post, was out of favour, having voted against the Government on an Excise bill. He was supported by the Country Party, a loose grouping with Jacobite leanings. He was married to Lady Christian Hamilton. His opponent was James Fall, a wealthy Dunbar merchant and strong supporter of the Government.

Since only magistrates voted in General Elections, and they were few in number – in 1734 the electorate numbered 99 – every vote had great value. The Congress supported Fall and they were trying to maximise his vote by confining the Haddington Magistracy to themselves. Why did Lord Milton consign sitting Magistrates to prison on the evidence of one side without making further enquiries? The Government 'manager' in Scotland was the Duke of Argyll, who was often out of the country, when his right-hand man, Lord Milton, would act for him. We may not

11. Sir James Dalrymple of Hailes, by Allan Ramsay. Member of Parliament for Haddington Burghs, he was defeated by James Fall of Dunbar in the acrimonious 1734 election. He later sought to heal the divisions in Haddington. (Private Scottish collection)

12. Lord Milton of the High Court, by Allan Ramsay. He is remembered for having consigned some forty Haddington Magistrates, Councillors and Burgesses to prison in Dunbar. (Private Scottish collection)

have a high-level plot to oust Sir James, but it is hard to believe that Lord Milton did not know what was going on and, at the least, he appears to have condoned it even to the extent of ordering the councillors and burgesses to prison in Dunbar, the power base of the Government candidate.

Parliament having decided, for whatever reasons, to take no action, the aggrieved councillors resorted to the law. They can have had little hope of success, as victory for them would have called into question the integrity of a very powerful judge with friends in very high places. The case dragged on until December, 1747, when Sir James convened a meeting of the parties and achieved an out-of-court settlement, which seems to have made it a draw.

James Fall won the election and served as member for Haddington Burghs until 1741, when the next election was held. This one, too, was controversial; the result was declared in two of the burghs at the same time, but they each declared a different candidate, so it looked as if both had won. Fall withdrew from the contest and was appointed to the sinecure of Collector of the Bishop's Rents in Scotland.

The Congress affair was one of the more scandalous surrounding elections but not at all exceptional; as late as 1831 Bailie Simpson of Haddington was kidnapped at Lauder while on his way to the

poll at Jedburgh. This incident provoked a riot in Haddington when witnesses were being examined. In another case, 15 guineas is quoted as the price of a vote.

'Hey, Johnnie Cope!'

By 1745 the Hanoverian succession was well entrenched, and the adverse economic situation that had come with the Union of 1707 was beginning to abate. Scots were earning a reputation as hardworking and enterprising; those in Government service were willing to serve abroad in posts unpopular with their English counterparts. Dr Johnson's comment that 'The noblest prospect which a Scotchman ever sees, is the high road that leads him to England' would not have been denied by those Scots now making careers in public life. But the traffic was not all one-way: elocutionists from the south, among them the Irish-born playwright Sheridan, found a ready demand among those wishing to make their speech acceptable to southern ears.

The affectation may have been regarded with amusement but the arrival of Customs Dues and Customs Officers from the south was a different matter. Smuggling was rife, tea, French brandy and wine being the main commodities. And the men prepared to supply them duty-free were popular. The Porteous Riot of 1736 in Edinburgh started with public resentment at the hanging of a popular smuggler. But the good councillors of Haddington did not share the general appreciation: after all they were responsible for the levying of customs dues within the burgh, and brewing was a local industry that was suffering from the smuggler's trade. Their view was endorsed by some public figures in the county who publicly declared that 'an expensive and luxurious way of living had crept in among all ranks of people who, neglecting the good and wholesome produce of their own country, had got into the habit of an immoderate use of French wines and spirits ...' It is doubtful if these remarks had much effect on the nocturnal landings along the East Lothian coast.

Time was running out for the Jacobite cause, if it was not already too late. James the Old Pretender had grown old trying to raise support on the Continent for his restoration, but changing alliances and that old Stewart commodity, sheer bad luck, had frustrated all his plans. Now his son hoped to achieve the success that had eluded his father. Prince Charles Edward Stewart raised the Standard in Glenfinnan on 19 August, 1745. Some of the clans rallied

to the cause, not so much from any great optimism but, rather, from a sense of honour and loyalty to the Stewart family, and also to their own family and Highland traditions. Soon Charles judged that he had sufficient forces to move on Edinburgh. A small army commanded by General Sir John Cope was despatched to put an end to what seemed to be a minor insurrection. Charles easily eluded Cope and took Edinburgh; less than a month after the raising of the Standard, Bonnie Prince Charlie was installed in Holyrood Palace.

General Cope, meantime, had marched his army to Aberdeen, and from there moved his force by sea, south to Dunbar. The army arrived there on 17 September, the same day that Charles took Edinburgh. The principal characters were moving into position for the last major battle in a county that over the centuries had felt the clash of opposing armies.

On 19 September, Cope led his small army of some 600 cavalry and little more than 1,500 foot out of Dunbar towards Haddington. There they made camp on rising ground west of the town. One of the young men excited by the military activity was John Home of Leith, later to be minister of Athelstaneford and author of *Douglas*, a play celebrated in its day. He was among a group of locals recruited to act as scouts on behalf of the Government army, riding out to report any sightings and movements of the Jacobites.

Some of these volunteers are among those who recorded their impressions of the army. It is said that they looked more like a mob than a disciplined force. Jacobite sentiment was thought to be strong in East Lothian and there was concern at the easy mingling of troops with civilians who, it was suspected, were able to frighten them with rumours and stories of the enemy they were about to face.

The army was certainly jittery; on a report of an approaching Jacobite force there was a scene of great confusion as the troops mustered in battle order. The 'Jacobite force', when it arrived, must have caused confusion of a different sort – it was a coach bearing a wedding party, with attendant guests on horseback, on their way to New Amisfield.

Meanwhile two of the young scouting party had failed to find any sign of the Jacobite army and decided to continue their scouting in a Musselburgh pub. There they engaged two men in conversation, asking them if they had seen any sign of the rebels.

The men replied that they had not, but since their questioners seemed so interested in the rebels, no doubt they were looking to join them. Protesting their innocence, the scouts produced their authority from General Sir John Cope, only to be arrested. They had been questioning two Jacobite officers. They were taken prisoner and found the Jacobite army at last, in Duddingston, but were in no position to report this valuable intelligence. Happily they were not treated as spies, one of them, Francis Garden, eventually becoming a Court of Session judge.

Sir John's army left Haddington and made its way by the coast road to camp on low ground near Prestonpans. Prince Charles' army arrived by the high road to camp just west of Tranent. Between the two armies stretched an area of bog which the Government forces regarded as an insurance against a surprise attack. It was the evening of 20 September. At sunrise, before the Hanoverian army had time to muster, they were attacked and with such ferocity that they were routed within ten minutes. An obliging local, said to be a shepherd, had shown the Jacobites a route through the bog. Sir John escaped the slaughter, making his way from the field by what is still called Johnnie Cope's Road, and on to Berwick on Tweed.

One man viewed the débâcle with glee. Adam Skirving (1719–1803) was a farmer at East Garleton, and also a song writer and

13. Adam Skirving of East Garleton, author of 'Hey! Johnny Cope', painted by Archibald Skirving. (SNPG)

a master of the witty remark. He went to Prestonpans right after the battle. On his way he fell in with some marauding Highlanders who robbed him:

> That afternoon, when a' was done,
> I gaed to see the fray, man;
> But had I wist what after past,
> I'd better staid away, man.
>
> On Seton sands, wi' nimble hands,
> They pick'd my pockets bare, man;
> But I wish neer to dree sic fear,
> For a' the sum and mair man.

A survivor of the battle, Lieutenant Peter Smith of Hamilton's Regiment, was criticised by Skirving for his presumed cowardice in having come out of the affair in one piece. On hearing of this, Smith sent Skirving a challenge to a duel. Skirving instructed the messenger to 'Gang awa' back to Mr Smith. Tell him that I have nae time to come to Haddington to gie him satisfaction, but say, if he likes to come here, I'll tak a look o' him, and if I think I'm fit to fecht him, I'll fecht him, and, if no, I'll just do as he did – I'll rin awa'.' There was no reply.

Skirving is also credited with the ballad 'Johnnie Cope', poking fun at the hapless general on his headlong departure from the scene of his humiliation.

Skirving's son Archibald (1749–1819) achieved local fame as a portrait painter, working mostly in crayon. He studied in London and Rome, finally setting up his studio in Edinburgh. He is best known for his drawing of Robert Burns. This is in red chalk and is partly based on the portrait by Nasmyth. He was talented but lazy, producing only one work a year. But as his fee was said to be four times as much as Raeburn could command he, presumably, made a good living. He is buried beside his father in Athelstaneford kirkyard.

The Jacobites lost but one battle – the last. In the aftermath of Culloden, as is well known, the clans and their culture were suppressed with brutal efficiency. Throughout the rest of the country Jacobite sympathisers were sought. A list of those identified in East Lothian gives thirteen names from Haddington. These included the schoolmaster and the procurator fiscal who collaborated with the rebels, as did several Episcopalians. Of the handful

who actually joined the army, most deserted rather than cross the Border. During the Jacobite occupation of Edinburgh the Council were summoned to Holyrood and told to bring their assessed contribution to the royal exchequer, £50. This they did without protest. It was probably their ready acceptance of Stewart demands that caused them to adopt a sycophantic approach to the victorious Duke of Cumberland. After Culloden they voted Cumberland the freedom of the burgh, incongruously describing him as the darling of the army! And, most inappropriately, as a protector of the oppressed. If Butcher Cumberland ever read these words, they cannot have impressed him; he returned to London, bypassing Haddington, and the silver casket containing the burgess ticket had to be sent after him.

'The land is our birthright' (Rev Donald MacCallum)

Before the introduction of modern drainage systems, cultivation was confined to free-draining land, around which the farming community was based. There were no farms at the centre of a large expanse of farmland; instead there were grouped the houses of the community that farmed the area. The land nearest the houses was the best land and was called the infield. This was rented from the laird who was paid in surplus crops, usually oats, bere and wheat. Beyond that was the outfield which grew crops until the ground lost its fertility, when it would be left fallow for several years to recover. Whilst fallow, this ground could be used for grazing animals so that their droppings would help to revitalise the ground. Beyond the outfield was open land, uncultivated, semi-wild, which was used for communal grazing, each tenant being allowed to keep livestock in proportion to the amount of arable land he held.

The work was labour-intensive; ploughing, for instance, required a team of eight oxen to draw the plough. They needed one man to lead them, another went alongside to encourage the animals, a third man guided the plough with another helping to control it, and then a group followed, breaking up clods with spades. So, although there were individual or family tenancies, some assets were held and much work was done on a community basis. We have seen the post of Baron Bailie filled by the burgh council in their annual elections, and this is where it originated. The 'Baron' in the title presumably means he was originally appointed by the

laird and it was his duty to hold a court adjudicating on disputes where the use of common assets had been abused, taking more than a fair share of firewood or exceeding the number of grazing animals on the common land, for example. The arable land was divided into rigs which were raised strips allowing excess water to run off. Traces of these can still be seen in the countryside. Runrig was a system where the tenants rotated the holding of scattered rigs so that each farmer got a share of the better ground in turn. Rig eventually came to mean any parcel of land, so the original Haddingtonians had their rigs, but as the town developed these were walled off and survived as gardens, but the walls are still the rig walls and some of them have been retained in the town-centre car park but pierced and lowered in places to allow the easy passage of vehicles.

Up to the Reformation the religious orders controlled much of the farm land, either working it themselves or renting it to tenants. The monks were good husbandmen, following the best practice of the day. They also created vegetable gardens and planted orchards. Around the year 1140 David I granted a toft (a dwelling with land) within the burgh, to the monks of St Andrews, and in 1159 his grandson, Malcolm IV, made a similar grant in favour of the monastery at Kelso.

Until the Industrial Revolution most of the people lived in the farming communities. They were largely self-sufficient and the town offered only those services they could not themselves provide. The most important would be the parish kirk. Then there would be the services of the trades – the smiths, the saddlers and the weavers – no doubt often paid for in kind.

But the division between town and country was a narrow one; the rigs were cultivated up to and within the town. Livestock was also a feature of urban life, but some of the animals could be a nuisance, particularly pigs. In 1738 the council issued an order, saying that in consequence of the damage done to crops, and the accidents they caused, swine were banned from the streets.

In 1761 the council was still trying to do something about the pig menace, and further problems incurred their displeasure: dunghills, the herding of loose horses, and carts left in the streets were all banned. Less than a month later the dunghill ban was lifted, but only for land labourers at the West Port who had protested against the measure.

In 1769 it was necessary to renew the ban on swine and this

time a fine of 6*d*. was to be levied from the proprietor of each pig found loose. Even as late as 1825 livestock in the streets were still causing concern, but as this time only fowls are mentioned we can presume that, at last, the pig menace had been brought under control.

In the eighteenth century the whole basis of society, with its division between on the one hand feudal lairds and the peasant tenantry and on the other the burghs with their merchants, craftsmen, and unfreemen was coming under great strain. The main reason for this was a huge increase in the population. This is dramatically illustrated by Glasgow which between 1708 and 1750 doubled its population to 25,000, over the next eighty years increasing eightfold to 200,000.

One of the reasons for this expansion was an increase in overseas trade brought about by the spread of British territories. Scotland had traditionally traded with the Baltic states, the Low Countries (where Haddington merchants were strongly engaged) and France. Now there was a large and growing market beyond Europe, particularly the Americas. Raw materials came from the colonies and manufactured goods were exported. The nation was on the brink of the Industrial Revolution, and the old farming methods based on self-sufficiency plus a small surplus for market could not suffice.

Improved agriculture

Before the Industrial Revolution could be sustained there had to be an agricultural revolution. East Lothian had always held a special place in Scottish agriculture, its excellent soil producing grain crops that put Haddington amongst the leading grain markets in Scotland, reflected in the fine Corn Exchange, erected in 1854 to a design by R. W. Billings.

Ground beyond the old outfield that had hitherto only been used as communal grazing was now brought under the plough, with the development of improved drainage using underground pipes, and was enclosed, using either hedges or dykes. These enclosures changed the countryside into the familiar landscape that we now know but, for the farmers of the day, it was a revolution that brought to an end a way of life that had been the accepted and natural relationship with the earth for over a thousand years.

After the Union of 1707, Andrew Fletcher of Saltoun retired from politics to devote himself to the management of his estates.

In 1710 he sent a joiner abroad to study the Dutch pot-barley mills. The joiner returned bringing back, not only the information needed, but also the design for a winnowing machine which he had seen in use. He constructed one for Fletcher, but the farmers could see no use for a machine that created something already provided by God; indeed it was regarded as heretical and was referred to as the 'Deil's wind'. Several decades had to pass before machinery would find general, if reluctant, acceptance.

One of the most significant developments was brought about by James Small of Dalkeith. He made a close study of the plough. In England he was able to see various designs, including the Dutch style. Returning to the Borders, he experimented with various shapes of reest (that part of the plough that turns the furrowed cut) in soft wood, until he found a shape that gave even wear. He took the pattern to the newly opened Carron Iron Works to copy and the swing plough was born.

The new plough was an immediate success, and was in great demand. Small refused to patent his design, believing that he should not profit from an invention intended to better the lot of the agriculturist. He did write a book on it which widened the demand, still without financial benefit to himself, apart from the little money his book would make. He died, penniless and weary from overwork, in 1793 aged 52.

Horses now replaced the team of eight oxen, being more biddable than oxen and cleverer at remembering what they had to do. In time it needed only one man and two horses to do the work of eight oxen and six workers. Ploughing with horses, within the confines of the newly enclosed fields, became a new skill and good ploughmen were in great demand. Ploughing matches encouraged excellence, and great pride was taken in a well turned out team of well groomed horses, in shining harness and gleaming brass.

Andrew Meikle of Houston, near Dunbar, perfected a threshing machine in 1789 and found that it was more favourably received than his father's winnowing machine had been in 1710. He fell on hard times in his old age and Sir John Sinclair of Ulbster, who had been President of the Board of Agriculture, raised £1,500 for his relief. Andrew Meikle died in 1811 at the age of 92.

New crops were introduced, potatoes made their appearance, a cheap and prolific crop to help feed the burgeoning population, as well as turnips and new varieties of grain. More land was tilled as drainage continued to improve; John Howden of Ugston was the

first in the parish to install tile drains in the fields. The small farming communities broke up, as the lairds amalgamated the old rigs and outfields into single farms, rented to one tenant. The dispossessed became farm servants selling their labour to the new single tenant. In the parish of Haddington the number of tenant farmers was reduced by 50% between 1790 and 1840.

Aided by roads improved under the Turnpike Acts, the new class of farm worker became more mobile, and he was prepared to change farms for a better pay or because he did not get on with the farmer. The 'hind' would take on a six or twelve-month engagement, but he had to provide 'bondagers', his wife and daughters, for work in the fields, planting and harvesting tatties and neeps and helping with the grain harvest. The 'bondager' system was a particular feature of East Lothian and much resented.

One day in early February each year was marked as Hiring Friday when farmers and farm workers would gather in Market Street to strike employment bargains for the coming year. The farm servant would negotiate with prospective employers, not only on pay, but on a range of details such as accommodation. Compared with the old thatched cottages, the new tied cottages were colder, often with leaking tiles and no ceilings. The East Lothian worker often had to supply his own fireplace or range for cooking and bring his own bricks for filling the gaps where it didn't fit.

Then there was the length of the term: was it to be six months or twelve and what crops, if any, would be allowed in kind? And there was the vexed question of the bondagers the farm worker would bring. The farmers would rarely employ single men unless they could supply one or more bondagers. Without wife or daughters, the single man then had to engage someone, out of his own pocket, to help with the spring planting and the harvest.

Hiring Friday was a lively event. Market Street was crowded with workers and farmers and their families. The public houses did brisk business and stalls along the street dispensed more substantial fare. It was a great social occasion as workers met and exchanged news and gossip and, more importantly for the business of the day, information on the conditions provided by individual farmers and whether or not they were good employers. Convenient as the hiring system was for the farmer, it also brought the workers together, allowing grievances to be aired and discussed. And above all, they could give vent to their feelings on the bondager system.

Resentment came to a head in the middle of the nineteenth century. Before attending the Hiring, the workers met on the East Haugh, from where they marched *en masse* to Market Street. More than half of the contracts due to be made that day failed on the bondager question and in 1866 the farmers abolished the system. Hiring Friday itself continued for a long time, the last being in 1925.

The Church

Presbyterianism, as practised by the Church of Scotland, was established as the official religion in Scotland by the acts of 1690. Far from entering a period of calm and reflection now that the religious wars were at an end, throughout the eighteenth century and most of the nineteenth, the church was torn apart by doctrinal and political division. At first, the church was free of patronage, the system established under the old religion, where the landlord gave to the church one tenth of the monies from his properties and, in return, retained the right to dictate the choice of priest in the parish. Now the congregation exercised the right to call the

14. Hiring Friday, by James Howe, showing an animated Market Street in the early nineteenth century. The Enclosures had reduced the number of independent farmers and created a skilled labour force here seeking an employer for the coming season.

minister of their choice to fill a vacancy, but this democratic state of affairs was only allowed to last until 1712, when the Patronage Act was re-imposed.

This led to the Secession of 1733, led by Ebenezer Erskine of Stirling, who was opposed to patronage, and thought the General Assembly too compliant. The Secession Church considered itself to be the true religion, and underlined this belief by renewing the Covenant in 1743. However, the Seceders divided again in 1747 over the oath which burgesses were required to swear; this required the candidate to swear to uphold the true religion authorised by the laws. Some of the Secession saw no harm in this and they were called Burghers, but those who objected to it broke away and became Anti Burghers. Each of these churches again divided in two, around the turn of the century, into Auld Lichts and New Lichts, on the question of the right of the State to maintain the Church. Most of the Burgher Auld Lichts rejoined the Church of Scotland in 1839, while the two New Lichts came together to form the United Secession Church.

There was a Burgher church in Haddington, supported by the majority of the original Secession congregation, but their minister had joined the Anti Burghers so, in their search for a new minister, their choice fell on John Brown, a man who would have attained prominence in any religious or academic field he chose to enter. That he chose to follow a minority faction of a splinter group and, from within that faction, to answer a call, from a small and poor congregation, in a small county town, demonstrates his dedication to his beliefs, and the strength of his faith.

Brown was born in 1722 at Carpow, near Abernethy in Perthshire, the son of a weaver. He was orphaned young and, while still of tender years, found employment as a shepherd. This work lent itself to study, and he taught himself Latin and Greek as well as making a start on Hebrew. For the ill-educated son of a poor weaver to be so proficient in languages was not credible: someone must be helping him and it could only be the Devil. The lad was investigated on a charge of witchcraft, and the experience must have been unpleasant enough for him to make a career change; he became an itinerant peddler, one of the chapmen. This, at least, would take him away from the atmosphere of primitive and irrational superstition and suspicion.

During the '45 Brown served with the garrison of Edinburgh Castle, which held out for Hanover during the Jacobite occupation

of the city. After the Rising, he entered the ministry of the Burgher persuasion and one of his teachers was Ebenezer Erskine who had led the Secession. From his studies, he came to Haddington on 4 July, 1751. His stipend never exceeded £50 per year, and on that he brought up two families. His first wife, Janet Thomson, gave him two sons, both surviving to become Secession ministers. His second wife was Violet Croumbie from Stenton, who bore him nine children. He took on the unpaid professorship of Divinity, dealing with up to thirty students at a time, on a five-year course. Every Sunday he preached four sermons, reduced to three in winter, conducted examinations in the catechism and was a dutiful and caring pastor among his flock, being particularly attentive to his pastoral visits.

With all this to occupy and concern him, John Brown's energy and intellect still posed questions and sought answers. He became proficient in several European and Oriental languages and his knowledge of the Bible was comprehensive. He drew on this latter store of knowledge to produce, firstly, his *Dictionary of the Bible* in 1796, followed in 1778 by the *Self-Interpreting Bible*, in two volumes. These are monumental works of scholarship, created by a man who was already writing several sermons a week at a time when an address of less than an hour was regarded as short measure. We can imagine him working at his desk, often by candle or lamplight, his quill pen scratching busily as he transferred the product of his intellect to paper 'in a manner that might best comport with the ability and leisure of the poorer and labouring part of mankind ...'

John Brown published many theological works, but his *Dictionary of the Bible* and the *Self-Interpreting Bible* were intended to reach a wider world than that of the academic or the theologian. He did reach that wider public: 'they took rank ... in shaping the religious life of the Scottish peasantry'. These works were to be found in many homes well into the twentieth century, and Robert Burns acknowledges his influence in the line: 'I there sit roastin' perusing Bunyan, Brown and Boston'.

John Brown died in 1787 and is buried in St Mary's churchyard. Some relics of this famous minister are kept within the church, including a copy of the *Self-Interpreting Bible*. His manse, which bears a commemorative plaque, is to be found off Market Street, not far from the *Courier* building. Behind the former manse is the former East United Presbyterian church, now converted to

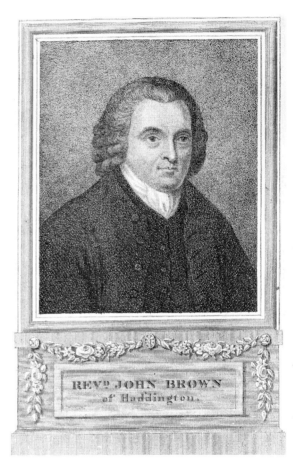

15. *Rev. John Brown of Haddington. His self-taught mastery of modern and classical languages enabled him to publish a* Dictionary of the Bible *and his famous* Self-Interpreting Bible. *He was a conscientious pastor to the Burgher congregation of Haddington.*

dwellings. This is the site of Brown's Burgher church. Some United Presbyterians split to join the Wee Frees in 1909, the remainder continuing as the United Free Church until 1929 when they rejoined the Church of Scotland.

Brown's eldest son, also John, is usually given the suffix 'of Whitburn' to distinguish him from his father. He followed in his father's footsteps to become a Secession minister. He was inducted to the charge at Whitburn where he served for fifty-six years until his death in 1832. He, too, was a writer on religious themes, publishing works including collections of sermons and a collection of his father's works.

Brown Street, near the former manse in Market Street, is named,

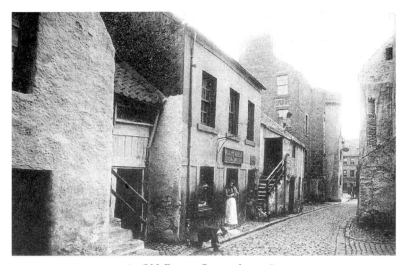

16. Old Brown Street about 1890.

not after the famous preacher, but another of his sons, Samuel, who was an ironmonger. He became provost in 1834, the first to be elected under the reformed system of voting.

For the Use of Travellers

Before the Turnpike Acts in the middle of the eighteenth century brought about the construction of roads financed by tolls, travel had been a difficult and dangerous undertaking. Roads had been little more than tracks, usually following high ground to avoid the marshy, undrained lower ground. The better-off travellers went on horseback, the less fortunate by donkey or crude wagon, or they walked. Long distances could be more conveniently covered by sea, between Leith and London for example, though it would be a difficult choice to make between the hazard of shipwreck and the danger of highwaymen; the mail to the south was frequently robbed when it was carried by the mounted courier or post boy.

There were other hazards for the mail. The *Caledonian Mercury* for January 1734 reported that the Edinburgh Postmaster had apologised for the late delivery of mail because 'It seems the post boy, who rides the stage from Haddington to Edinburgh, is perished in the river Tyne, the mail this morning being taken out of the river'. On other occasions the mishap could be self-inflicted

as when the Dunbar to Haddington stage was delayed because 'the post boy, being in liquor, fell off'.

All this changed with the construction of the turnpike roads and, to the economic wellbeing of Haddington, the High Street was part of the Great North Road. One of the last of the town's toll houses stands at Goatfield, on the Dunbar Road, which the new stage coaches would clear on their way from Edinburgh to London, a journey that could now be done in sixty hours for a fare of £10 in 1804.

This travelling public had to be serviced. Haddington's two main coaching inns were the George and the Blue Bell. The George is older than its first dated mention in 1764, when it was owned by a James Fairbairn. Originally the Old Post House, then the George and Dragon, and for many years now the George, its imposing, turreted facade dominates the east end of the High Street. In the eighteenth century it provided superior accommodation to that on offer in the inns and taverns, even boasting piped water from a spring to the kitchen. The class of clientèle catered for can be gauged from the facilities for twenty-three horses and four carriages. The 'place for feeding pigs' seems rather an unlikely provision for the carriage trade and must have been an indication of the availability of fresh pork for the kitchen.

In later times the George boasted a small but elegant assembly room, which was an ideal venue for festive dinners, receptions and balls. Over the years it provided an ideal setting for the annual supper of the Haddington Burns Club, one of the first to be founded. There are many who will recall with affection those evenings under the supervision of the club's Musical Director, Herbert Main, a local solicitor, who conducted proceedings from the piano, an instrument that seemed at times a little wayward in responding to the intentions of the Musical Director, but did nothing to detract from the gaiety of the occasion.

The Blue Bell and Post House was at the other end of the High Street, on the north side. It no longer exists as an inn, but the building is still there, tall and with a distinctive semi-circular turret. The pend, through which the coaches once clattered, now gives access to Carlyle Court, a modern development of small apartments. In the heyday of coaching, however, this was where intending passengers boarded the Haddington Fly for Edinburgh. This coach went as far as Birsley Brae where it met a coach from Edinburgh; there was an exchange of passengers, and then each

coach returned to its starting point. This was a daily service. There were also two coaches providing local services, the 'Good Intent' and the 'Lord Nelson'. In general a stage coach ran to a schedule, either daily or on specified days. Other coaches ran as and when required. The first stage coach in East Lothian was established in 1804, and ran between Dunbar and Edinburgh, the journey time of five hours being eventually reduced to three. The arrival of the four-in-hand London stage coaches would generate great excitement and activity as they arrived to change horses. Southbound, they would have got up a good speed on the gradual descent into the town and would arrive in the High Street, horses with nostrils flaring, foaming at the bit and, on cool days, steam rising from their flanks. Some way off the post horn would have been sounded, alerting the ostlers so that they would be standing by with fresh horses ready for the changeover. Inside the coach the passengers would be looking forward to the chance to stretch their legs and to partake of some refreshment, while contemplating fifty or more hours of the journey ahead.

17. The George Omnibus outside the hotel, c. 1905.

Both the Blue Bell and the George catered for this traffic, the George dealing with the mail coaches while, at one point, the Blue Bell had two companies to service. These were the Highflyer and the Telegraph, which were in competition for a year until commercial reality brought them to an amalgamation, under the apt title of the Union.

Alas, the Blue Bell did not long survive the coming of the railway, succumbing in 1855. The George is still there, having played an important part in the social history of Haddington since the eighteenth century. The animated scene as the mail coach arrived is no longer even a memory; gone, too, are the elegant soirées and social functions of a more mannerly age, but the building survives, harbouring its memories and its ghosts.

The George Inn was lucky to escape serious damage in 1773, just a few days before Christmas, when an apprentice in the employ of Messrs Brown and Crombie, ironmongers, was sent on an errand down to their cellar. He took a lighted candle with him and placed it too close to a keg of gunpowder. He was killed in the resultant explosion, and a maidservant suffered severe burns. The fire that followed destroyed the building, despite the best efforts of the 'water engine' and its crew, aided by the provost and magistrates, as well as some of the military who joined in the struggle. The George Inn was next door but did not suffer serious damage.

The upper floor of the building was the trades hall of the Incorporation of Wrights and Masons. They were insured, but had neglected to tell the company that dangerous materials were stored in the building. In spite of this, the insurers, Sunfire, paid up, relaxing their rules because the Incorporation was a charitable organisation.

A Time of Revolution

As the eighteenth century waned, discontent with the, still largely, feudal structure of society waxed. The French Revolution in 1789 made a huge impact on people's attitudes to society and politics. Societies sprang up to discuss the ideas of liberty and equality. The establishment reacted by infiltrating these organisations with spies and informers, so that men who had been heard to propose measures that would seem very mild today were tried for sedition ('a crime unknown in Scottish law until 1795', says J. D. Mackie) and punished with sentences of up to fourteen years' transportation.

In view of their subsequent enthusiasm for reform, Haddington-ians must have regarded the French Revolution, at the least, with interested detachment, if not with wholehearted enthusiasm. It was only with the transformation of the bright dawn of liberty into the bloody Terror, with the execution of the French king in January 1793, that the magistrates were stirred into declaring their loyalty to the throne, four years after the start of the Revolution. To make sure their loyal sentiments were made known to the widest possible audience, they published them in the Edinburgh journals.

In 1798 Britain found herself alone in the fight against Napoleon, there was a danger of invasion, and patriotism was running high. The magistrates voted £100 for the defence of the county. They further decided that the crisis should be faced in 'a subdued and sober spirit'. To set a good example, they resolved that they would not indulge in any public entertainments, apart from a few patriotic glasses of wine at the Cross on the King's birthday.

The threat of invasion loomed large as peace negotiations failed, and the gentle beaches of East Lothian, far from the military concentrations in the south of England, offered a tempting gateway for the aggressor. Military units were moved into the area and a signal station was set up on the Garleton Hills.

Whereas militias had existed in England for many years, Scotland had been allowed to raise regular troops only, as governments had been loath to allow the widescale arming of civilians in a country they could not entirely rely on. The war changed all that and a Militia Act for Scotland came into force in 1797. In the event the introduction of the new units was not at all smooth. Whether from incompetence or malicious rumourmongering, the purpose of the Militia was widely misunderstood. While volunteers certainly formed the core of the units, any shortages were to be made up through conscription by ballot. It was commonly believed that men would be required to serve overseas. This obviously would have implications for family men and others with commit-ments, such as craft apprentices. These fears led to riots against the Militia Act. The worst of these was in Tranent, where the army was called out, and eleven of the protesters were shot dead and many wounded.

The volunteers were, in fact, paid a bounty and this could be transferred to another if a conscript found someone who had not been called, but was willing to serve. In normal times service was limited to a yearly drill, but the force would be embodied in time

of national emergency, as now became the case. Far from serving overseas, the militia was confined to the British Isles but, during the Napoleonic wars, many Volunteers found military life to their liking and they became regulars, so many that it was said that the British Army at Waterloo had a rather motley appearance due to the medley of militia uniforms mixed in with the regulars.

If any of these uniforms were of the Haddington militia they would certainly have stood out. The government allowed a fixed sum for equipping each man but Haddington wanted only the best for its force, and the Council subsidised the uniform allowance, and it was said that the Haddington force presented a smarter appearance even than the regulars. Their tunics were of red, faced with green, their breeches, grey with white leggings, and in their hats they sported a black cockade.

This mustering had taken many workers away, and their loss was felt, especially by the farmers. They were willing to pay up to £65 to substitutes willing to replace them. John Crombie, the ironmonger, saw the commercial potential in the situation, and launched an insurance plan to cover the eventuality. For three guineas he insured clients against the possibility of being drawn in the ballot to give militia service.

There were nearly two thousand troops in and around Haddington. Infantry, by far the largest group, had barracks covering Goatfield, Gourlay Bank, Templedean and Vetch Park. There were 104 huts accommodating 1,158 officers and men, as well as a hospital capable of taking 96 patients. Stabling for 40 horses was also erected. Part of Amisfield Farm was home to the gunners and is still known as Artillery Park. There were huts for 300 of that regiment as well as the gun shed and workshops for the smiths and wheelwrights. With 140 horses to be cared for, some for the officers, but most for the gun carriages, saddlers and farriers completed the complement. Between Lydgait and the Black Palings were the cavalry barracks for the 326 men and their mounts.

Haddington was now enjoying an era of prosperity in which practically every aspect of life, both social and economic, blossomed. The influx of over 2,000 men with money to spend benefited the retailers, not to mention the inn and tavern keepers. The farmers supplied food not only for the troops, but also their horses which required large quantities of grain and straw. And with around 150 officers in the town, the social life of the burgeoning middle class was enriched.

Meanwhile the Volunteers drilled twice a week on the Haughs or on one of the nearby estates and joined in manoeuvres at Gladsmuir at weekends. Sometimes they were despatched on duties around the county. In May, 1804 they did a fortnight at Dunbar, at the end of which they were reviewed by the Commander-in-Chief, Scotland on West Barns links.

The magistrates' self-imposed abstinence was relaxed at the time of George III's Golden Jubilee in 1810. There was a series of functions, illuminations and a fireworks display, and a congratulatory address was sent to the monarch. The self-imposed limitation of 1798 on celebrations must have been a sore penance. The Council now resolved, evidently with a sigh of relief, that the King's birthday should be celebrated by the burgesses at the Cross, with wine and toddy at the town's expense, as before:

> The Provost and Bailies on auld Geordies birth-night
> Invite the town's folk to enjoy themselves a'right;
> They drink wine at the Cross, with very much glee,
> So every man to his mind, brave Haddington for me.

The Napoleonic wars virtually ended in 1814 when the former Emperor was exiled to Elba by the victorious allies. The Hundred Days were to come in the following year but the immediate threat had diminished over the years and had faded when Napoleon embarked on his Russian adventure.

The Volunteers stood down, but continued to function; as well as performing their now much reduced military duties, they enlivened the Haddington calendar with all kinds of social events. The Militia, of which they were a part, were again called upon for home service during the Crimean War and, during the Boer War, many volunteered for service overseas. In time they were deprived of their local titles and incorporated into the army structure as reserve battalions of the regular regiments. They had not functioned for many years when they were finally disbanded in the 1950s.

'Brave Haddington for me'

This has been quoted earlier; it is a song said to be of great age, although the reference to 'Geordie' places that verse, at least, in the Hanoverian period. It is printed in full in Dr Martine's *Reminiscences of Old Haddington*. He says that it was sung in the Assembly Rooms at the annual celebrations of the King's birthday, from the

latter part of George III's reign and throughout that of George IV. The singer was a William Colston, a tobacconist. After his death the song was more or less forgotten, but the then Earl of Haddington had heard of it and he got a version from a Bailie Moodie. This, 'with some amendments', is given by Martine. One is left wondering what the 'amendments' were: was it libellous or was it unsuitable for the eyes of the genteel reader and had to be bowdlerized? There is no mention of the tune to which it was sung, but a couple of verses will give a flavour of its pre-McGonagall style:

> The famous town of Haddington, long prosper it will,
> It stands so delightful, below Skid hill.
> It stands so delightful, for all men to see,
> So every man to his mind, brave Haddington for me.

> There runs a fine river by the back of the town,
> Which separates the Nungate from brave Haddington,
> The large and small fishes in it do sport and do play,
> So every man to his mind, brave Haddington for me.

Coal and Candle

Haddington had suffered a disastrous fire in 1598, not through enemy action but carelessness on the part of someone unknown. The danger of a carelessly discarded smouldering cigarette is well enough known today; how much greater the risks in the days when there was no alternative to the naked flame, whether of candle, cruisie or the open fire. Add to that the mingling of workshops such as smiths and wheelwrights among the houses and, as we have seen, the storing of dangerous products, and the wonder is, not that there were fires, but that there were not more.

The fire of 1598 was one of the worst. One side of the High Street was completely destroyed, many were made homeless and the economic effects were considerable. At the time the council was engaged in rebuilding the town wall and, soon after, had to cope with an outbreak of the plague. An appeal went out to sister burghs on behalf on 'ye faithful burgh, presently burnt and destroyed' and for the 'most indigent persons that had their houses and gear brunt'. This appeal was taken to the burghs, with some success, by a party of four burgesses, including the minister and the provost.

It was now decreed that all house owners were to provide, and have ready at all times, a ladder as tall as the house and a bucket.

In addition, the town crier was to go through the town nightly, urging caution in the use of 'coal and candle'. This was done throughout the darkest and coldest months from Martinmas, 11 November to Candlemas, 2 February. A rhyme was chanted by the crier perhaps not at the outset, but for most of the period that the warning was proclaimed. Samuel Smiles, who was born in 1812, heard it and often enough to be able to transcribe the music in his autobiography. James Miller gives the words in his *Lamp of Lothian* (1844):

> A' gude men-servants where'er ye be,
> Keep coal and can'le for charitie.
> In bakehouse, brewhouse, barn and byres,
> It's for your sakes, keep weel your fires:
> Baith in your kitchen and your ha',
> Keep weel your fires, what 'er befa',
> For oftentimes a little spark
> Brings mony hands to meikle wark;
> Ye nourices that hae bairns to keep,
> Tak' care ye fa' na o'er sound asleep:
> For losing o' your good renown,
> and banishing o' this burrow town.
> It's for your sakes that I do cry,
> Tak' warning by your neighbours by.

The town crier gave his admonition until the mid-nineteenth century, by which time it had become a handy marker for getting children to bed. About the same time a new constraint on juvenile activity came in with gaslight, the appearance of leerie on the street signalling time to go indoors.

Not only was the crier patrolling the streets with his fire safety advice; there was also the town drummer and piper. A town piper is mentioned as early as 1542 (it is sometimes argued that the pipes were a Highland instrument and foreign to the Lowlands but it seems to have to have been an important enough instrument in Haddington quite early on to warrant official use) and the drummer appears in 1572. These are the earliest surviving references; earlier information may well have been lost in the frequent sackings of the town.

The drummer's task was to patrol the streets at 4.00 am beating his drum to rouse the citizens, and again at 8.00 pm. If these hours seem a bit irrational, if not uncivil in the case of the morning

call, they made sense, as the town ports opened at 5.00 am and closed at 9.00 pm. He was also required to summon the people to the Cross, to hear proclamations, and to be at the Riding of the Marches. The drummer could be fined for not beating his rounds in good weather, but in inclement weather he was permitted to shelter in a stairhead to protect his drum. The piper's main duties would be ceremonial, but private performances were also given: a John Wilkie was doing a spell in the Tolbooth, having insulted a magistrate, and was finding time heavy in passing. The town piper, Richard Scougall, took pity on him and, to relieve the prisoner's boredom, played to him 'all ye nyt in ye tolbuith and upoun ye wall heid thereof'. One hopes that the residents within earshot were also keen music lovers. By the eighteenth century the piper had joined the drummer to do the morning and evening rounds. As town officers they wore the town's grey livery.

'It is a good cause, it shall finally prevail'

The agitation for reform at all levels of government, stoked by the French Revolution, and damped down by the Napoleonic Wars, now flared again. Low wages and unemployment followed with the peace. The favouritism in appointments was clear to all. The burghs of Haddington, North Berwick, Dunbar, Lauder and Jedburgh were allowed a total of only ninety-nine votes. Outwith the burghs there were only 3,000 voters in the whole of Scotland. Elections could be, and were, influenced by favours and scarcely even concealed bribery. The Government's 'manager' in Scotland at the turn of the century was Henry Dundas, Viscount Melville. Melville controlled all government appointments in Scotland, and he used this power to place his friends where they could influence the outcome of elections. Melville fell from power in 1805, but the corrupt system he had so astutely managed to the benefit of William Pitt continued.

The first serious agitation for reform came in 1820 with a strike call in Glasgow to which 60,000 men responded. They set up a 'committee of Organisation for forming a Provisional Government'; the military were called out and the strikers were subdued after a skirmish near Carron in Stirlingshire. Three were killed and a further three hanged after trial. This incident was called the Radical War.

In spite of the Radical War, or perhaps because of it, reform fever continued to run high, but in a less revolutionary manner.

Reformers were not only from the disenfranchised and underprivileged, but numbered men from the professions and the upper and middle classes. In the wake of the 'war', the Tory government tinkered with the constitution, but did nothing to redress the anomalies inherent in Scotland's Parliamentary representation, embodied in the Treaty of Union. Apart from the franchise, administrations in London had done nothing to address the problem of Scotland's growing urban population, largely in towns that did not enjoy the electoral and trading privileges of the Royal Burghs. The small Fife fishing ports, for instance, had declined, but retained their privileged burgh status. Other towns were growing under the impact of the flight from the land and industrialisation, towns like Paisley which had never had burgh status. Haddington had not hugely expanded its population: 4049 in 1801 rasing to 5525 in 1851, a sizeable increase but not on the scale seen elsewhere.

Feeling in Haddington was as strong as elsewhere, the council petitioned the Lords, and public meetings were held, one of the largest in May 1832. This was a big affair, what was said to be an unprecedented gathering assembled on the East Haugh, the crafts paraded to it, carrying the symbols of their respective incorporations. The Baxters carried a banner declaring:

> Our oven now is just in trim
> We'll push the borough-mongers in.

The meeting was addressed by a nurseryman and a former provost, William Dods, and Patrick Shirreff, among others. Shirreff was a local farmer, born near Haddington, who had done pioneering work in the hybridising of cereals, and produced many new varieties. He went on to associate himself with Free Trade and the anti-Corn Law faction. We cannot claim that this meeting alone was instrumental in getting the first Scottish Bill for Parliamentary Reform on the Statute Book, but within weeks of the East Haugh meeting the reactionary House of Lords had given way, and the Bill received the royal assent in July. The meeting was one of many throughout Scotland, the cumulative effect of which was to overcome the obstruction of those, including the Duke of Wellington, who saw the popular tide as a flood threatening the security of the State. In Edinburgh the Reform campaign had culminated in rioting, and its success brought the populace onto the streets again. In a spontaneous explosion of joy, they paraded under a

triumphal arch which bore the victorious slogan: 'A United People Makes Tyrants Tremble'.

Along with Parliamentary Reform came reforms for the burghs. Two systems were devised, the police burgh and the traditional burgh with a provost, bailies and councillors. Haddington was one of the latter. Further changes meant that by 1892 all burghs became traditional. They kept their traditional titles and, to a certain extent, structure, but in two very important respects they had changed: they no longer elected themselves, and they no longer monopolised parliamentary votes. Each year one third of the council retired and an election was held to fill the vacancies. The franchise was still limited, but extended to a much broader electorate: the £10 householders, i.e. male citizens whose rents were £10 or more annually, voted in both municipal and parliamentary elections.

This was a tremendous advance on the system that had existed for centuries, but had outlived its time. There was still a lot to be done: votes for all at twenty-one and, most importantly, recognition of women as full citizens with equal rights with men. These were struggles that would not be won until well into the next century, but in the meantime the shade of Thomas Muir the reformer could be reasonably content, for at his trial for sedition in 1793 he had said, 'It is a good cause, it shall finally prevail, it shall ultimately triumph'.

'The Angel of Mechanical Destruction'

'I never see a scene of Scotch beauty, without being thankful that I have beheld it before it has been breathed over by the angel of mechanical destruction.' What Lord Cockburn would think of the motorway network, entombing swathes of the countryside in concrete, can only be imagined.

The first railway track in Scotland was laid in 1722 between Tranent and Cockenzie, to transport coal efficiently from local mines which had been worked since early medieval times, when the monasteries had been authorised by charter to work the deposits. This 'railway' used horses to draw the wagons along wooden rails, which were replaced with iron rails in the 1850s, and the line operated as a normal gauge railway until 1886. The line was fought over during the battle of Prestonpans in 1745, and the mention of 'the coals' in Skirving's song 'Hey Johnnie Cope' is a passing reference to it.

The first passenger line in Scotland, between Edinburgh and

Glasgow, opened in 1842. In 1846 the North British Company inaugurated the line between the new Waverley Station and Berwick upon Tweed, and in the same year the company chose a site for its Haddington terminus, on the then outskirts of the town, at the top of the present Station Road. Local feeling was that the station should have been situated nearer the town centre, and land which is now Neilson Park was proposed but was rejected by the company. Haddington was connected by a branch line which joined the main line at Longniddry, a few miles to the north. In 1850 Stephenson's Royal Border Bridge was opened by Queen Victoria and Haddington was linked to a still-developing transport system which opened up virtually the whole of Britain.

It might be thought that the coming of the railway, with all its economic potential, would have been beneficial to the town. Sadly it had rather the opposite effect: it brought to an end the era of the stage coach, it diverted commercial traffic and the independent traveller from the roads, and it drew trade and customers away to Edinburgh. Haddington town centre, once an animated and bustling 'metropolis', now took on a deserted and melancholy air; 'branch line' became synonymous with 'dead end'. The occasional traveller, arriving at the George Inn by the omnibus from the station, might have welcomed the tranquillity, but he would not have found many traders to agree with him.

The railways to a large extent replaced the canals, which had enjoyed a short period of prosperity in those parts of the country suited to their construction. It was an age of ambitious engineering, and it seemed that no project was so big or so difficult that it could not be achieved. James Vetch was born in Haddington in 1789, the third son of Robert Vetch of Caponflat. He was educated at the burgh school and Edinburgh. He decided on an army career and joined the Royal Engineers, serving in the Peninsular wars with distinction. After the war he worked on the Ordnance Survey in the Northern and Western Isles. He managed and developed silver mines in Mexico. And in England, he became resident engineer for the Birmingham and Gloucester Railway, between 1836 and 1840. This was the age of sail, and Britain's communications with its Eastern possessions necessitated a long and hazardous voyage by southern Africa. Vetch saw the great advantages that would be gained by the construction of a canal from the Mediterranean to the Red Sea. He drew up a paper for a project between Port Said and Suez, submitting it to the Government in

1843. Lord Palmerston rejected the plan as not being in Britain's interests. A French-led company started work in 1856 and the canal opened in 1869. Ferdinand de Lesseps, who initiated the scheme, included a copy of James Vetch's proposals in the submission that won approval for the project.

Vetch was one of those inventive and innovative engineers who more or less created the systems for the modernising of urban living during the nineteenth century. He designed the sewage system for Leeds, he planned a drainage system for Windsor castle, and he surveyed and prepared reports on harbours around Britain and as far away as Table Bay and Port Natal. He was made a member of the Royal Society and published many books including works on the Island of Foula, a geographical work on Australia, another *On Structural Arrangement most favourable to the Health of Towns*, and one on harbours, more succinctly entitled, *Havens of Safety*. James Vetch died in 1863 and is buried in Highgate Cemetery in London.

The Trades Incorporations

The Trades Incorporations were a feature of every burgh, their number varying according to the size of the burgh and the variety of trades followed; not every town, for example, could boast a guild of goldsmiths. In earlier times there had been tensions between the trades and the merchants, basically a power struggle, leading to riots in some towns. The position was stabilised in the sixteenth century, when the merchants were established as the superior body. It was at this time that the Haddington trades were reduced to one magistrate from their councillors who, in their turn, numbered fewer than the merchant allocation.

The nine craft incorporations of Haddington frequently appear in records from the early sixteenth century, but they would certainly have been in existence from a much earlier date. The nine were the Baxters, Cordiners, Fleshers, Hammermen, Masons, Skinners, Tailors, Weavers and Wrights. The first two were the bakers and the shoemakers. The Hammermen were usually metal workers but, in Haddington, included trades too few in numbers to form their own incorporation. They included smiths, clockmakers and saddlers and were the largest of the incorporations. They were legally established by a Seal of Cause which gave them rights on the burgh council, complete control of the craft within the burgh including the right to exclude non-members from trade, and control over

the admission of apprentices. In pre-Reformation times they would finance an altar in the church, and took a prominent part in religious processions, carrying their craft banners and the symbols of their trade. After the Reformation they were most jealous of their own stall in the kirk. From their council members, they were allowed one magistrate who sat in judgement with the merchant magistrates and voted in Parliamentary elections. To look after their mutual interests, they had their Convener Court, presided over by the Convener, in his robes of office and wearing a gold medallion.

The Nungate gave the incorporations a lot of trouble as it was not regarded as part of Haddington. The Baxters policed their members at markets, checking weights, quality and prices. James Hislop, the deacon of the Baxters, seized the bread of a Nungate Baxter, Alexander Thomson, at a market on the Nungate Bridge. Thomson won a decree against Hislop, and the incorporation refused Hislop his expenses on the grounds that it was his own fault, as the Nungate was outside his jurisdiction.

In the eighteenth century the Cordiners closed a shop selling imported fashion shoes from France, and in 1738 the Wrights seized six chairs from Andrew Dickson, on the grounds that they had been made by an unfreeman outwith the burgh. Social niceties had to be observed also: a slater, David Anderson, was fined half a merk for failing to attend the funeral of a late colleague, and was imprisoned for refusing to pay.

The pressures that brought about Parliamentary reform were also affecting the incorporations. The new towns, thrusting up in the heat of the Industrial Revolution, did not have the rigid social structures of the old burghs, many of which were not in the right place to profit from the opportunities now available. The West of Scotland, with the deepwater Firth of Clyde and its proximity to a large reserve of cheap labour from Ireland, prospered most. While the trend nationally showed a doubling of the population, Haddington's went from 4049 in 1801 to 5525 in 1851 and stayed around that figure until 1961.

Nevertheless, as the nineteenth century advanced, social and legal pressures impinged on the incorporations to such an extent that in 1835 a report showed that the craft system was, more or less, moribund. The crafts still existed but fewer were coming forward to enrol, and outsiders were trading with impunity now that burgh reform had removed the craft's access to the council and the magistrates. The report showed that the Hammermen were still

the wealthiest with funds of £180; the others had smaller amounts, down to the Tailors who were in debt. The incorporations could offer little in the way of argument for retaining the few privileges left to them and one by one they faded away, many of their restrictive practices being adopted by the infant Trades Unions.

Mercat Cross and Tolbooth

The Tolbooth was a central feature in most Scottish burghs and Haddington, in its role as the Scottish burgh *par excellence*, was no exception. Its Tolbooth no longer exists; it stood in the present Market Street, facing Newton Port. But it reached such a decrepit state by 1738 that it had to be demolished. Old age would certainly have contributed to its decayed condition; it was there in the fifteenth century, and may have been part of the rebuilding that followed the Burnt Candlemas of 1356. Subsequent burnings, both malicious and accidental, would also have played a part in its final indignity, as would military action, such as the siege of 1548.

The Tolbooth contained the town jail which latterly must have been a foul, dank experience for those imprisoned. However its age also made it comparatively easy to breach its security, and escapes were frequent. The council also met in the Tolbooth and the burgh records were kept there. It had a steeple with a clock and a bell, and it was fortified with a tower and a drawbridge. In times of danger, a watch was posted on the roof of the tower. Several Tolbooths still exist, the nearest, dating from 1650, being at Dunbar, and the Canongate Tolbooth in Edinburgh belongs to the previous century.

To replace the old Tolbooth, the council invited William Adam to submit a design; he was the father of Robert Adam, the celebrated architect and designer. One of William's finest achievements was Hopetoun House near South Queensferry. Work in Haddington did not start until 1748 and, when completed, it provided accommodation for the council, the court and, continuing the Tolbooth tradition, prisoners in three cells. A fine steeple, housing a new clock by Roger Parkinson of Edinburgh, dominated its site at the West end of the Mid Raw, on the junction of High Street, Market Street and Court Street.

The county had long felt the need for an Assembly Room and this was built on to the Adam building in 1788, extending it westwards. At first this stood on arches, under which markets were held, particularly the grain market, thus perpetuating the medieval

system of colonnaded streets providing shelter for the merchants. The markets were soon moved out, and a ground floor was added, then in 1830 the present steeple was added, incorporating a new clock by James Clark of Edinburgh. The new steeple was 170 feet high, but during post-Second World War renovations its height was reduced by seven feet.

18. The Town House.

Another symbol of burgh authority was the Mercat Cross, a recurring feature in this chronicle. There must have been a Cross when David I established Haddington as a Royal Burgh, and it would have been cruciform in shape. Since then there have been at least three further crosses. The first known example was erected in 1693 and was surmounted by a sculpted unicorn. This stood until about 1811, when a young man (some accounts refer darkly to an 'Englishman'), in an act of bravado, climbed the Cross and brought it down in pieces. It was replaced by a wooden pillar which did service until it was burned down, and Haddington lacked this essential burgh symbol until 1881, when the firm of D. & J. Bernard donated a new one. Surmounted by the burgh's heraldic goat, it has stood for over a hundred years, but not without damage: in 1936 the goat was broken in what has been described as a frolic, but might more accurately be termed vandalism.

'A little dusty omnibus, licensed to carry any number'

In 1799 John Welsh, a young doctor, came to join a practice in Haddington, bringing with him his young bride, Grace. They set up house in Lodge Street and it was there, on 14 July, 1801, that their daughter and only child was born. She was christened Jane Baillie, but was always known as Jeannie in Haddington. She was something of a juvenile feminist in her wish to learn Latin, a subject reserved for boys, and a daredevil tomboy, joining in the rough and tumble of boyish escapades; she even went into secret training until she was ready to demonstrate that she could cross the Tyne by the parapet of the Nungate Bridge along with the best of them.

Jeannie was taught by her father as well as attending the Mathematical School in Church Street under the tutelage of Edward Irving. Her best friends at school were Agnes and Janet Burns whose father was Gilbert, the brother of Robert Burns. They lived at Grants Braes in the parish of Bolton where Jeannie was a frequent visitor. Edward Irving became a friend of the Welsh family and was a frequent guest in Lodge Street. He moved to a post in Kirkcaldy when Jeannie was eleven, but the friendship was maintained and was to influence the course of Jeannie's life. The scholarly tomboy was growing into a beautiful young woman, no ordinary beauty of conventional insipidity, but a beauty of slightly irregular features that reflected a radiant personality, the tip-tilted nose, the fine bones of the shapely face, in which the large, dark

eyes danced with light, the whole framed by a cascade of raven black curls tumbling from the high forehead, earning her many admirers, all seeking the hand of 'The Flower of Haddington'. Dr John Welsh died of typhus in 1819 at the age of forty-four, leaving a distraught widow and despairing daughter. It was into this unhappy home that Edward Irving came two years later, bringing with him a friend who was to take Jeannie far beyond the marches 'of the dimest (sic) deadest spot in the Creator's Universe'.

Thomas Carlyle was twenty-six, born in Ecclefechan to deeply religious parents. He had been intended for the Secession ministry, but had turned to teaching, working in Kirkcaldy where he met Irving. He had written several articles for the *Encyclopedia Britannica*, and had made a deep study of German literature. Jane fell under the spell of his powerful intellect and he was attracted at once to this beautiful and intelligent young woman. It was the start of a five-year courtship.

They were married in 1826 and went to live in Edinburgh, moving after two years to Craigenputtoch, near Dumfries, where Jane had come into property, and finally, to London and 5 Cheyne Row, Chelsea, where they spent the rest of their lives. There Carlyle continued to write on social themes and political philosophy, he produced his mammoth *History of the French Revolution*, he lectured, and 5 Cheyne Row became a centre where the writers and thinkers of the day, including Dickens, John Stuart Mill, the Brownings, Tennyson, John Ruskin and Thackeray, called to pay their respects or to pass an evening listening to the 'Sage of Chelsea' on some current topic, while his wife leavened the discussion with gentle teasing or rendering some Scottish airs on the piano. Jane presided over all this, maintaining an efficient household, ensuring that her husband was able to work in a stable and calm atmosphere, supporting him in his frequent fits of depression, and acting as a charming hostess to the literary society of the day.

In her letters, Jane demonstrated considerable literary skill, and it has been said that she could have bettered any of the works produced by the women writers of the day, women such as the Brontë sisters and George Eliot. She returned to Haddington, incognito, in 1849, and wrote an account of it to Thomas. Apart from the pleasures it gives as pure narrative, her letter is also an interesting snapshot of Haddington in the Railway Age. She comments excitedly on the speed of the journey, only four hours from

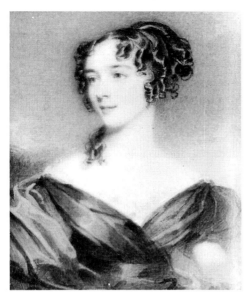

19. Jane Baillie Welsh, from a miniature by Kenneth Macleay. (Courtesy of the Scottish National Portrait Gallery)

Morpeth, and describes an amusing scene at Dunbar station between a truculent member of the Yeomanry and the young woman he was seeing off. To all the efforts of the girl to initiate a pleasant conversation before parting, 'Ye'll maybe come and see us the morn's nicht?' the soldier would only repeat, 'What for did ye no come to the ball?' The train leaves; the young woman is accompanied by her elderly widowed mother who regards Jane as one would a stranger, and it is only when the couple leave the train at Drem that Jane realises 'the pale, old, shrivelled widow' was the 'buxom, bright-eyed, rosy Mrs Frank Sheriff' of her own time. In her account of the young couple's conversation, Jane seems to be taking pleasure in hearing again the East Lothian tongue.

The train arrives at Haddington station and she looks out 'timidly, then more boldly, as my senses took in the utter strangeness of the scene; and luckily I had 'the cares of luggage' to keep down sentiment for the moment. No vehicle was in waiting but a little dusty omnibus, licensed to carry any number, it seemed; for, on remarking there was no seat for me I was told by all the insides in a breath, 'Never heed! come in! that makes no difference!' And so I was trundled to the 'George Inn', where a landlord and waiter, both strangers to me, and looking half asleep, showed me to the best room on the first floor, a large, old

fashioned, three-windowed room, looking out on Fore Street, and without having spoken one word, shut the door on me, and there I was at the end of it! Actually in the 'George Inn', Haddington, alone, amidst the silence of death!'

This was, of course, the death of a town that had once been alive with bustle and excitement as the hub of both a local and national transport network 'I sat down quite composedly at a window, and looked up the street towards our old house. It was the same street, the same houses: but so silent, dead, petrified!' She goes on to describe going to the churchyard early the next morning, intending to clean the moss from her father's gravestone. 'The gate was still locked ... so I made a dash at the wall, some seven feet high I should think, and dropt safe on the inside ...' Jane did not remain completely incognito; in two instances she revealed herself, to the Miss Donaldsons of Sunny Bank (now Tenterfield) and to Jamie Robertson, her father's old groom, two very emotional encounters. But soon it was time to go, and she paid her bill at the George: '... I have that bill of 6s. 6d. in my writing-case, and shall keep it all my days'. It was back into the 'shabby little omnibus again'. She recognised the elderly man who shared the compartment on the train; it was Mr Lea and he had deduced who she was: 'Was it you got over the churchyard wall this morning? I saw a stranger lady climb the wall, and I said to myself, that's Jeannie Welsh! no other woman would climb the wall instead of going in at the gate ...'

In 1866 Thomas Carlyle was elected Rector by the students of Edinburgh University, and in April he went North to deliver his rectorial address. On the 21st, two days before her husband's scheduled return, Jane went out for a drive in her carriage. She had taken a friend's little dog with her, and got a fright when the dog was struck by the wheel of another carriage, but it wasn't badly hurt, and Jane, with her charge, regained the carriage. After a little while the coachman, expecting further instructions which were not forthcoming, climbed down and, opening the coach door, found his mistress, seated, hands on lap, motionless. Jane had died from a heart attack.

Carlyle was recalled by telegram from his sister's home in Dumfries, where he was visiting, after his inauguration at Edinburgh. He returned home immediately, dazed and grief-stricken. He had given an undertaking that, in the event of her death, he would arrange for Jane to be buried with her father. So Jeannie

Walsh returned to the town of her birth. The provost, William Dods, who as a boy had helped Jane to learn Latin like the boys, gave the coffin shelter in his home overnight (Dods' house is now the Royal Bank of Scotland). Carlyle walked the streets of Haddington and looked up at the windows of Jane's old home where he had first met her, forty-five years earlier: '... The beautifullest young creature I had ever beheld'. The next day the funeral was attended by a small group of old friends, and Jane was laid to rest beside her father. Carlyle composed the inscription for her memorial, which now lies within the restored choir of St Mary's: 'Here likewise now rests Jane Welsh Carlyle, Spouse of Thomas Carlyle, Chelsea, London. She was born at Haddington, 14th July, 1801; only child of the above John Welsh, and of Grace Welsh, Caplegil, Dumfriesshire, his wife. In her bright existence she had more sorrows than are common; but also a soft invincibility, a clearness of discernment, and a noble loyalty of heart, which are rare. For forty years she was the true and ever loving helpmate of her husband; and by act and word, unweariedly forwarded him, as none else could, in all of worthy that he did or attempted. She died at London, 21st April, 1866; suddenly snatched away from him, and the light of his life as if gone out'.

The Cheap Magazine

The first printing press did not arrive in East Lothian until 1795 when one was set up by George Miller in Dunbar, where he was in business as a bookseller. He moved it to Haddington in 1804 and from there in 1812 *The Cheap Magazine* was launched. It announced itself as 'a work of humble import', and it would have '... a tendency to counteract the baneful influence of depraved habit'. It was intended to be read mostly by the labouring class, and cost fourpence a month. It was sold throughout Scotland, even reaching Shetland; sales were said to be between 12,000 and 20,000 monthly. It certainly made an impact. Over seventy years later James Barrie had one of his characters in *A Window in Thrums* quote accurately from an article on cock fighting which he had read in the 'Cheapie'. Incidentally the 'Cheapie' did not approve of the 'sport': 'A striking disgrace to the manly character of Britons!' Sadly, in spite of what appear to have been healthy circulation figures, the *Cheap Magazine* folded after two years. It would seem that George Miller was ahead of his time, for forty or so years later the railways would have made distribution simpler

and more economic. He must have faced huge problems and costs in achieving the coverage he did, in the era of the stage coach. Nevertheless, in producing a large-circulation magazine of popular appeal, Miller had achieved a notable 'first'.

The business was in some difficulties by 1819 and Miller's son, James, took over the helm. In its time, the Millers' press produced editions of popular works such as *Robinson Crusoe* (2,000 ordered by Paisley alone!), the *Haddington Register*, which was a directory of property and proprietors, and the Rev John Brown's *Dictionary of the Bible*. James also wrote and published his *Lamp of Lothian*, still sought after in antiquarian bookshops.

Another bookseller and publisher in Haddington around this time was the Neill family. The business came to Haddington in 1771, as an extension of an Edinburgh enterprise, founded by Archibald Neill. Their premises were in the High Street, and from there they published John Brown's edition of the Psalms (though this may have been printed in Edinburgh and sold from the Haddington shop), and *The Monthly Advertiser*. When Miller ceased business, Neills took over the printing of the *Annual Register*, and Adam, grandson of Archibald, illustrated it with his drawings of interesting buildings in the locality.

Adam Neill was on the spot when demolition work began, in 1833, on some nondescript buildings in Court Street (as it was renamed) to clear the ground for the building of a new court house and county building. Thus, when demolition of the ancient properties exposed elegant stone arches and the entrance to a vault, he was able to sketch them, thus preserving for us an impression of the surviving fragments of the Palace of William I, the Lion, for this is what it is believed to have been.

The foundation stone of the new buildings was laid on 27 May, 1833 by Sir John Gordon Sinclair, Bart., of Stevenston, 'in presence of all the beauty and fashion of the neighbourhood'. The finished building, designed by William Burn, is in Gothic style and of local stone, but finished with Culello stone from Fife. Echoing the find of the tantalising fragments, sketched by Neill, a plaque is set into the front of the building, recording that it occupies the site of King William's Palace.

Queen Victoria

The accession of Victoria in 1838 brought the customary pledge of loyalty and effusive congratulations from the Council. These

had been presented on past occasions, and might be thought to have been a bit overdone, in the light of the subsequent record of the recipients. But, what could any prudent council do in the face of an absolute monarch? If he wanted to impose his will against all opposition, they were damned if they welcomed him, but would be doubly damned if they didn't. If a Charles cynically pledged himself to the Covenant until he gained the crown, and then reneged on that pledge, what was a small burgh, relying on royal charters for its existence, to do? But reform was in the air, the franchise had been extended and gradually the abuses of privilege were being reduced. The times were changing and the monarchy was changing with them. Queen Victoria was well worthy of a loyal address; whether or not she intentionally developed the concept of the constitutional monarch, she was, throughout her long reign, a symbol of stability at the heart of the Empire.

Haddington was happy to welcome the dawn of a new era. This was a time of optimism, a time of hope and a belief that all progress was good and, underpinned by a strong religious faith, it was an era that would reach into the next century. It is doubtful if any of this was in the minds of Haddingtonians on 28 June, Coronation Day. The town bells sang out at nine o'clock while a band performed around the town. The shops closed early and, in the evening, the Council and their guests celebrated in the Assembly Room. The celebration ended with a grand firework display. The *Scotsman*'s correspondent reported: 'We have not for a long time past seen a demonstration of so much happiness in our little town'.

'... We quit the establishment ... but would rejoice in returning to a pure one'

Ever since 1712, when the Patronage Act ended a short period of freedom, which had allowed congregations to choose their ministers, there had been a simmering resentment in the Church of Scotland. It led to a division between the Moderates, who did not see the problem as critical, and the Evangelicals, who saw it as a fundamental right, that congregations should select their pastor, rather than have him imposed by the laird.

We have seen how the Secession of 1747 itself divided into two and then into four. The Church had held to its path as the mainstream faith of the nation but, in 1843, the debate over patronage came to a head at the General Assembly of that year. About 190 clergy walked out, led by the retiring Moderator. They

marched, arm in arm through large, cheering crowds, to the Tanfield Hall, a mile away. Ministers who had not been at the Assembly Hall swelled their numbers, and 474 were on hand to sign the Act of Separation. They then convened their own Assembly, and the Free Church of Scotland was born. Every missionary in the field separated, and only one Presbytery of the Church remained intact.

In signing away patronage, the Free Church had also signed away the revenues that paid their salaries and they no longer had churches. Under the leadership of their first moderator, Thomas Chalmers, 500 churches were built within two years, and schools were set up as well as theological colleges. All this was funded by a levy of one penny, minimum, per week on each member.

East Lothian was strong in its support of the Free Church: of 28 ministers in the county, 15 'came out', leaving 13, less than half, with the establishment. In Haddington, both the Rev R. Lorimer of St Mary's and the Rev John Wright of St John's joined the Free Church. The latter church, in Newton Port, had only opened in 1838, to relieve the pressure on St Mary's which, with accommodation for 1,200 worshippers, could not meet the needs of the parish church hall, and the Free Church built a new and second St John's next door. In 1890 it moved again when the third St John's was opened in Court Street, near the old West Port. In 1929 the breach between the Free Church and the Church of Scotland was healed. Thomas Chalmers had said of the Disruption, 'though we quit the Establishment, we go out on the Establishment principle, we quit a vitiated Establishment, but would rejoice in returning to a pure one'. It had come to pass.

Behind the new church there was another which had come about because of a division in 1733 which had produced the Relief Church. This movement had subsequently merged with other factions following the secession of 1747 and in 1900 was the place of worship of the West United Free Church. The tower of this church has been incorporated into Hilton Lodge, a complex for the retired. This congregation merged in 1933 with St John's which changed its name; it is now the West Church that stands at the West Port, with its loyal and independently minded congregation making its distinctive contribution to the life of the town. Commenting on the Disruption the *Encyclopedia of Scotland* says: 'during its existence the Free Church proper was a vital and bold expression of Presbyterianism in the midst of a rapidly changing society ... the impact

of standing by principles and against interference by civil powers left an affection for it in the history of the Church'.

'We come before our readers with no pretentious flourish of trumpets'

The *Haddingtonshire Courier* was born on Friday, 28 October 1859, founded by the brothers David and James Croal in their premises in Market Street, where it is still put to bed every Thursday. It devoted its first leader column to a defence of gathering news, citing no less an authority than Dr Johnson as saying that curiosity is the sign of an active intellect and going on to declare that the new publication would be 'a medium for keeping alive in the hearts of the community that kindly interest in each others' welfare which a local journal is so well calculated to foster ...' And when it comes to political matters the leader writer is pleased to draw our attention to these times 'when party feeling, once so rancorous, has given place to a manly toleration of opposite opinions'. 'Rancorous' might be thought too mild a word to describe some of the exchanges that have enlivened the *Courier*'s letter columns over the years, whether in the local or national context. As for that 'kindly interest in each others' welfare', some sections of the press could take that as their motto, with one amendment, changing 'kindly' to 'prurient'. Happily the *Courier* has not gone down that road in the circulation war, for, with the advent of the *East Lothian News*, those with a kindly interest in the welfare of others can now make a choice.

The first print run of the *Courier* numbered six hundred copies, produced on a hand press, formerly used for the *Caledonian Mercury*. The circulation increased rapidly, and for nearly a century and a half, the *Courier* has furnished us with all the news of the county, from the councils and the courts, the shows and the societies, the ballrooms and the Bible classes. In the early days not only local news was put before the reader, there was 'Topics of the Town', a digest of Edinburgh news, and 'General News' consisting of gleanings from all corners of Britain and further afield. The news that 'The last accounts from the western coast of Africa have brought the news of the death of Guezo, King of Dahomey' cannot have had the same impact locally as the announcement, on the same page, that the Nungate Brewery, 'now has on hand a stock of . . . October Ale, and is now ready to supply same in wood or in bottle'.

D. & J. Croal is still the name of the *Courier*'s proprietors, but it is now a limited company, still specialising in printing and publishing. The paper, too, has changed over the years, exchanging broadsheet format for tabloid and putting news on the front page. Gone, too, are the long, verbatim accounts of council meetings and the word-for-word reports of speeches by the good and the great, and the not so great! It is to be hoped that this latter trend does not go too far; the *Courier* not only serves today's impatient readers, but as a newspaper of record it also serves readers not yet born.

'Be it by water or by fire, o make me clean'

Before public health became a concern in the nineteenth century, town life must have been a malodorous ordeal for those of a delicate nature. Though the hymnist was appealing for a spiritual cleansing, the simile of material cleansing is apt for that age. John Wesley had already delivered that *bête noire* of all small boys, the aphorism that 'cleanliness is next to Godliness', and the engineering skills were there to bring the cleansing water.

In Haddington open drains ran down the streets and into them leached the distillations of domestic cess pits. For many years, in these streets, the fleshers carried on their trade of killing and butchering, and it was not until 1757 that an abattoir was imposed by law, the first in Newton Port, after which in 1804, it moved to Hardgate. Due to poor drainage, the streets were prone to flooding, and in 1765 the Council ordered the removal of several small bridges at the custom stone, placed there presumably as a means of crossing with dry feet.

Street lighting was in place in 1749, when the Council ordered that the profits from dung collected off the streets should be used to buy oil for the lamps; these were replaced by gas lamps in 1836. For the benefit of strangers, painted direction boards were erected at suitable sites in 1792. Street names were not displayed until 1839.

In 1814 a Mr James Burn supervised the laying of drains, common sewers and cesspools, for which he received a vote of thanks from the Council, no doubt echoed wholeheartedly by the residents. Sadly, these improvements failed to prevent Haddington being the first place in Scotland to be visited by the cholera epidemic of 1832; there were 125 cases of whom 57 died.

The issue of water, sewers and drains continued to preoccupy

both the residents and the Council. A letter to the *Courier* in April, 1860 deplores the attitude of councillors who had opposed improvements on the grounds of cost rather than health. It goes on to criticise the Provost who, when proprietor of the Star Inn, had allowed his cesspool to discharge into the gutter. But there is, it says, a greater concern '... by far the larger proportion of cess pools in Haddington have no connection with the gutter at all, but their contents percolate through the soil, and contaminate every well around them. Perhaps in the eyes of the Provost these are not a nuisance'. An even worse nuisance is identified by the writer as the Loth Burn. He concludes, 'apart altogether from the necessity for drainage in a sanitary point of view, which no one can deny, common decency urgently demands it. I am, Sir, an Inhabitant'.

In the previous year, the residents had organised the Inhabitants Drainage Committee; they retained a water engineer to report on a scheme to alleviate Haddington's problem. The engineer was a Mr W. Burns of Ely, which town, we are told, he had drained successfully. In October 1860, Mr John Richardson, deputed by the IDC, submitted the report to the Council. It was a fairly comprehensive document, first of all laying out the needs of the town and then going on to state that the need must be met. It then recommends a network of pipes of specific dimensions with a main junction at the custom stone which would lead to a sewage works by the Tyne in Amisfield Park. The report stresses that none of this would be effective without a powerful supply of mains water. The committee retained a Mr Paterson, plumber, to find a suitable source. The only supply strong enough that he could find was at St Lawrence House, which had the added virtue of being at a high enough level to create sufficient pressure for the system. The cost of the whole works was estimated at £4,500. In the meantime the IDC was making the detailed reports available to the Council at little or no cost, the fees of the experts they had retained having been met from a public subscription.

A scheme in line with most of Mr Burns' suggestions was implemented, and the lay-out of the town centre drains still follows his plans to an extent, maintenance works having come across sections of tile drains.

The means of procuring efficient education for their children

In 1864 the government set up a Royal Commission to look into the state of Scottish education; the reports of the Commission led to the Education Act of 1872, which sought to change the law of Scotland 'in such a manner that the means of procuring efficient education for their children may be furnished and made available to the whole people of Scotland'. At the same time as this reform was evolving, the people of Haddington were debating what form a memorial to John Knox should take. Probably influenced by the climate of educational reform engendered, first, by the Royal Commission, and then by the Parliamentary debate on the Education Act (which was hotly disputed), it was decided that the man who had endeavoured to bring education to every parish in the land would most fittingly be commemorated by a new educational establishment.

From proposal to completion took seven years. The Knox Institute did not welcome its first pupils until 1 October, 1879. The first rector was J. C. Graham, MA., a former classics master at Merchiston in Edinburgh. As the scholars entered their new home of learning for the first time, did the shade of Knox look down a little more compassionately than the stern gaze directed at them from his statue mounted in the facade above the entrance? This sculpture by D. W. Stevenson shows the reformer in what we imagine to be a typical pose, gowned and capped, hand on Bible.

Centuries before Knox set out his imaginative plans, indeed from the beginnings of Christianity in Scotland, the Church had taken an interest in education, originally, no doubt, to widen the religious knowledge of those wishing to join in the life of the Church by taking holy orders. Because religious communities were mostly self-sufficient, the earliest subjects such as Latin, Greek and Theology would soon be supplemented by practical studies, medicine, agriculture and building among them. As the needs of society became more complex, mathematics and the sciences would be added. Haddington was such an important centre of the Church that teaching must have been an important element of its work from earliest times.

That education in the burgh was well established by 1378 is demonstrated by the record of a payment, from the royal purse, to the master of the school. That this transaction was authorised by the King indicates the high standing of the school. Early records

are scarce, those of the burgh being reduced by regular pillaging and burning, and those of the central authority suffering also, if to a lesser extent. Nevertheless another entry in the royal accounts is significant, in that it shows a payment on behalf of a pupil to allow him to board in the town, an early example of a scholarship. By the fifteenth century Haddington had what was called the Grammar School, the grammar being Latin. One of its pupils in that century was John Mair or Major, who was born at Gleghornie, near North Berwick, in 1469. He would board in the town like the other pupils from outwith the burgh, the long hours of study and the difficulties of travel making commuting difficult if not impossible. Mair disapproved of the Franciscan Lamp of Lothian as being too ornate, and later he was to advocate reform of the excesses of the Church, but was staunchly supportive of Roman theology.

He was briefly in Cambridge before, like many Scots, going on to Paris where he graduated MA in 1496. He published books on logic and theology as well as being a teacher. Early in the sixteenth century he returned to Scotland, teaching at Glasgow and then at St Andrews before returning to Paris (where John Calvin may have been one of his students). In 1553 he was made provost of St Salvator's at St Andrews, and John Knox, who thought highly of Mair, was one of his students.

Mair did not live to see the Reformation which had as big an impact on education as on so many other aspects of life. Teaching had been the prerogative of the priests for centuries, and under the new religion it remained within the control of the Church. The *First Book of Discipline*, largely the work of Knox, set out a plan to provide schools in ascending levels of scope, starting with elementary in every parish, secondary in every town, and colleges or universities in the larger towns. This was the difference that the Reformation had brought about, not the implementation of the plan – it was too grand and the money was not there – but the idea of universal education, that it should be open to all, rich or poor, and that ignorance should not be used as a political tool.

Slightly ahead of the plan, the first Protestant teacher arrived in Haddington. Robert Dormont was provided with a schoolhouse and a basic salary supplemented by a *per capita* payment for 'ilk toun bairn'. The Grammar School was, therefore, fee-paying but subsidised by the Council, and pupils from outwith the town would have to board. This was the pattern of schooling until 1731.

Attempts to open private schools were frustrated. In 1606 the master, William Bowie, complained to the Council that parents were withdrawing their children to a rival establishment in the Nungate, and the Council ordained that parents could not send their offspring to any other school within a mile of the burgh school.

The range of subjects offered widened over the years. Greek joined Latin and in the early eighteenth century drama was being encouraged. On 29 August 1729 the boys performed both *Julius Caesar* and the *Gentle Shepherd* with no less a person on hand to supervise the productions than Allan Ramsay, the author of the second work; Ramsay also provided poetic prologues for both works.

The school had so far occupied premises in the Sands, near the old bowling green, the only change in this time being a move from one building to the one next door, but now came a move to a new building, incorporating a house for the school-master. It was still in the same area, but round the corner in Church Street. The building is still there, with its rather grander proportions, standing out in red sandstone from its more humbly scaled domestic neighbours.

English had come to be as important a subject as the classics and a department specialising in it was set up in 1761 alongside the school, and as the demand for modern subjects increased it was joined by the mathematical school in 1809. The first teacher was Edward Irving, who was to play such an important part in the life of Jane Welsh.

There were now two assistants to the rector, with responsibilities for subjects other than the classics which were the province of the rector himself. Around 1838 Robert Nicol was responsible for English and French. He believed in strong discipline and he had a novel method of enforcing it. Punishment was dispensed at a weekly court where Nicol acted as judge. The jury and other 'law' officers were drawn from the pupils in an unusual example of trial by peers.

Landowners outside the burgh had long wanted a parish school. One was at last set up in Lodge Street in 1826. At first something of a rival to the Grammar School, it was to become an ornament to the burgh. At the same time, private schools were beginning to get a foothold, and they too were to appeal to a wider range of pupils in the course of time. Among the best of these was Paterson

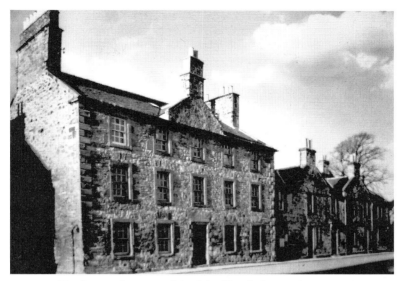

20. The former Grammar School in Church Street after restoration.
(Private collection)

Place Academy, established by the Rev John Paterson, a United Presbyterian minister, and Flora Bank School, supervised by Charles McNab. Several establishments catering for young ladies also existed. Into this mélange of competing dominies came one who was to be a considerable benefit to them, the Rev William Whyte.

William Whyte was the classics master at George Watson's in Edinburgh before he was appointed rector of the burgh's Grammar School in 1843. For a man of cloth, he seems to have been preoccupied with more earthly considerations, such as money, frequently arguing with the Council over the level of his salary. This would have been tolerable if his administration and teaching had been, at the least, satisfactory. But they were not. Indeed he has been described as 'remiss and inefficient'. Worst of all, his method of maintaining discipline was brutal to a degree that today would have landed him in prison. Pupils were dragged by the hair, beaten with the tawse until they bled, and one was floored by a blow from the rector's fist and then kicked where he lay. The rector seems to have laid into the victims, beating them about the head and body indiscriminately. The parents of one boy who died

from an 'effusion in the brain', learning that their son had been beaten about the head and then flung on the fire, had no doubt about the cause of death. On another occasion, an under master who was moved to intervene, by the screams of a victim, was promptly dismissed.

Indeed, it became impossible to find staff to work with the Reverend Whyte, but he was not dismayed; he appointed his own English master, with interim responsibility for writing and arithmetic. The only problem was that the candidate, Mr James Neilson, was fourteen years of age, though from an educated background to be sure, being the son of the schoolmaster at Bolton.

In spite of all this the rector clung tenaciously to his post. It is clear that the Council would have liked him to go but he was immovable. Not that he was averse to going, but only if he received a settlement handsome enough to be worthy of acceptance by a 'preacher of the Gospel and veteran classic'. He was offered a retiring allowance of £50, but this was not handsome enough, and he remained.

In this stalemate only one interested group could take action: the parents, and they did. Whyte had taken over a school roll which was consistently in the range of 200 to 300, but in the autumn of 1870 it was nil! The parish school and the best of the private schools benefited from the Rev Whyte's tenure, but the once-esteemed Haddington Grammar School was moribund. It was the 1872 Education Act that came to the rescue of the Council. Quoting it, they were able to dismiss the tyrant rector. But he was a hard act to get rid of; it still needed an action in the Court of Session to get him to vacate the schoolhouse in 1874 and, at last, after thirty-one years, the Council was shot of him.

When the Knox Institute opened in 1879, the old Burgh School was put on the market. Today it houses a mixture of flats and consulting rooms, the howls of pupils having been replaced by the occasional 'ouch' from the physiotherapists' couch.

Every child in the land now had to receive an education, and there was also to be an element of secondary teaching as well. The new school had to provide for this greatly increased demand, and restore the tarnished reputation of education in Haddington. This it proceeded to do, and the private schools were affected; the loss of the Paterson Place Academy was a sad one, as it was well thought of and its owner, Walter Haig, was a respected and much loved teacher. The opening of a well-equipped elementary

school behind the Knox then brought about the decline and fall of the remaining schools, including the Parish.

'Self-respect is the noblest garment'

Samuel Smiles was born in Haddington in 1812, and a plaque marks his birthplace in the High Street near the Town House. He died in 1904 and 92 years were little enough for what this tireless toiler achieved. The family came of Covenanting stock, his great-grandfather having been a field preacher in the Cameronian Presbyterian faith. Samuel Smiles senior was a general merchant in Haddington and was father to eleven children. He died in the cholera epidemic of 1832 when young Samuel was twenty.

Smiles was educated at a school in St Ann's Place and at the Burgh School, leaving at fourteen to enter an apprenticeship with the medical practice of Lewins and Lorimer. He made time to read books on a wide range of subjects, as well as receiving private tuition in French, Latin and Mathematics. When Dr Lewins moved to Leith in 1829, Samuel went with him. He was now able to attend the University, earning his diploma in 1832. He then

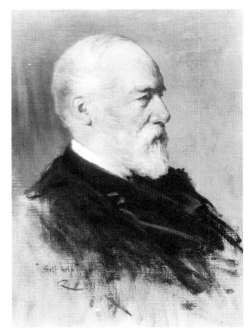

21. Samuel Smiles in 1891, by Sir George Reid. Born in Haddington in 1812, he made a career as an administrator in the growing railway network. Alongside this he pursued a literary bent, both as an editor and a writer. Self Help *achieved an international reputation and is still recommended reading. (SNPG)*

returned to Haddington and opened a pharmacy near the George Hotel.

Samuel Brown was a close friend who was able to explain the theory of the structure of atoms. Smiles must have made an impression in the Brown family circle because Brown's father asked him to deliver a course of twelve lectures on chemistry promoted by the Haddington School of Art. This led to other lecture engagements and it is clear that Smiles was a good communicator. He took this aptitude a stage further in 1837, by publishing a book, at his own expense, with the title *Physical Education, or the Nurture and Management of Children*, and it was still in print sixty-eight years later.

Competition in medicine was keen in the Haddington of the mid-nineteenth century and Smiles decided to seek both new pastures and a fresh vocation; his successful book, along with some journalism he had tried, pointed the way.

Following a walking tour on the Continent, he entered journalism. Smiles started, if not at the top of the profession – for the *Leeds Times* did not have the same standing as its London namesake – certainly at the top as far as Leeds was concerned, by filling the post of editor. This put him in touch with radical politics: he was involved in the movement for electoral reform and he worked to improve the condition of the working class.

From journalism, Smiles moved to the developing railway industry in 1845, at first with the local Leeds and Thirsk Company. Nine years later he was appointed secretary of the much larger South Eastern Railway. In the evenings Smiles lectured and wrote on social subjects as well as campaigning for better education and the establishment of public libraries. The best known of his books was written during this period. *Self Help, With Illustrations of Character and Conduct* appeared in 1859 and was an immediate success, selling over 250,000 copies. Its philosophy of learning and hard work, leading to self-improvement, sums up the author's own experience. No one could have foreseen that a young Haddington lad, apprenticed to a country doctor at fourteen, would become secretary of one of the largest railway companies, and in his spare time write one of the bestsellers of the century.

In 1866 he became President of the National Provident Institution but he continued to write, mainly biography as well as his autobiography. He had seen Sir Walter Scott at work in the Court of Session, he worked with and was a friend of George Stevenson,

he had been introduced to Garibaldi in Italy and honoured with an LLD from his old University of Edinburgh. He was born at the height of the stage-coach era and died in 1904, a year after the flight of the first powered aeroplane and on the fringe of the century of atomic power.

'Long to reign over us'

In 1874, the great Liberal statesman, W. E. Gladstone, was a guest at Whittingehame and the town council seized the opportunity to offer him the freedom of the burgh. Sadly, and not for the first time, the invitation had to be refused: the great man's engagement diary was full. However, Gladstone did Haddington a more important favour when he extended the franchise by removing the property condition. The constituency of Haddington Burghs, comprising three East Lothian and two border burghs, still existed at the election of 1879. This was the first election under the extended franchise, and it was bitterly fought. The Conservative candidate, Sir John H. A. Macdonald, was shouted down when he tried to address a public meeting in Haddington and the Liberal, Sir David Wedderburn, swept into Westminster on a wave of votes from the newly enfranchised working class. His supporters gave the defeated candidate a consolation dinner in the Corn Exchange, and it is interesting to note that three local ministers, including the incumbent at the parish kirk, gave speeches in his honour.

Gladstone was also responsible for ending the peculiar constituency of Haddington Burghs, which had been created in the wake of the Treaty of Union in 1707. Haddington was now incorporated into its own county constituency, along with Dunbar and North Berwick. This change, too, ended a long period of Tory ascendency, the next election giving victory to Richard Haldane. He was Secretary of State for War in the Liberal Governments that preceded the Great War of 1914. In that post he was responsible for army reforms, including establishing an Expeditionary Force and creating the Territorial Army. Both were central to Britain's preparedness when war broke out, and again, in 1939/40, the 51st Highland Division that played such a courageous part in the Battle for France was largely composed of Terries, the weekend soldier. Haldane is remembered by the Avenue that bears his name, and forms part of what we must now learn to call the old Bypass Road.

Queen Victoria's Golden Jubilee was celebrated with a service of thanksgiving in the parish kirk when the Rev R. Nimmo Smith

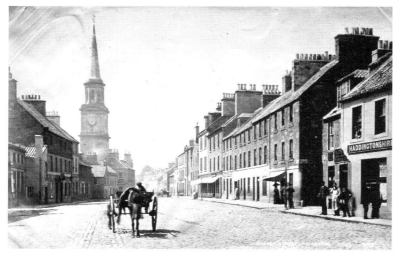

22. Market Street c. 1880.

preached an eloquent sermon. The bells were rung and three hundred of the parish sat down to lunch in the Corn Exchange. The Tyneside Games were revived in Amisfield Park and in the evening 150 guests enjoyed a banquet in the Town House.

Ten years on and the town was again gaily bedecked with banners and decorations for the Diamond Jubilee. An army band led a procession to the West End Park, where a tree was planted by the provost, and from there they paraded to a row of new houses, to be named 'Victoria Park' by Mrs Main, wife of the provost. With nightfall, a huge bonfire blazed a beacon from the Garletons to the surrounding countryside.

John George Wallace-James

In the 1880s a young doctor moved from the island of Mull to Haddington. He married the daughter of a mining proprietor, and set up home in Tyne House. His name was John George Wallace-James. He involved himself in the affairs of the burgh, serving as a councillor for thirty years, and became the Provost. His main interest in life was scholarly research. Skilled in Latin, he worked among the ancient records of the town, as well as collecting many other documents himself. In 1895 he brought out his book, *Charters and Writs Concerning Haddington, 1318–1543*, followed in 1899 by *Deeds Relating to East Lothian*. These were published for private

circulation, but are now available for research at Haddington Library. His translations, along with explanatory notes, bring the dusty documents to life, and one can almost hear Princess Ada or James V dictating their decisions to the scribes. Wallace-James also transcribed the records of the Burgh Court, and he made copious notes on the civil and religious history of the county, all to be transcribed into several volumes of material which were lodged with Register House in Edinburgh. This doctor-antiquarian died in 1924 and is buried in the kirkyard of the burgh he served so well.

World War One

During the latter part of the nineteenth century and the beginning of the twentieth political, economic and military power were all shifting as industrialism changed the economic basis of the Continent. Germany had emerged as a unified country, and was building up a strong army and navy which worried a Britain determined to control the seas in order to service her worldwide empire and import food for a population too large to be fed from home produce. There was now an arms race as Britain built warships in large numbers to maintain superiority over the German navy. In this atmosphere of feverish activity the nations of Europe made alliances, as an insurance against aggression, and in so doing unintentionally drew up the battle lines of the most destructive war ever suffered up to that time, also sowing the seeds of a later conflict on an even larger scale.

Almost immediately after the outbreak of war in 1914 Haddington was thronged with troops. Numbering about 3,000, they were quartered in the Corn Exchange, the Maltings and private homes. Amisfield House was requisitioned for officers, and soon Amisfield Park was covered with huts, housing the Lothians and Border Horse. These were regulars, and, as yet, there was no conscription, but the Territorials, founded by East Lothian's own MP, Richard Haldane, were mobilised. On Monday 2 November they were ready to leave for France. A platform had been erected in front of the County Buildings, and it was occupied by the Provost and Councillors and a former Prime Minister, Arthur Balfour, soon to be working with Winston Churchill at the Admiralty. It was a gloomy November evening, and a thin drizzle was falling as the troops lined up in Court Street. Balfour made a short speech, wishing them 'God speed, in the name of friends and neighbours'.

Then it was up to the station, led by a pipe band, and the young lads of the Haddington area were off to war, a war started by two pistol shots, in a faraway town called Sarajevo which most of them had never heard of.

The Haddington Territorials, commanded by Major Alexander Brook, formed part of the 8th Battalion, Royal Scots. This is the oldest regiment in the British Army, was founded in 1633 by Sir John Hepburn, of Athelstaneford, Marshal of France. The recruits were drawn mainly from Scots, sharing exile with Charles II. The French called it *Le Regiment D'Hebron*, which, confusingly, was the nearest they could get to 'Hepburn'. The regiment returned to Britain with the Restoration. Its headquarters is in Edinburgh and it is regarded as the local regiment. In the Great War the Royal Scots raised thirty-five battalions.

The Haddington contingent was early in action, and gained praise from John Buchan, who was a war correspondent for *The Times*, for their part in the action at Festubert, fought around a tiny hamlet a few miles to the east of Bethune in May 1915. Lasting over three days, it was initiated by General Haig to relieve pressure on the French to the south. The Germans held a strong position from which their machine guns dominated the field. With the Canadian Scottish also involved, the engagement ended with the Allies in possession of the enemy positions. It cost the 8th Royal Scots 32 dead, including Colonel Brook, and 159 wounded. Colonel Brook was succeeded by Lt Colonel William Gemmill, who had left his farm at Greendykes to answer his country's call; he too died leading his men, in March 1918, the last year of the war. He had been awarded the Distinguished Service Order for his part in the Battle of Festubert.

The few survivors of those who had left Haddington Station on that dreary evening in November 1914 came back to the Station in March 1919, along with the comrades who had joined them as they attained either recruiting or conscription age. They were met by the Council, led by Provost Thomas Ross, and entertained to lunch. Their regimental flags were presented to the Council and they now hang in the parish kirk. As you enter the west gate of the kirk the war memorial is on your left, and on it are the names of the 130 men, of all services, who left Haddington never to return. What it does not list are the many more who did return, broken in body and in mind, to try and make some kind of life in the peace.

'What else would I do?'

Towards the end of the nineteenth century, East Linton had become the centre for a group of artists attracted both by the picturesque old burgh and the gently contoured countryside. It was John Pettie who first drew the attention of the art world to the area. The son of a local grocer, he was a brilliant painter, working mainly on historic subjects, a genre which, sadly, has become less fashionable. He was followed by Robert Noble of Edinburgh, who settled in the town, Charles Martin Hardie, a local man, and Arthur Melville, whose family had moved to the area from Angus. Another, William Darling Mackay, born in Gifford, lived in St Ann's Place, Haddington.

In Haddington around this time, John Gillies, a tailor to trade, was building up a business as a tobacconist. Today, when smoking is regarded, quite rightly, as anti-social, it is hard to believe that tobacconists' premises were ever thought of as exotic, upmarket establishments. This was not the place you would go to for five Woodbines in a flimsy packet, price 1*d* or 2*d*, but rather for twenty Players Navy Cut or, if you wanted to display your superiority over lesser mortals, Capstan Full Strength. If you were in funds, you might consider Balkan Sobranie or Passing Clouds; the latter, we were told, would have been smoked by Cavaliers if they had been on sale in the seventeenth century! Whilst being served, you could have a look at the 'smoker's requisites' on sale, the cigarette cases, holders and lighters, and the varied ash trays from floor-standing to dainty ones for the boudoir: well brought-up ladies did not smoke in public. And the scent of a myriad blends of pipe tobacco hung in the air, a tempting aromatic sweetness mixed with the aroma from fat cigars in their colourful boxes. Much later, the son of the proprietor was characterised by the perpetual cigarette, the nicotine giving his mop of white hair a golden aura and preserving the ginger of his small moustache.

Although William George Gillies is not directly connected with the East Linton group, he was born into an area where painters flourished and where both landscape and townscape offered subjects in abundance. He made his entrance to this world on 21 September, 1898, in the family home above the shop. He had an elder sister, Jenny, and his younger sister, Emma, was born two years later. John's business was doing well, and soon they were able to have a house built in Meadow Park which they called West Lea. When schooling commenced, William did not have far to go

*23. Sir William George
Gillies, CBE, RSA, RA,
RSW. Self Portrait.
(SNPG)*

to the Knox Institute. He quickly displayed an aptitude for art and, although the school did not have a dedicated art department, his talent was recognised and he was encouraged mainly by Miss Fordyce who taught English, with art as a second subject. This perceptive lady even allowed him to cycle into the country during school hours in search of subjects.

Another influential figure in the early days was Gillies' Uncle William, his mother's brother, who taught art at Broughty Ferry. William Ryle Smith spent summer holidays in Haddington, taking his nephew on painting expeditions, around the town and into the countryside. There were other trips to the National Gallery in Edinburgh and to the annual exhibitions of the Royal Scottish Academy and the Society of Scottish Artists. Then there were holidays with his uncle in Broughty Ferry. That gave William access to his uncle's collection of books on art as well as giving him the opportunity to see work by local artists.

Two local men gave the teenage Gillies great encouragement, at a time when he was having to decide the direction he should take in life. One of these was R. A. Dakers, the editor of the *Haddingtonshire Courier*, whose favourite pastime was painting in oils. Dakers allowed young George to use his studio, and coached

him in the use of oils. Alexander Wright, watchmaker and art collector, was the other influence on Gillies' developing talent, and he allowed the use of his shop window to display his water-colours of local scenes. It was the first Gillies exhibition. It was a success, not only that some of the paintings sold, but because a wider public than that of the art world had seen and admired his work. A water-colour from that period is a proud possession of the Knox Academy, the successor to the Knox Institute.

Gillies' course was now set: he was going to paint and teach. He had not neglected his studies in pursuit of his calling: in his last year at the Knox he was Dux of the school. It was 1916 and the Great War was a stalemate of bloody attrition. It still had two years of carnage to reap, but to the people it seemed as if there would be no end to it. Conscription had been introduced and Gillies knew that he would have to go to the army now that he was eighteen. Before leaving the Knox, he painted and decorated a roll of honour listing the former pupils serving in the forces. The *Courier* reported that '. . . the whole work in every way [reflects] great credit upon the artist, who is the son of Mr Gillies, tobacconist'.

His call-up came at the end of his second term at Edinburgh College of Art. Naturally, he was unhappy that his studies were so brusquely interrupted, especially as the whole college experience was proving so exhilarating, but he had to go, and, after training, he arrived in France as a soldier in the 10th Battalion, the Scottish Rifles. The regiment was involved in heavy fighting near Arras. Gillies was twice wounded, and gassed. Following a long spell in hospital, he was discharged from the army in the spring of 1919 and resumed his studies in Edinburgh.

Halfway through his course, John Gillies died suddenly, the tobacconist's business was the only source of income, and William's studies were threatened. He was now the head of the family, and he felt he had a commitment to his sisters and, especially, his mother. In this crisis the family came together, and to allow her brother to continue his studies, Emma left her job in the *Courier* office and took over the shop. William graduated with a diploma in drawing and painting in 1922. He had won a bursary and this allowed him to continue working hard on technique for a further year. His portfolio at the end of this earned him a travelling scholarship, and he went to Paris and then Florence.

On his return he taught for a year in Inverness, but in 1929 the Edinburgh College of Art once again became the centre of his life

when he was asked back to be a part-time lecturer. Just about this time, too, the family moved to Willowbrae Road, in Edinburgh, to be nearer the college. William Gillies was now in his element. He loved teaching and he loved painting, he now had the scope for both and he was back with his family, the members of which had done so much to support him.

He loved the scenery of Scotland and he went out to it by motor cycle or by car. The West Highlands and the East Neuk of Fife were his favourite beats. He spent his spare time at his easel, recording luminous west-coast land- or seascapes, or the village harbours of Fife, and then it was back to his students at the College. It was a contented way of life, but tragedy entered it in 1935 when Emma died, at just the same age as the century. This event must have had an unsettling effect, for in 1939 William, Mrs Gillies and Jenny moved to Temple in Midlothian.

In 1946 he was made Head of Painting at the College of Art and in 1960 he became Principal. He was a member of both the Scottish and the English Royal Academies, he was a CBE and he was knighted in 1970. In spite of his teaching and administrative commitments, he never stopped painting, and after his death in 1973 his executors found a studio filled with his work; when the carpets were lifted, more were found underneath, presumably used as insulation! Much of this legacy, along with documents and family snapshot albums, is now in the care of the Royal Scottish Academy. As Principal, Gillies had to attend many social functions, but he usually left early: 'Going home to paint another picture, Bill?' He had but one reply: 'What else would I do?'

Between the Wars

The two decades that separated the two world wars started with an outburst of optimistic joy, that gradually ebbed to be replaced by an uneasy feeling, that the peace was merely a respite in an unresolved conflict. The changes that people had expected would come with the Armistice, largely did not materialise. Unemployment remained, poor housing and overcrowding had scarcely improved. Haddington made a start to slum clearance, old insanitary buildings were demolished and new homes replaced them. The Nungate, in particular, was given several new streets of family homes. The A1 was taken to the north of the town by a bypass, which promptly attracted a row of houses along it, built by Richard Baillie & Sons of Market Street. Haldane Avenue was just a smaller

CHARLES BRUCE

BOOKSELLER AND STATIONER.

PLAIN AND FANCY STATIONERY.
PHOTOGRAPHS.

Upwards of 100 Local and County Views, Album of Views
from One Shilling upwards.

PICTORIAL POST-CARDS.

MAGAZINES AND PERIODICALS.
DAILY AND WEEKLY NEWSPAPERS
DELIVERED OR POSTED

BOOKBINDING, ENGRAVING & LITHOGRAPHING,
PICTURES FRAMED AT MODERATE CHARGES.

ARTISTS' MATERIALS SKETCHING BLOCKS. TOURISTS' CASES.

Agent for Anchor Line and Union Castle S.S. Coys.

List of Furnished Apartments and Houses to Let on application.

22, Market Street, HADDINGTON.

*24. Pre-1914 stationer's business card. These premises are now occupied by
John Menzies.*

25. Grocer's van in Market Street between the wars. Before car boots were loaded in supermarket car parks, purchases could be delivered to order, but most ordinary housewives shopped on a daily basis, rarely looking forward more than 24 hours, except at weekends.

version of what happened on the outskirts of most towns, before the advent of stricter planning regulations. It was called 'ribbon development' and usually featured the newly fashionable 'bungalow'.

In 1939 the Knox Institute moved into a new building in Meadowpark, and changed its name to the Knox Academy. The old Institute building accommodated the infant and primary pupils.

The landowners were finding problems in maintaining the large mansions they had inherited from a more affluent age. These building were ageing and maintenance was expensive, their size made running them labour-intensive and servants, though still available, were fewer and more expensive than before the war.

One of the first to go was Amisfield House, the property of the Wemyss family. It was built in 1760 and enlarged in 1785. The park was the scene of the Tyneside Games which, from 1833, were an annual event for some twenty years. Haddington Golf Club was founded in 1865 and it, too, used Amisfield Park and still does. During the war, Amisfield House had been requisitioned for the use of officers, but now there was no use for it and it was demolished. The fine red sandstone was used in the building of a new school at Prestonpans and the Vert Hospital which stands on the corner of Haldane Avenue and the Aberlady road.

26. *Emma Gillies, younger sister of the artist W. G. Gillies, at the door of the family business in High Street in the early 1920s.*

27. *Carrie Hamilton at the door of her shop, now a café, in 1996. The plaque on the wall was placed there by Haddington's History Society to mark the artist's birthplace. (J Tully Jackson)*

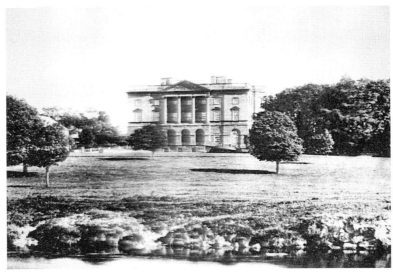

28. Amisfield House, demolished after the first World War. It stood on the site of Sir James Stanfield's Woollen Manufactory. Its stone went into the Vert Memorial Hospital and a school at Prestonpans.

29. Playing a round on Amisfield before the second World War. Plus fours were de rigueur *for the well dressed golfer.*

30. The Tyne in flood, 1928. Pedestrians are brought to a halt at the east end of the High Street, while a cart horse takes its passengers, dry shod, into Hardgate. (ECL Library)

The site for the hospital was given to the town by Henry Vetch of Caponflat who died in 1936. The hospital was donated by John Vert, whose father had been Provost from 1866 to 1869. Provost Vert had been presented with a piece of silver plate in recognition of his efforts to have road tolls lifted. His son, who now lived in America, returned for the opening of the hospital in 1930. He brought with him his father's piece of silver plate which he gifted to the Council, along with an eighteenth-century clock made by Andrew Bell, a Haddington clockmaker. Now the hospital is no more, and the property, which was generously given to the burgh, is to be commercially developed as housing.

The Second World War

On 3 September, 1939 Britain was plunged into another world war. Aerial warfare had been developed in the First World War, mainly as a reconnaissance and tactical support to the army. What the new German air force could do against sprawling urban areas had been demonstrated in Spain, and was even now being perfected against Warsaw. So along with the mobilisation of the forces, the Government stepped up the building of air-raid shelters, and the evacuation of children from the towns. The columns of

31. A façade erected to lend glamour to the marquee behind, housing the mobile cinema. It was replaced by the more permanent New County Cinema, which gave valuable service during the war and continued to be popular in the fifties and early sixties but very soon lost out to television.

evacuees, carrying their little bundles or attaché cases, a string round their necks supporting the cardboard box containing a gas mask, was one of the first pitiful images of a war which was to prove even more pitiless in its treatment of the innocents. Many of the Edinburgh children came to East Lothian, the inevitable culture shock, to both hosts and guests, resulting in a homeward drift of the homesick.

As the war progressed, East Lothian took on the aspect of an armed camp, with Haddington at its centre. Along the sweep of the coastal plain, to the north, there were three major airfields within a few miles of each other. A further airfield, with a grass runway, was laid out at Lennoxlove, its purpose being to receive aircraft for store, where they would be difficult to detect from the air.

And the Poles arrived, driven out of their homeland by the German blitzkrieg. Units of the Polish army contrived to make the, seemingly impossible, transition from the Eastern Front to the Western. The French collapse found them, once again, seeking a base from which to continue the fight, and so they arrived in Britain, many of them coming to the east coast for re-equipping and training. One armoured unit was stationed in Amisfield Park,

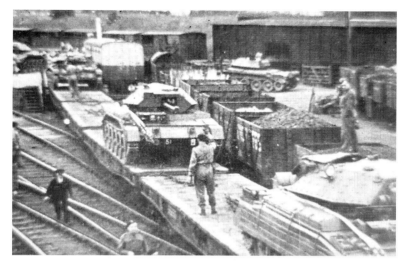

32. Polish tanks loading onto railway wagons at Haddington station in preparation for D-Day.

and these dashing gallants, with their continental courtesy, made a big impact on the town and on the heart of many a young lass. A souvenir of their sojourn is the plaque bearing their heraldic badge, which hangs in the Town House, but the number of Polish surnames to be found locally is an indication of the individual conquests they made. It is also ironic that, on having gone through so much to free their homeland, the division of Europe, in victory, forced many of them to stay on, instead of returning to Poland with their young brides.

When the Poles moved south to prepare for D-Day, their camp was converted to receive prisoners-of-war. It was to be some time before Haddington Golf Club got their course back.

Life in Haddington was much the same as any other town in wartime. There was the blackout enforced by air raid wardens on the lookout for the slightest chink of light, there were queues at shops on the slightest hint of any item in short supply being available, rationed essentials were collected and eked out, and nearly everyone was engaged in some activity to help the 'war effort'. One of these was the Home Guard, comprising men un-available for full-time service, by reason of age or their occupation being an essential one. Haddington Post Office Home Guardsmen held themselves to be the most mobile unit in the county, with

the Post Office motor cycle and sidecar combinations at their disposal.

Then there were those, mostly women from the churches, the WVS and the WRI, who ran canteens providing welcome refreshments for troops on the move or as havens in off-duty hours. Haddington churches combined to run one in Holy Trinity Church hall, and there was another in the High Street, organised by the WRI. There were committees for a myriad of activities from knitting bees to fundraising promotions such as Wings for Victory.

Newspapers were reduced to four pages and many popular magazines stopped appearing. The radio reigned supreme, the evening nine o' clock news being essential listening in virtually every home; and the popular discussion session, the Brains Trust, made stars of erudite academics. These featured on the Home Service; the Forces Programme dispensed a lighter mixture of variety, comedy and dance and swing music. Outside the home, cinema-going and dancing were the most popular pastimes, and there were many sophisticated and not so sophisticated dance halls as well as local 'hops' organised in any convenient hall. Even the children joined in the spirit of the times, putting on 'back green' concerts to earn money for wartime causes.

Many served in Air Raid Precautions as wardens, first-aid and ambulance personnel and fire and rescue units. Others manned their places of employment overnight as fire watchers to deal with any incendiary bombs in an air raid. To many small towns with no obvious military significance, and not having a large population to be diverted from war work by the consequences of mass bombing, all of this precautionary activity might have seemed a bit excessive. Anyone in Haddington harbouring such views, however, had them quickly dispelled on the night of 3 March, 1941. The warning siren sounded, not for the first time, at 8.30 pm, and many treated this as another false alarm, or perhaps someone else was 'getting it'. A fatalism had also developed: 'If it's got your name on it, it'll get you'. Whatever the reason, the audience in the New County Cinema remained in their seats and the Women's Guild in the WRI rooms continued their meeting.

Thirty minutes later the bombs fell. The first demolished the corner of Hardgate and Victoria Terrace, leaving a gap that was to become a petrol station; the cinema was only yards away in Hardgate. A few yards further east, the *Courier* office was hit, the bomb scything through the building without exploding. The Guild

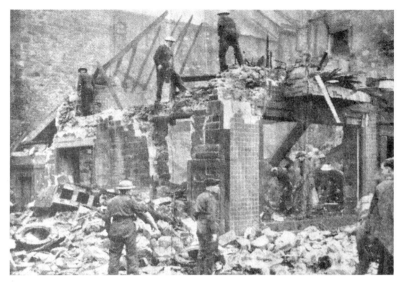

33. Baillie's shop in Market Street. Next door was the telephone exchange where the girls continued to deal with calls while the flames spread into their building.

members were just leaving their meeting in the High Street when Baillie's shop, to the rear in Market Street, was hit; some were caught in the blast and one person was injured. The shop was completely destroyed and has not been replaced. Mains water and gas services were disrupted by a further explosion that made a large crater in Market Street outside Halliday's garage. Incendiaries had also rained down on Amisfield Park.

Many fires broke out and the service was stretched to the limit. Flames from Baillie's demolished building were spreading to the telephone exchange next door and the black-out curtains were ablaze, but the girl operators were still passing calls to the emergency services when the firefighters arrived on the scene.

The lone raider vanished into the night, having, in a few minutes, created a scene of random destruction, shattering the tranquillity of an early spring evening in Haddington. Casualties were mercifully light: two soldiers and a local man were killed. How much worse it could have been if the first bomb had hit a few yards nearer the crowded picture house.

The war in Europe ended in May 1945, and in the Far East in August that year. The demobilised servicemen started to return

home, not in units marching back to a civic welcome as after the
first war, but singly according to a system of numbers based on
length of service and age. In spite of this, the Town Council was
able to get a large gathering together for a party in the Town
House.

The end of the war did not bring with it an end to the austerity
endured over the six years of struggle. The cost of the war had
brought Britain to the verge of bankruptcy, food was still short,
importing it used scarce foreign exchange, so rationing continued.
Bread was now rationed for the first time, and food-saving hints
continued to be issued by the Ministry of Food.

Those with relatives living in countries with plentiful food sup-
plies had their rations supplemented by food parcels from the
Commonwealth and from America. There were also organised
consignments of gifts of food for the needy. In February 1950 the
Courier received a number of such parcels for distribution to people
engaged in newspaper work. Thousands had been sent to news-
papers throughout the country to mark the despatch of the two
millionth food parcel by the Australian Express Scheme.

At least the black-out was a thing of the past, and street lights
shone out again – in between power cuts, anyway. Only essential
maintenance or refurbishment had been done during the war, but

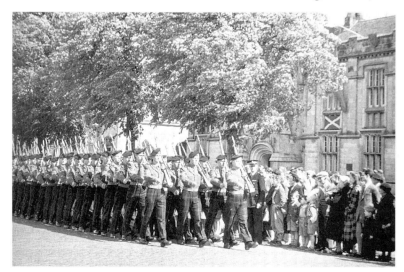

*34. The Royal Scots march through the town with bayonets fixed, having
received the freedom of the burgh.*

within a year of the end of hostilities the *Courier* reported that the West Church had replaced its gas lighting with electricity. The Rev. R. Mitchell preached from the text, 'God is light and in Him is no darkness at all', and the choir sang two anthems.

An Infusion of New Blood

Overcrowding and lack of housing had been a social problem in 1939, and it was now at crisis point. Using techniques evolved during the war, the government had developed temporary houses: prefabricated section built in factories and quickly assembled on prepared sites. Haddington was allocated those of the Tartan design which were erected in Lynn Lea Avenue and Herdmanflatt. They were essentially little bungalows, and had such built-in refinements as a gas refrigerator, a heated towel rail, a fitted kitchen and an immersion heater. Working-class homes had never known such luxury! They were due to be replaced by traditional homes after ten years.

The building of council housing was to continue for many years, and in Haddington the Vetch estate at Caponflat was built over in the '50s.

In the west of the country, Glasgow was trying to cope with a massive housing problem, partly by the building of large housing schemes and by the planning of the new towns of East Kilbride and Cumbernauld. But these solutions would take time and something needed to be done immediately. Could some of the needy be accommodated in other towns? The overspill scheme was born, and in an imaginative move the Town Council, under Provost William Crow, approached Glasgow with an offer to take around 200 families, an influx of around 1,000 new citizens. Haddington did not have to finance the housing required so the houses were a gain. But a more important asset were the people. The council had a say in the selection of candidates and the town 'has had her reward in the infusion of new blood, and of the use of hands, in small industries more suitable to Haddington than to Glasgow. Haddington has also built houses on the periphery for these newcomers ...' (Moray McLaren)

In fact the newcomers were not all accommodated in the new houses, built as part of the agreement, but were scattered throughout the town, to integrate better into the community. Although they had the option, very few of the newcomers asked to return to Glasgow, and it is fair to say that their arrival was the start of

something of a renaissance for Haddington. In population terms, a town which had averaged around 5,500 citizens over the previous hundred years stood at 6,592 in 1961, and by the next census in 1971 it was 7,787.

Flood Alert

Walter Bower wrote one of the first accounts of the River Tyne in its destructive mood. Heavy rain around 7 September 1358 caused a devastating flood, bringing death to many as well as destruction. The wood and wattle homes were no protection, the Nungate was swept away and many houses in the town were destroyed. As the flood threatened the Abbey down-river, a nun vowed to throw a small statue of the Virgin into the waters if the Holy Mother did not protect the Abbey; at once the flood began to abate.

The Tyne rises near the appropriately named Tynehead in Midlothian. By the time it reaches the East Lothian border, near Ormiston, it is broadening out from a burn into a respectable river. From there, it gains the force that made it a power source for mills. A feature of the Tyne at Haddington are the mill lades, channels that diverted and confined the flow of water to the mill wheel. A former mill, Poldrate, on the south side of the town, still has a working wheel, though the mill itself is now used as a social and educational centre by the Lamp of Lothian. Preston Mill a few miles to the east, at East Linton, was a working mill within living memory. It is now owned and kept in working order by the National Trust for Scotland as a living example of the technology that processed the grain for the 'baxters' of East Lothian.

The Tyne makes a graceful sweep, once around, but now through Haddington and just a few miles to the east it is hemmed into a narrow gorge formed by the same geological action that created nearby Traprain Law. On a rocky outcrop on the south bank is ruined Hailes Castle, once the stronghold of the Hepburns. For this was the main road, and from the castle they controlled passage through their territory. It was near here that Bothwell levied a rather hefty toll from the hapless Cockburn of Ormiston.

From East Linton, the Tyne widens and assumes a more tranquil form before losing itself in the North Sea at Tynemouth, near Tyninghame House, 28 miles from its source.

On the wall at the corner of Sidegate and High Street can be seen a plaque which records that on 4 October 1775 the Tyne

rose to that level. In fact, the highest point was 8 feet 9 inches. A torrential downpour lasting around two hours did the damage and took the townspeople by surprise. Again, the Nungate and the east end of the town were flooded. Some took to the roof tops, other waded to safety with water up to their armpits. Among the flotsam of furniture, wooden fittings and dead cattle were carts, some of them carrying domestic poultry as passengers. After about two hours the waters began gradually to subside. It was providential that it all happened during daylight, starting at two in the afternoon. There was no loss of life, but the situation could have been very different at night.

The feature of that flood was its suddenness, and the depth it reached in a short time. More often the rise is slower but steady, monitored from the Victoria Bridge by burgh officials and councillors with a group of unofficial advisers, ready to offer opinions and advice.

There have been other inundations: in recent times parts of the Nungate and as far as the High Street have been under water, notably in 1928 and 1953, but by far the worst was that of 1948.

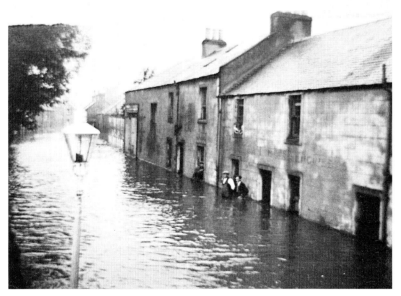

35. St Martin's Gate in 1948. One of the worst floods ever recorded. Note the gas lamp.

On the night of 12–13 August the Tyne flooded to a depth of ten feet. At its height as it swept through the town, the surge stretched from the Town House in the west to the gates of Amisfield Park in the east, more than three-quarters of a mile. Some 450 dwellings were affected as well as 31 businesses and 59 shops. More than ten tons of provisions had to be condemned.

When the waters relented, a layer of mud up to a foot deep coated street and the interiors of dwellings, and many were left homeless. The Town House was opened as a rest centre and volunteers served food, prepared in the Education Authority's domestic science kitchens. In the following week they served 2,000 meals.

Army Nissen huts in Amisfield Park were converted into emergency homes. Sixteen Cruden houses were started and two were completed, ready for occupation, in eleven weeks. By the end of the year the most pressing housing needs had been satisfied. Those who had lost all but the clothes they stood in were helped from relief funds, set up by the provosts of Haddington and Edinburgh. A total of £17,460 was disbursed.

The Town House Restored

From the time of the overspill agreement with Glasgow in the late '50s, Haddington entered a period of renewal, which was a reawakening from the sleepy town that Jane Welsh had found on her return, and a reaction to the civic stagnation of the war years. Throughout the '60s and early '70s, there was an air of confidence, born from a succession of projects, some coming from the councils, others from individuals and private bodies. It was a period of renewal, rebuilding and restoration. Sadly, in developing the town, there were some losses: the widening of Hardgate to appease the new god motor car, saw the demolition of some interesting old buildings. Ironically, the broader Hardgate has provided motorists with a parking haven, narrowing the street to its former dimensions. The authorities, surely, will not allow this situation to persist, but cars may be harder to remove than historic buildings. On the whole, however, what was done was for the better, and Haddington today retains its style and character, but with no sense of being a museum piece.

During the Second World War, public building had received very little maintenance. Not long after the war was over it was found that dry rot had taken hold in the Town House. A survey found the dry rot to be more extensive than first thought, and that

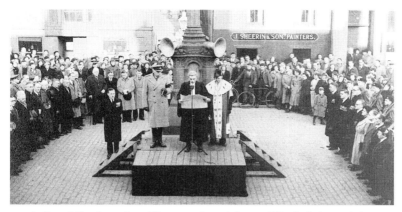

36. Royal Proclamation. The accession of Queen Elizabeth is proclaimed from the Cross by Sheriff Middleton in 1953. At the foot of the steps to the left is William Wallace, Sheriff Clerk. The officials and councillors are on the right. Town Clerk John McVie and burgh Chamberlain, Matthew Carlaw, both wearing medals. The Burgh Surveyor, Lee Hogg, Mary Taylor in a light coloured coat, has Harvey Gardiner on her left. In guide uniform is Miss Robertson, Superintendent of the Christie Homes and then Hugh Craig. The Marquis of Tweeddale, Lord Lieutenant and Provost Robert Fortune are on the platform.

wet rot and woodworm were also present. It was clear that major works would be necessary to eradicate the infestation, if, indeed, eradication were possible. Techniques for the control of these problems were not as advanced as they later became, and there was concern that neighbouring properties in the town centre could be affected.

Drastic measures appeared to be necessary, and the initial reaction was that the Town House should be demolished, and replaced by a new building, on a greenfield site. Visiting Nunraw where the new monastery was being built, the Town Clerk, John McVie, met Peter Whiston, the architect on that project. In the course of their conversation, Whiston offered to have a look at the problem. Subsequently, his report convinced the Council that the Town House was not beyond saving, and that they would be able to conserve one of Scotland's finest examples of an eighteenth-century Town House for the nation.

The extent of the work gave an opportunity to replan the interior, so that the accommodation could be brought into harmony with modern requirements. These changes mainly affected

37. Town Clerk John McVie addresses a meeting to discuss the 'Face Lift'. Provost W. Crow, who also had an interest as proprietor of the George Hotel, listens carefully. (Private collection)

the ground floor. An open pend was enclosed and the prison cells were demolished, allowing a new ground-floor plan to be made. The work was done to a very high standard, from the terrazzo-tiled, rotunda entrance hall, with its glass mosaic of the town seal, to the mahogany-panelled Council Chamber. The exposed stonework on the staircase, leading to the elegant Assembly Room, retains the feel of the original Tolbooth, while the opening up of dummy windows gives the interior a light and airy ambience.

On 10 March, 1956 Provost Robert L Fortune presided over a distinguished gathering at the opening ceremony, performed by HRH Mary, the Princess Royal, daughter of George V. One wonders if any of the weel-kent bailies, councillors and officials, supporting the Provost that proud day, had any premonition that the days of the Royal Burgh of Haddington, and its Council, were numbered.

Three months later Queen Elizabeth and Prince Philip were in residence at Holyrood House on their traditional annual round of Scottish engagements. On this occasion they attended the East Lothian Agricultural Show, which was held at Lennoxlove. From there the royal party made the short journey into Haddington,

38. Her Royal Highness, Mary, the Princess Royal, talking to Chief Constable William Merrilees at the opening of the restored Town House, 10 March 1956.

39. July 1956. Her Majesty the Queen arrives at the Town House to receive local dignitaries, including the Provosts of North Berwick and Dunbar. Provost Hugh Craig escorts her to the dais.

where a dais had been set up at the west end of the Town House. The dais was decorated with masses of hydrangeas and covered by a canopy. A number of people in public life were presented to the Queen, including Mrs Croall, the last member of the founding family, still engaged in the running of the *Haddingtonshire Courier*, and its associated printing business. The Provosts and Town Clerks of Dunbar and North Berwick were also presented.

In conversation with Haddington's Town Clerk, John McVie, the Queen asked what was the building behind the dais. On being told that it was the Town House, recently restored and opened by the Princess Royal three months earlier, she turned to Prince Philip and said, 'Philip, this is the building opened by Aunt Mary in March, we must see it.' There followed an unscheduled tour of the Town House.

Not long after the reconstruction of the Town House interior, Town Clerk John McVie, whilst on holiday in the south, made a trip to Norwich. He was most impressed with the appearance of the town, which had recently undergone a facelift under the auspices of the Civic Trust. Back in Haddington, he reported on what he had seen to Provost William Crow. There then arrived an invitation to Windsor, where the Queen was to be the guest of honour at the conclusion of a similar scheme. Provost and Town Clerk winged their way south, leaving from East Fortune, which was standing in for Turnhouse, where a new runway was being built.

They returned to Haddington convinced of the benefits that such a scheme would bring to the County Town. The first task was to sell the idea to the proprietors of the town-centre properties. This was crucial, as without their full co-operation the scheme could not proceed. A meeting of the proprietors was addressed by the Burgh Surveyor, Bill Dudgeon. By the end of the meeting they had all agreed, firstly, to co-ordinate the exterior maintenance of their buildings and, secondly, to conform to a scheme devised to avoid clashes of colour.

Architects Campbell Arnott produced panoramic views of the streets involved, showing the colour scheme, and this was followed by the proprietors. The Town Council did its part, tidying the clutter of street furniture, and repainting and replacing such items as litter bins and lamp posts. From this, in a very short time, emerged a spruced-up town centre, as fresh and as bright as a butterfly emerging from its chrysalis.

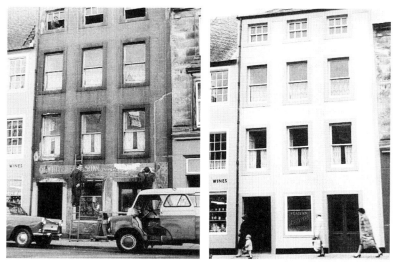

40. The 'Face Lift' before and after.
(Left) Work starts on Hugh Whitehead's. Purves the grocer to the left has
been completed. (Right) 'Face Lift' completed. This work spruced up the
town and gave a boost to morale after the long period of post-war austerity.

41. The Provost, Harvey Gardiner, leads the procession, which includes, as
well as local personalities, representatives of the Civic Trust and councillors
and officials from burghs throughout Scotland. With the Provost are the
Marquis of Tweeddale and James Stuart, Secretary of State. The Town
Clerk who inspired the exercise is there, robed and be-wigged, and behind
him is the Duke of Hamilton. (Private collection)

The Haddington facelift was marked by a procession through the pristine streets of representatives of the Civic Trust, civic dignitaries of other burghs and, guest of honour, the Secretary of State for Scotland, followed by a reception in the Corn Exchange. The exercise had cost the burgh very little, the proprietors bore their own costs, and the architects gave their services free. Today, High Street shopping everywhere is suffering competition from out-of-town shopping malls, but the High Street, with its range of shops offering personal attention, could be looked upon as the original one-stop shopping centre. Attracting shoppers requires an attractive environment, and perhaps it is time for another facelift.

Jumelage Cordial

The Franco-Scottish connection officially dates from the treaty of 1295, known as the Auld Alliance, but some trace the link back to William I, while others, rather more tenuously, go back to Charlemagne. Haddington's French connection is rather better documented, having been established in 1965. But it springs from a historical event in 1421. At that time France was near to final defeat at the hands of the English, in the conflict that became known as the Hundred Years' War. The French, weakened by the loss of men and seasoned leaders, appealed to Scotland for assistance. A force of 6,000 men, under the command of John Stewart, Earl of Buchan, was despatched. On the evening of 22 March, 1421 the English engaged the Scots and their allies at Vieil Baugé, north of Tours. Within an hour the English had suffered a crushing defeat in which their commander, Thomas, Duke of Clarence, brother of King Henry V, lost his life. It was a turning-point in the war, and it also demonstrated the value of the alliance, leading to a drawing together of the two nations, reaching its apogee in the sixteenth century when Mary Stuart was Queen of both countries, and ending with France's reluctant and minimal contribution to the '45.

Aubigny-sur-Nère is a pretty town in central France, situated between Orléans to the north and Bourges to the south. Sir John Stewart of Darnley, as Constable (Marshal) of the Scottish force under Buchan, had played a leading role at Baugé, and the French rewarded him with this town, and its rich lands. Now we must change to the French spelling, and say that the Stuarts were such notable Seigneurs of Aubigny, that when, in the seventeenth

century, the town passed out of the direct Stuart line it continued to be known as *La Cité des Stuarts*, and still is to this day.

Nearer our own time, it was a Mrs Stuart Stevenson, of Edinburgh, a regular visitor to Aubigny, who had the idea that this French town, with its Scottish past, should be put in touch with a Scottish town with Stuart links. She thought that Haddington would be the ideal 'twin'. After all, it had seen the Franco-Scottish alliance in action during the siege of 1548, in which the Queen mother, Mary of Guise, took a close interest, even to the extent of putting her own life at risk, and it was at Haddington that Parliament made the decision to send the infant Mary to France.

The twinning took a decisive step forward in April, 1965 when Provost Harvey M. Gardiner, Town Clerk John McVie and their wives visited Aubigny at the invitation of the Maire, M. Gaston Vannier and of the Comte de Vogue. The Comte is the owner of the Chateau Verrerie, a fine building closely associated with the original Stuarts of Aubigny. The Haddington envoys were guests at the chateau where a reception was given in their honour, and Provost Gardiner presented Maire Vannier with a suitably engraved

42. The Aubigny connection. Haddingtonians and friends in front of the Hotel de Ville (Council Building). Coach driver Gordon Briggs is on the left. Centre is Alice Burnett who has funded an Aubigny scholarship, to the right of Miss Burnett is Tom Wilson, chairman of the former District Council. Alan Colley can be seen on the right of the picture. The Hotel de Ville is the former chateau of the Stuarts of Aubigny.

43. The Maire of Aubigny, M. Roger Pelata, in Haddington, centre, with Tom Wilson on his left. Next to him is Mme Jacqueline Pelata and behind her is Mr Hugh Fraser. Mr and Mrs Graham Duncan are on the right next to Mr D. Buttenshaw.

silver quaich. On this visit outline plans were laid for a first school exchange by six Haddington pupils in July of that year. Their stay was to be for two weeks, and they would return to Haddington with six Aubigny *écoliers*, was would stay in Haddington for two weeks.

It would seem that this first exchange did not come about as planned; perhaps the timescale was too tight. In any event, the return visit to Haddington by Maire Vannier and some thirty of his fellow-citizens continued the theme of proposed exchange visits. The French group included eighteen members of the 'famous Aubigny Accordion Band', who gave a concert in the Town House, followed by a slide show depicting Aubigny and the surrounding area. The Maire presented the town with large silver cup which Provost John B. Wood, in his reply, said would receive a place of honour in the Council Chamber.

During this visit the tricouleur flew over the Town House, and it has flown many times since. Virtually every visit has been a memorable event for the hosts. The thirtieth anniversary in 1995 brought *L'Atelier Choral d'Aubigny* to St Mary's with a concert, partly of Renaissance music. the choir made their entrance in

procession down the aisle, each singer richly costumed in period, to the accompaniment of stately music. The concert that followed was a delight, with a strong sense of authenticity, both in performance and appearance. So much so that when the choir took their places for the second half, dressed in ordinary attire for the more modern pieces in the programme, it seemed as if we had come back to earth after travelling in time to the court of Louis XII, in the first half of the sixteenth century.

The visits in the other direction have also been happy occasions. The *Comice Agricole*, which takes place every seven years in Aubigny, is a kind of agricultural show only more so; it is such a long interval between shows that each one releases a build-up of ideas, energy and enthusiasm, making every *Comice* special. Each one that has taken place over the period of the twinning has been memorable for those Haddingtonians able to make the trip.

In Aubigny the national holiday on 14 July, Bastille day, is used as an occasion around which to stage a Franco-Scottish festival. In 1995 the highlight was to be the Paris Pipe Band, but at the last minute it had to cancel. This posed a problem to the organisers: a celebration of Scotland without a pipe band? *Zut alors, impossible! SOS 'addington!* Pipe Major Leckie was traced to Scarborough, and within hours he had got together at least half of the band, enough to put on a show. Then it was the Shuttle to Heathrow for an onward flight to Paris, where they were met by a coach from Aubigny. During this flying visit they took part in a concert in the *Salle des Fêtes*, a parade through the town and, just to show their versatility, joined in a 'jam session' with a jazz band in a popular café. This all took place over a weekend and they were home again on the Monday.

School exchanges have been a regular feature of the twinning, developing language skills and the appreciation of cultural differences through the forming of friendships. The pupils are usually lodged with host families, giving them more of an insight into the way of life of another country than could ever be gained on an ordinary holiday.

'Go, Hart, unto the Lamp of Licht' (Wedderburn)

The Wedderburns' 'Lamp of Licht' was the Saviour, and Haddingtonians had found Him through their own Lamp of Lothian in the fourteenth century. After the successive sacrilegious destructions by the invader, they were left with only the ruins of the once

magnificent parish church. As we have seen, the Nave was re-roofed after the Reformation, and it continued to serve the community. Meanwhile, the rest, windowless and open to the skies, took on the patina of a romantic ruin. But, in the main, the walls still stood, and they were never allowed finally to crumble. Was there a sense that, one day, the whole church could be re-born?

That day was coming.

In 1967 the Lamp of Lothian Trust was set up 'to induce the growth of a whole (or healed) community'. This was to be achieved through the restoration of old buildings, valuable in their contribution to the character of the town, and to use them as bases for the encouragement of arts and crafts in the community.

Poldrate Mill and its associated cottages now form a most attractive group of living buildings, near the Tyne at the south end of Sidegate. They house a wide range of activities from keep-fit, dance and yoga to painting, weaving and photography, whilst the mill building is able to accommodate meetings, exhibitions or wedding receptions.

In Lodge Street, the home of Jane Welsh has been restored and furnished in the style of her day. During the summer, visitors can taste the style of an early nineteenth-century home, and view a large collection of pictures and reproductions of places and people associated with the Welsh and Carlyle families. The south-facing garden is also maintained by the Lamp in the style of the period, and is a pleasant place to linger.

Haddington House in Sidegate is the oldest detached house in the town. It dates from the seventeenth-century and is a fine example of the home of a wealthy Scottish laird or merchant of the day. Alexander Maitland, who built it, was a member of the powerful Lauderdale family. He served the town as a Burgess, Councillor and Bailie. The house is L-shaped with a turret at the junction of the two wings. The Lamp restored this handsome building, and used it as its administrative centre. It was also an elegant venue for meetings, receptions and art exhibitions. Recently the Lamp had reorganised itself and moved to the Poldrate complex allowing Haddington House to be let to East Lothian Council, which provides a valuable source of income. Unfortunately this denies the visitor the opportunity to view the interior, but the fine garden to the rear is open to the public. This has been laid out as an old Scottish garden by Haddington Garden Trust. It has a

sunken garden and a cottage-style garden. It also features a physic or herb garden, with each plant labelled, and its particular properties and functions detailed. At the eastern end there is a stretch of wild meadowland with an easily scaled mont, giving an overview of the garden.

All of this, achieved by the Lamp in a relatively short time, might be thought sufficient rebuilding and restoring for one charitable, and largely voluntary, organisation. Time now, perhaps, if not to sit back, at least to settle down to running the projects created to bring life to the re-born buildings. But the Chairman of the Trust, and moving spirit in all this, Elizabeth, Duchess of Hamilton, had an even more ambitious task in mind, nothing less than the restoration of St Mary's Collegiate Kirk – the gaping ruin had waited for over four centuries for the miracle which was about to happen.

The Reverend R. Nimmo Smith served over forty years as the minister of St Mary's, and it was his daughter, Hilda, who came forward in 1964 with the offer of £33,000 to replace the bells, looted by the English in 1549. Experts from the old Ministry of Works advised that the tower was no longer strong enough to support the weight, and the idea had to be abandoned. Miss Nimmo Smith very generously allowed her gift to remain with the church as the base on which to build a fund, for the restoration of the ruined transepts and choir.

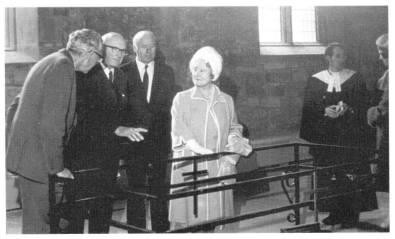

44. The Queen Mother visits St Mary's. Stewart McPhail is making a point about Carlyle's tribute to his wife, Jane. On the right are the Duchess of Hamilton and the minister, the Rev. J. Riach.

There now came together three interested groups, dedicated to making a reality of what had long been a dream. They were the Kirk Session, the Lamp of Lothian Trust and the Friends of St Mary's. The work of fund-raising went on until 1971, by which time sufficient had been raised, much of it by the Lamp under the vigorous leadership of the Duchess, to allow the Kirk Session to authorise a start to the work. The supervision of the rebuilding was placed in the hands of architects Ian Lindsay and Partners of Edinburgh.

The first task was to re-roof the choir, transepts and tower, and the north transept had to be built up. All the stonework of the great windows had to be replaced. The glass, handmade in England, was then set in the restored tracery. The work went so well that the great wall of 1560, separating the nave from the ruins, was removed after the first year's work. The church was whole again but not complete, and a huge plastic curtain replaced the wall until the work was finished.

One problem that had to be overcome in order to comply with official requirements was that the ceiling vaulting had to be in the original medieval style, but the walls were no longer strong enough to support stone. Modern technology in the form of fibreglass provided the answer. Moulded to the same design as the existing vaulting, and coloured to match, the new work cannot be distinguished from the old.

On 12 July, 1973 Queen Elizabeth and Prince Philip paid a visit to St Mary's, where they met the minister the Rev J. F. Riach, Elizabeth, Duchess of Hamilton, Chairman of the Lamp of Lothian Trust and the Very Rev Dr Neville Davidson, Chairman of the Friends of St Mary's. Among others presented on this important visit was Miss Hilda Nimmo Smith, whose generosity inspired the act of faith that reached, not a conclusion, but a new beginning when the work was completed some two years later.

Since then St Mary's had become special in the life of the community; it is an inspiring place of worship for its congregation, and a place of pilgrimage, most notably around Pentecost, for many thousands, of all denominations, who come together to worship in the same place, if not yet at the same table. Many will have journeyed from the kirk at Whitekirk near East Linton, the able on foot and assisting those less able.

The Lamp still takes a leading part in the life of the church, organising events within it. The acoustic of the restored building

has proved ideal for musicians and it has been the venue for a number of splendid concerts. The Duchess of Hamilton has been instrumental in bringing Yehudi Menuhin to St Mary's, and he has played there several times, before, during and after the restoration. Sir Yehudi's interest has led to his becoming Honorary President of the Lamp. He has brought pupils from his famous school to take part in the summer series of concerts, organised by the Lamp, which are now an enriching experience, and not only for locals, but for many who travel from much further afield.

The first Haddington Festival opened on Sunday, 2 June, 1968 with an open-air service on the East Haugh conducted by five ministers and with music supplied by the Leith Salvation Army Band. Other events during the week included a barbecue organised by the Round Table promising 'Spit Roasted Pigs and Charcoal Roasted Chickens' followed by folksinging compèred by Effie and Jimmy Bowman; then came Open Air Dancing, all for 7/6! The Bowmans were also to the fore in a production of Bridie's *Tobias and the Angel* at the Parish Church Hall, while James Bowman, wearing his artist's cap, mounted an exhibition in Laidlaw's tea rooms. Haddington Amateur Operatic Society presented *No No Nanette* produced by James Tinline, and the week's entertainment was given a foot-tapping start by the 'Jimmy Shand Show' in the Assembly Hall of the Knox Academy.

There was a bowls tournament, five-a-side senior football and a golf competition. A car rally took place in the High Street and a gymkhana in the grounds of Herdmanflat. There were children's sports in the Neilson Park and a raft race on the Tyne.

Some of the features of the first festival have become traditional, like the Fancy Dress Parade, but the theatrical ventures are no longer to the fore. No doubt the rise of television contributed to the loss of the drama and operatic societies, and while there is always a platform for good singers in the various choirs and choral societies which flourish still, those with a talent for the legitimate stage do not have the same opportunities. With the 'box' now no longer a novelty, there may be an opening for a revival of drama in Haddington.

A Royal Burgh

At the end of her visit to St Mary's on 12 July, 1973, the Queen went to the High Street to meet her Provost, Bailies, Councillors and officials of her Royal Burgh of Haddington, the then current

representatives of a body dating back to at least 1296, when 'Alisaundre le Barker', was recorded as 'provost of the burgh of Hadingtone'. Soon she was to sign the Act which would, at a stroke, wipe out centuries of Scottish local government. Sadly, Provost William Grant and his colleagues were to be the last to hold office in Haddington.

The Royal Commission on Local Government in Scotland under Lord Wheatley had been sitting since 1966. It reported in 1969 and the Act, much amended, received the Royal Assent in 1973. It was introduced on 16 May, 1975.

On that day there came into being nine regional councils which were subdivided into fifty-three district councils. The theory was to bring about efficiency by 'economies of scale'. That theory was early undermined when the three island groups successfully opted out of their region, to form three more or less all purpose authorities, in spite of an aggregate population of only 71,000. This was two thirds that of Paisley, which disappeared into Renfrew, a District of Strathclyde!

Locally, East Lothian narrowly escaped incorporation into a super Firth of Forth Region, but Fife, which was to form half of it, fought vigorously to preserve its identity and won. To make a large enough population, Musselburgh was detached from Midlothian, and given to East Lothian. It has been hinted that this gift was not unconnected with electoral votes but, whatever the reason, it has deprived Midlothian of its largest burgh and given East Lothian an unbalanced character, creating a densely populated western edge of the county, outnumbering the whole of the rest. In his book, *Portrait of the Lothians*, Nigel Tranter decided to continue treating Musselburgh as a Midlothian burgh and he was not alone: the Post Office still regards Musselburgh, Midlothian as the proper form of address.

The introduction of regionalisation had been achieved by a Government of one persuasion, but the merry-go-round of politics brought its inevitable change. The latest tenants of the corridors of power decided that at least one of the regions was 'monstrous' and so they would all have to go. Not that many tears were shed, but many were only just getting to grips with the division of responsibilities between region and district, and it was to be all-change again.

On 1 April, 1996 – I am sure the choice of day was in no way symbolic – the new councils came to power. The ancient Royal

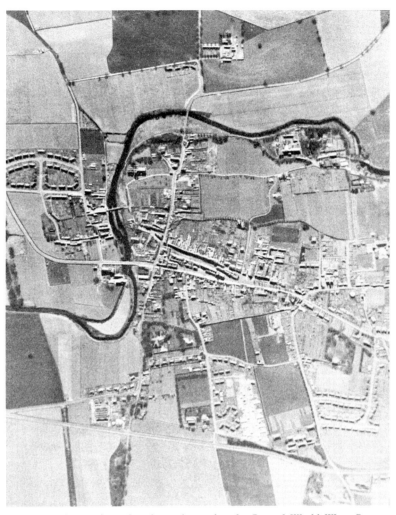

45. Haddington from the air not long after the Second World War. Some idea of the post war development of the town can be gained from the large areas of open space within the town, much of it now filled by housing. Davidson Terrace is in the bottom right but at only about a quarter of its eventual length. To the left is Herdmanflat Hospital and to the left again the Herdmanflatt pre-fabs are being built. On the left Artillery Park and Abbot's View are still agricultural land. While, near the top, Briery Bank is just beginning. In the town centre the bomb site in Market Street is clearly visible.

Burgh of Haddington is now Wards 13 and 14 of the 18-ward East
Lothian Council, although there is a suggestion of Haddington
being allowed an additional councillor. The 1975 Act did allow
for the setting up of Community Councils; these are elected bodies
which seem to have been more successful where they are aligned
with existing, well-defined communities, such as the former
burghs, as opposed to those in larger towns and cities. Hadding-
ton's council has its regular meetings which are usually attended
by the area councillors, for want of a better word, for the new
entity has not been granted the dignity of a county, shire or even
a district. This attendance is useful, keeping the area councillors
in touch with local thinking. Apart from being able to suggest and
advise, the community councillors have no powers and very little
responsibility, their only income being a small grant from the area
council to cover running expenses. In these circumstances it is not
surprising that sufficient candidates are not always forthcoming,
and co-options are more frequent than contested elections. This
is almost a reversion to the self-selected councils of long ago!

The population of Haddington is now in the region of 8,800,
approaching its Structure Plan optimum of 10,000. When its
population was around a quarter of that figure the burgh raised
taxes and customs, traded directly with the Continent and admin-
istered justice up to the extreme penalty. No one, I trust, would
want to bring the hanging hook on the Nungate Bridge into service
again, nor would it be equitable to restore the ancient privileges
of a royal burgh, but surely an entity such as Haddington should
be capable of taking responsibility for some aspects of the Burgh's
wellbeing. Subsidiarity is an 'in' word at the time of writing, and
there has been talk of further adjustments to local government,
talk even of directly elected provosts. If this implies a degree of
power returning to the burghs in the wake of some, not yet clearly
detailed, constitutional change, it is an implication democratically
to be wished!

In the meantime well over sixty organisations with Haddington
in their title are listed in the *Haddington Handbook* and the ancient
Burgh designation is preserved in the rather lengthy title of the
'Royal Burgh of Haddington and District Community Council'.
All is not lost, and Haddington is still, to all intents and purposes,
what it always has been, the County Town. The ancient privileges
of holding markets and fairs are no longer relevant, but the Burgh,
with its central position, both geographically and administratively,

should be a focus for the County. To do this it should be able to offer a central museum and an art gallery. The artefacts and art works to form the core of such institutions are already in the possession of the Council, and it is time they were seen by the citizens who, *de facto* and *de jure*, are the owners. Anyone interested in art can already get an insight into both modern and traditional styles, as there are two galleries at the Sands which frequently feature contemporary works, and a gallery behind the bookshop in Market Street displays mostly Scottish works of the last hundred or so years.

When the English relinquished their hold on Haddington in 1549, they took the kirk bells with them. From that time the town bells have performed the duty of calling the faithful to worship. As the decades have passed, the other timely announcements made by the town drummer and piper, the bellman and coal and candle, have come together to be sounded by 'the bells'. From the Town House they sound the new day at 7.00 am every day, no long lie on Sundays, and its knell at 10 pm. The town is still compact enough for them to be heard in most parts. And there are those, exiled from the town of their birth, who claim to hear them sounding far over land and sea, perhaps not on the air, but in their hearts.

❦ 2 ❧

Street Names of Haddington

DAVID DICK OBE

The street names of any town give many clues to its history, its people and its customs. Haddington is no exception; in fact there is a wealth of history, some fascinating fables and many interesting characters of the past, both ancient and modern, in this Royal Burgh. The following does not purport to be a definitive, or complete, list of derivations of street names; merely a selection of some of the more interesting.

Abbots View, parallel to Dunbar Road, takes it name from the ecclesiastical history of the area which was well endowed with churches, chapels and monasteries from the twelfth century – the Franciscan Friary ('Lamp of Lothian'), the old St Mary's Church granted by David I in 1134 to the priory of St Andrews and the Cistercian Abbey of St Mary, east of the town. The houses of Abbots View were built in 1964–65.

Aberlady Road, the continuation of Hope Park, was named from the fact that this was the road used in the fifteenth century to Aberlady, its main overseas trading port. For example, Haddington exported goods valued £220 whilst Edinburgh exported goods valued £418 in the year 1441.

Acredales, off Pencaitland Road, takes its name from the farm of that name shown on the 1906 Plan of Haddington south-west of Rosehall and bounded by Pencaitland Road. The houses of Acredales were built in the 1980s.

Alderston Road, between West Road and Haldane Avenue, is named after the Lairds of Alderston, the earliest of whom was probably Thomas Hay (1602–54). A later laird, with the Earl of Haddington and Lord Elibank, was required, in 1659, to keep the 40-foot roadway in good condition – this was an inalienable right of the town. Alderston House was built in 1790 by Robert Steuart. His son, Robert, was the first MP for East Lothian in the Reformed Parliamentary election of 1832, defeating Sir Adolphus Dalrymple. He became Lord of the Treasury and was

re-elected MP until 1841. He died in Bogota on 15 July 1843 where he was Consul-General. The Alderston tomb in St Mary's Churchyard is in memory of Robert Steuart Esq of Alderston (1765–1823) and his second wife Louisa Clementina Steuart (1771–1823) who died six days after her husband. Other lairds included James Aitchison (1837) and the 2nd Baron Denman who married Aitchison's eldest daughter Marion in 1871. The last laird was William Cossar Mackenzie DSc, PhD. He died after a fall from the roof of Alderston; his wife and family continued to live there until 1919.

Alexandra Place, off Newton Port, was St John's Free Church and was converted into flats in 1926. It was named shortly after the death of Queen Alexandra, wife of Edward VII. Born in 1844, she was daughter of King Christian IX of Denmark. Her marriage took place in 1863, and she tolerated her husband's numerous love affairs with dignity. Her charitable works were numerous and her special interest was the nursing service.

Amisfield Park was part of the estate of the Earl of Wemyss and March, as shown on the 1819 Plan of Haddington and Nungate. This land was owned by the Cistercian Nunnery in the twelfth century. It was used by the New Mills in 1681 when Colonel Stanfield was a partner. He was elected MP for East Lothian and knighted for his services to industry. He was murdered by his spendthrift son. The land was purchased by Colonel Charteris of Amisfield in Dumfriesshire. He named the land after the estate at Amisfield. Francis Charteris Wemyss, 7th Earl (*de jure*) of Wemyss, built Amisfield House in 1755. The land was used by the military during the Jacobite rebellion of 1745, again during the Napoleonic War (1793–1815) when invasion by the French was thought to be imminent, and during the Great War of 1914–18. Amisfield House was demolished in 1923. The land was sold to Haddington Town Council in 1960 for £49,000 and 159 houses and 100 garages were built on Amisfield Mains.

Artillery Park, originally part of Amisfield Mains, was named from the fact that artillerymen were billeted there in 34 huts because of the threat of invasion during the Napoleonic War of 1793–1815. Artillery Park is now a small section of Hardgate at the sunken gardens and was known locally as Spoutwell Brae.

Aubigny Centre is the sports centre and swimming pool at Mill Wynd named after the twin town of Haddington – Aubigny-sur-Nère, about 180 km south of Paris.

Ba' Alley, between St Mary's Church and the Tyne, was named from the fact that on each Shrove Tuesday from about 1799 a game of football was played between masters and pupils of the Grammar School. The money for Ba' Alley was raised in Haddington; it was intended for the construction of a bridge at East Saltoun where severe flooding had occurred during the seventeenth century. However, two years of drought meant the money was not used and was spent in making the first bowling green in Scotland at Ba' Alley.

Baird Terrace, off Aberlady road, is named after Lady Hersey Baird of Lennoxlove, well-known for her work for the Red Cross and her membership of the County Council. She was the wife of Major William Baird of Lennoxlove. He was responsible for the major restoration of Lennoxlove by Sir Robert Lorimer. Their son, Robert Baird, sold the estate to the 14th Duke of Hamilton in 1946.

Bearford Place, off Seggarsdean Crescent, is named from East and West Bearford farms owned by John Hepburn of Bearford (1770–1823), a distinguished student of Edinburgh University who admired the ideals of the Revolutionaries in France. His farming methods were a model but he died in poverty, a victim of scroungers.

Briery Bank, a delightful park and green area by Waterloo Bridge, is shown as 'Brierybauk' on the 1819 Plan of Haddington and Nungate. The first houses were built under the 1921 Housing Act in 1925 and the houses on the skyline were built in 1947. It was probably named from the briers which grew on its embankment.

Britannia Wynd was renamed in 1981 after the Britannia Hotel (1850) which was adjacent to the Wynd. The Britannia Hotel became the Commercial Hotel and the Wynd was then named Commercial Lane. The Mercat Hotel opposite the Mercat Cross was the old Commercial Hotel.

Broad Wynd. Variously known as Wheat and Pease Market in 1800, then Market Lane which became Mark Lane. However, before that it was called Pirie's Lane which took its name from the large house on its west side known as Pirie's Building. It became the Heather Inn, described by Gray and Jamieson as 'a rather tumble-down building reached by an outside stair'. On the immediate east side of Broad Wynd the shop which is now a baker's was a famous wigmaker's, famed for its exceptional quality.

Brown Street. Named after a shopkeeper of that name in the lane. It was previously called Strumpet Lane, then George Inn Wynd off which was Burley's Walls (Or Birlie's Wa's).

Bullet Loan, at the end of St Martin's Gate, takes its name from the powder store nearby. It was used during the period when Amisfield was used as a camp for the artillery during the Napoleonic War of 1793.

Burley's Wa's. There are two schools of thought relating to the derivation: (i) Burley or Burleigh was a Yorkshire well-digger who was contracted to sink a well or 'wall' in 1660; (ii) Burley was a local drunk who was teased by small boys who took a delight in 'Birlin' him round until he steadied himself against 'Burley's Wall'.

The Butts. Named from the old archery butts which existed in the sixteenth century. Archery was certainly practised in 1563 at the 'bow buttis' at the Sands. Another school of thought suggests that the name is simply an abbreviation of buttress; a section of the heavily buttressed Town Wall, built between 1597 and the early 1600s as a defence against lawless intruders and the plague, was nearby.

Calder's Lawn, off Newton Port leading to the short- and long-stay car park, was named in 1992 after the Calder family who owned the ground and who were residents of the former manse nearby for over 100 years. The Calder boys, Jim and Finlay, were renowned as international rugby players.

Carlyle Court, off High Street, was named after Thomas Carlyle, the 'Sage of Chelsea'. He married Jane Welsh, daughter of Dr Welsh whose house is now the Jane Welsh Museum. Carlyle Court is entered through a stone arch and leads to the Butts. Next to the archway was the Blue Bell Inn which was a coaching station from the mid-1700s when it was called the White Hart, the name being changed in 1764 by its new owner, James Fairbairn. It is shown on the 1819 Plan as the Bell Inn, by which name it had pretensions to the grand style and was popular with travellers from England. The stables of the inn vied with the other coaching inn, The George (now the George Hotel), for their speed in changing a team of horses.

Church Street takes its name from the existence of the Franciscan Monastery on the site of Holy Trinity Church. It was known as *Lucerna Laudoniae* or the Lamp of Lothian.

Clerkington Road and **Walk**, off Pencaitland Road. The name

Clerkington appears in an ancient charter in the cartulary of the Priory of St Andrews 'that the parish church of Haddington, and most of the teinds of the parish belonged to that priory ... Carta Ricardi Episcopi (St And.) de Ecclessia de Hadintun, cum terra de Clerchetune (Clerkington) Richard, Chaplain to Malcolm IV elected in 1163'.

Court Street, according to the 1819 Plan, was part of High Street but it was named King Street during the reign of George III (1760–1820). Its name was changed to Court Street in 1833 when the foundation stone of the new Court House was laid.

Craig Avenue, between Artillery Park and Traprain Terrace, is named after Provost Hugh Craig (1887–1967) who farmed Harperdean and was Provost of Haddington in 1959 during the visit of Queen Elizabeth.

Cross Lane, off High Street, is immediately opposite the Mercat Cross in the High Street. The first cross is thought to have been erected in the reign of David I (1124–1153); a pre-Reformation cross existed in 1693 after which a stone cross was made by stonemason John Jack for the sum of 'fortie pund Scots'; it survived until 1811 when it collapsed under the strain of a prankster climbing it. Its base was discovered underground opposite Cross Lane (then Fishmarket Close) in 1926 and its height was twelve feet, with a unicorn on top. In 1811 Messrs. D. & J. Bernard erected the next cross with a goat on top; it was smashed in the same manner as its predecessor. The goat was replaced in 1936. On its east side is the lion rampant of Scotland; on its west side is the figure of the goat; on the north side is the crest of the donor of the cross and the figure of a muzzled bear.

Davidson Terrace. Between Hospital Road and Aberlady Road on the 'property of Robert Vetch' (1819 Plan). Old Davidson Terrace was built in 1938 and the new section in the 1950s. It is named after Provost William Davidson, born in 1863 at Hawick. He lived near the Maltings and worked at Paterson's Tweed Mill for 62 years as a handloom woollen pattern weaver. He was a 'lad o' pairts', self-educated, his special interest being the French Revolution. He was elected to the Town Council in 1925 and was Convener of the Housing Committee. He was elected a Bailie in 1930 and Provost in 1932 to represent the Royal Burgh at the coronation of George VI in 1937. A hut in Neilson's Park is named after him and a plaque bearing his

name was affixed to the wall of the former Vert Memorial Hospital. He died on 16 August 1938.

Dobson's Place, View were named after a local landowner. **Dobson's Well**, or Dobie's Well, as it was known, was famed for its chalybeate or 'iron water' and its iron cup. **Chalybeate**, off Long Cram, takes its name from the iron waters of the well. Sadly its water supply was cut off in the '60s when drains were being laid for the newly built houses at Burnside. Wellside, off Pencaitland Road, was named after the well.

Dunollie Gardens, off St Martin's Gate, takes its name from the market garden of that name which was owned by the Mac-Dougall family. Dunollie Castle is a MacDougall stronghold in Argyll.

Dunpender Drive and **Traprain Terrace**. Dunpender is the old Celtic name for Traprain Law. Both names are old – Traprain first appears as Treprenne in 1370. The most famous fable of Traprain relates to King Loth, from whom Lothian may take its name. His palace was on top of the hill. He ordered his daughter Princess Thanea (or Thenew) to marry Prince Owen from Galloway. She refused and her father banished her to the Lammermuir Hills. The spurned Prince found her and raped her, and on discovering her pregnancy her father order her to be stoned to death. No-one would lift a stone. He then ordered that she be tied to a sled and thrown from the top of Traprain Law. The sled caught on a protruding branch and she was now placed in a coracle in the River Forth. She was washed ashore at Culross where she bore a baby boy, Kentigern, who founded Glasgow as St Mungo. Traprain is also known for the fable of the fairies who were said to dance at the foot of the hill; a bright light which shone around them was said to be a reflection of a huge diamond but they disappeared immediately on the appearance of any curious person. A horde of silver plate was found in the vicinity and was thought to have been hidden by pirates (see page 174). Fragments of Iron Age pots and dishes were discovered during a heath fire on the Law in August 1996.

Edward Court, off Hospital Road, was named in 1990 after the developer Mr Edward Anderson.

Fortune Avenue, off Newton Port, is named after Robert Leslie Fortune (1896–1977) who was Provost of Haddington from 1947 to 1956. He gave 35 years of service on the Town Council. He

was made a Freeman of Haddington in 1964 and was presented with a silver casket.

Gateside Avenue and **Road** were named in 1992 after Gateside Farm.

Gifford Road is shown on the 1819 Plan as the 'Road to Gifford'. Giffordgate takes its name from the ancient Norman family of Giffard of Yester who owned the lands of Giffordgate. Hugh de Giffard (original spelling) built Yester Castle with the mysterious Goblin Hall.

Goatfield owes its name to the fact that goats were herded there several centuries ago. Goats must have been a common sight because the goat is incorporated in the coat-of-arms of Haddington.

Gourlaybank, built in 1958 on the 'property of the late David Gourlay', is adjacent to Dunbar Road. David Gourlay bequeathed £1,290 and the rent of the field at Gourlay Bank in aid of the industrious poor of Haddington. He was an eccentric who owned a distillery and kept many cats. He enjoyed giving parties at his house to observe his inebriated guests.

Gowl Close is a small lane which runs down to the Tyne at Victoria Bridge; its name means 'Windy' Close, although a 'gow' is the Scots word for a narrow pass, usually between two hills. The 4th Earl of Bothwell is reported to have made his escape down 'a lane called the Gowl' to the Tyne in 1559. He had ambushed Cockburn of Ormiston near Traprain Law and relieved him of £3,000 – money intended for the Lords of Congregation in their campaign against Mary Queen of Scots. The Earl of Arran and Lord James Stuart (who became the 'Good Regent') sought retribution and arrived in Haddington, with 200 horsemen and as many foot soldiers, to capture Bothwell who had taken refuge in Bothwell Castle, a house nearby which belonged to Cockburn of Sandybed. For this protection given to Bothwell, Cockburn was given 'a perpetual ground annual out of the lands of Mainshill' which is at Morham.

Haldane Avenue is a section of the A199 (former A1) between Alderston Road and Aberlady Road; its houses were built by Richard Baillie in the 1930s and it was named after Richard Burdon, 1st Viscount Haldane (1856–1928), the Liberal statesman, philosopher and lawyer who became MP for East Lothian in 1884 for 25 years. He was Secretary of State for War (1905–12), Lord Chancellor 1912–15) and Minister of Labour (1925).

Hardgate. The name appears in the 'Auld Register of Haddington' dated 1423; it was originally called Herdgate at the east end of Market Street. Hardgate was a narrow street of workmen's cottages on the east side of which were the ruins of Bothwell Castle (Sandybed House). There was a proposal to widen Hardgate in August 1770 but widening did not take place until 1950 when the ruins of the castle were replaced by the sunken garden and the cottages nearby were removed.

Hepburn Road, linking Princess Mary Road to Fortune Avenue, is named after John Hepburn of Bearford (1770–1823), a farmer at Easter and Wester Bearford and Monkrigg and writer of 'republican' articles who died in poverty, the victim of scroungers.

High Street is shown on the 1819 Plan of Haddington and Nungate stretching from Station Road at West Port Toll (where the Ferguson monument now stands) to Sidegate. About 1854 some renaming of streets took place and High Street was halved in length with Court Street and Market Street being introduced. In the eighteenth century High Street was known as Crocegait, which became Crossgate in which the Cross of Haddington was situated. The High Street of Haddington was the first in Scotland, in 1962, to have a coordinated painting scheme for its shops.

Hope Park, Hope Park Crescent, Hopetoun Drive, Mews, Hopetoun Monument are named after Sir John Hope, 4th Earl of Hopetoun (1765–1823), hero of the Peninsular War (1808–1814), especially at the Battle of Corunna (1808) where he took command when General Sir John Moore was killed and Sir David Baird of Newbyth was severely injured. Hope's successful and safe evacuation of his men earned him a knighthood from George III. He was a governor of the Royal Bank of Scotland. His monument on Byres Hill was erected by the tenantry in 1824.

John Brown Court, off the north side of Market Street, was named in 1989 to commemorate the scholarly minister of the Burgher Church, the Rev John Brown DD. The plaque on the manse wall in inscribed: 'John Brown DD lived in this house for 30 years and here wrote his 'Self-Interpreting Bible'. He died here in 1787 and was buried in Haddington. Original manuscripts of his works can be seen in the public library Newton Port.

King's Meadow Primary School, built in 1970 and recently burned by vandals, is named after Alexander II who was born in Haddington in 1198. His father, William the Lion, had built a palace in what is now called Court Street, and Alexander II spent most of his youth in Haddington. As King he formed alliances with the English nobility against the untrustworthy and excommunicated King John (r.1199–1216) who wrought vengeance by attacking and sacking the Lothians and Haddington in 1216. In 1833 various buildings on the site proposed for the County Buildings were demolished. Some pieces of masonry were found and identified as the remains of the old Palace of William the Lion.

Kilpair Street, linking Market Street to Brown Street, is mentioned as 'Calepery' in 'The Auld Register' of 1426 (Gray and Jamieson).

Knox Academy, Court, Place. The Knox Institute was opened in 1879 to commemorate the great Scottish Reformer John Knox who attended the Grammar School of Haddington and then University of Glasgow from 1521 to 1522, which places his date of birth about 1505, said to have taken place in Haddington in a house sited on the spot at Giffordgate where Thomas Carlyle requested that a tree be planted to commemorate the event. However, Morham is considered by some to have been his birthplace. The Knox Institute at Knox Place was eventually converted into flats, having been superseded by the more modern primary and secondary schools. John Knox was subjected to an assassination attempt by Cardinal Beaton. He was enslaved by the French and released on the plea of Edward VI but he had to flee from the vindictiveness of 'Bloody' Mary I. He translated the Geneva Bible and led Scotland into the Reformed Church. He died in 1572 aged sixty-seven and was thus described by Regent Morton during a tearful eulogium: 'Here lies one who never feared the face of man'. His statue by D. W. Stevenson stands in a niche in the central tower of Knox Court.

Lady Kitty's Doocot is opposite the southern end of the Nungate Bridge and dates from 1771. It is a castellated Gothic structure and takes its name from Lady Catherine Charteris Wemyss, or Lady Elcho, the wife of the *de jure* 7th Earl of Wemyss. She was the sixth daughter of the 2nd Duke of Gordon and was born in 1720. She died at Gosford House aged 66 years in 1786.

Lammermuir Terrace, named from the hills it faces, was

previously called Sprotlands Crescent which took its name from nearby Sprotlands Farm. The name was changed in 1970 when the houses were modernised.

Lennox Road was named after Charles Stewart the Duke of Richmond and Lennox (1639–73), whose third wife was Francis Teresa Stewart, 'La Belle Stewart'. She was Maid of Honour to Queen Catherine of Braganza in the court of Charles II, who did his best to seduce her, but she eloped with the Duke of Lennox. She bought the lands and property of Lethington as a gift for her nephew, the Master of Blantyre, with the provision that its name be changed to Lennoxlove in memory of her beloved husband who died thirty years before. This street was previously called Amisfield Road. Its name was changed in 1955 when the Town Council built six five-apartment houses.

Lennox Milne Court, named in 1984, commemorates the well-loved actress Lennox Milne McLaren OBE, MA, LRAM, ELOC (1909–80), the first Organiser of the Lamp of Lothian Collegiate Trust. She lived at Pegh-de-Loan with her eminent author-husband Moray McLaren, the first Programme Director of BBC Scotland.

Lodge Street, originally called 'Yarmouth Roads', was named from the Masonic Lodge – said to be the first in Scotland – St John's Kilwinning in 1599. Nearby is the home of Jane Welsh, now a museum cared for by the Lamp of Lothian.

Long Cram is a small section of the Tyne, west of Stevenson Bridge, after which Long Cram, off Pencaitland Road, is named.

Lydgait, shown as 'Lead Lau' on the 1819 Plan, lies between Newton Port and Aberlady Road and is said to have been named after the fact that lead was transported along this road to Longniddry. A more probable derivation comes from the old Scots word 'lyd' meaning calm or sheltered – Lydgait being simply a sheltered walk.

Lynn Lea Avenue. Named after the cottage called Lynn Lea.

M'Call's Park, on which the Old Knox Institute was built (now Knox Court), is named after Alexander M'Call who was Provost of Haddington from 1723 to 1728. He was Postmaster of Haddington when the Post Office was in Sidegate (until 1817). He was succeeded by John Martine in 1781.

Market Street was originally called Tolbooth Gate, then Fishmarket Street which was shortened to Market Street. A Saturday market was sanctioned by James V about 1530. It was a cul-de-

sac until 1800 when it was opened to the Hardgate. It is shown as 'Back Street' on the 1819 Plan.

Mill Wynd, off Sidegate at the Maitlandfield Hotel, takes its name from the fact that it leads to West Mills, shown as a Flour Mill on the 1819 Plan.

Mitchell's Close, off Market Street, was called Sweeney's Close in the 1920s and was restored in 1967. It was occupied by merchants and craftsmen from medieval times. Their houses had narrow strips of land (tofts) so that the houses had their gable-ends facing the street. Mitchell was probably a prosperous eighteenth-century merchant.

Monkmains Road runs parallel with Gifford Road opposite Briery Bank and was named after the two cottages at Mitchell Hall on the old Gifford Road.

Monkrigg Place and **Road** takes its name from Monkrigg Farm two miles south-east of Haddington.

Neilson Park appears on the 1973 Plan of Haddington – named after George Neilson, a rich draper who had a shop adjacent to Neilson's Wynd off High Street.

Newton Port takes its name from the port or gatehouse at the north-eastern end of the town and provided entry across Hardgate. After the erection of the Town Wall in 1597 this port was resited in the vicinity of St John's Free Church at Alexandra Place. This was 'Newtown Port', as it was then known, and the port was removed about 1763.

Nungate Bridge. This three-arched (extra arches were added to reduce the slope on each side), 100-foot bridge is first mentioned in a deed dated c.1282. Further mentions are made of its repair in 1293, 1311 and 1356. It was severely damaged during the Siege of Haddington in 1548. Further repairs were made in 1672 and its 'jougs' (iron collars for criminals) were removed and replaced by a stone tablet inscribed with the arms of the town. There are nineteen masons' marks on stones, indicating that stone from the ruined section of St Mary's Church was used in its repair.

Paterson Place, off Lodge Street, is thought to be named after Sir William Paterson of Granton, who was described as a figurehead rather than a Provost of Haddington. Another source states that this street is named after Adam Paterson, owner of the Tweed Mill; Paterson came from Hawick in the 1800s. A more likely derivation is from Paterson's Academy, which the Rev. John Paterson ran from 1831 until 1854. It became Walter

Haig's Academy in Paterson Place and was closed when the Knox Institute opened in 1879. The site was sold and is now Abbeyfield Retirement Homes.

Peachdales, off Station Road, was known locally as 'Pechty Brae' (the verb 'to pech' meaning to pant or gasp; on the other hand the word 'pecht' could simply mean small). The 1819 Plan of Haddington and Nungate shows 'Pechty Loan', and in this vicinity there was a market garden owned by the Watt family. The name Peachdales is doubtless derived from peach trees in the vicinity, the French word for peach being *pêche*.

Peffers Place, off Lodge Street, was probably named after a property owner in the vicinity. At the end of the street was Paterson's Sawmill, the timber yard of which is now the site of King's Meadow Primary School.

Pegh-de-Loan is the area behind the Ferguson Monument where the old gasworks was sited. Its name is thought to be derived from the word Pechts or Picts (Martine); it could equally be derived from the Scots word 'pech' or 'pecht', meaning to pant or puff, to gasp for breath.

Poldrate and **Poldrate Mill** (or East Mill) may take their names from the French *poudre droite*, a powder store during the Siege of Haddington of 1548, but the name Poldrate is mentioned in the 'Auld Register of Haddington' of 1423. Any derivation from the French is therefore unlikely. Eighteenth-century Poldrate Mill was built on the site of the old medieval Kirk Mill. It was reconstructed in 1843 but fell out of use with the advent of modern machinery and lay derelict until its major restoration by the Lamp of Lothian Trust in 1968. A more likely derivation may be from the Scots word 'polder' meaning powder – corn being ground to powder in the medieval mill.

Princess Mary Road, off Lydgait, was named after Princess Victoria Alexandra Alice Mary, the Princess Royal and Countess of Harewood (1897–1965), the only daughter of King George V and Queen Mary. She was Colonel-in-Chief of Haddington's famous regiment, the Royal Scots. She opened the newly restored Haddington Town House in 1956.

Priory Walk, which faces St Martin's Nunnery or Priory from which it was named, was previously called Balfour Street (after the 1st Earl of Balfour (1848–1930)), Prime Minister from 1902 to 1906) but was renamed in 1970 when the houses were modernised.

Queen's Avenue, off Hospital Road, runs parallel to Haldane Avenue and was named to commemorate the Coronation of Queen Elizabeth in 1953. The houses were built shortly afterwards.

Rosehall and **Rosehall Court** take their name from the toll and foundry sited on the Pencaitland Road.

Ross's Close, off the south side of the High Street, was restored during the 1960s; it is named after Tommy Ross (1860–1937), a well-known and cheery plumber. He was elected a Town Councillor in 1903 and Provost in 1918. He retired in 1923 after 20 years' council service.

The Sands, at the end of Church Street leading to the Nungate Bridge, was the site of the first bowling green in Scotland which was in use until 1962. The Fire Station, now Peter Potter's Gallery, accommodated the Burgh Surveyor, Sanitary Inspector and Firemaster, Mr Lee Hogg, a fine, imposing figure of a man who held all three appointments simultaneously. He died in 1992 aged ninety-seven years. The Sands was the site of a battle between the occupying forces and the French army during the Siege of Haddington of 1548.

Seggarsdean Court, Crescent, Park, Place and **Road** are named after Seggarsdean Farm which is about one mile south of Amisfield.

Sidegate is referred to as 'Sydgate' in the 'Auld Register of Haddington' of 1423.

St Anne's Place is a picturesque little street off Sidegate where Patrick Hardie had his seminary and taught Haddington-born Samuel Smiles (1812–1904), social reformer and author of *Self Help*. The street takes its name from one of eight chantry chapels of St Mary's, the mother church. The tenement of St Ann's chapel was demolished in 1813 to provide open space. The houses of **St Anne's Place** were remodelled in 1955 with a relief panel of the Haddington goat above the arch. St Ann was the maternal grandmother of Jesus.

St John's Street was named from the Knights Templar of St John who had a tenement near the Custom Stone at the corner of Sidegate and High Street.

St Lawrence, off Alderston Road, takes its name from the leper hospital, shown on the 1892 Plan as 'Leper House'. It was endowed by James V (1513–1542) and dedicated to St Laurence (an adaptation of St Lazarus). It was founded by Richard

Guthrie, the Abbot of St Thomas the Martyr's monastery of Arbroath and its preceptor was Walter Ramsay, a Royal Chaplain. In 1533 it was incorporated in the monastery of St Katherine of Sciennes in Edinburgh. According to the Exchequer Rolls of 23 July 1530, the Franciscans of Haddington augmented the revenues of the hospital by twenty shillings. In 1563 the nuns of St Katherine of Sciennes sold the land to Sir John Bellenden of Auchenoule, and his heir, Sir Lewis Bellenden, conveyed it in 1588 to Sir Thomas Craig, the Scottish writer and foremost expert on Feudal Law. Its location is explained by the fact that leper colonies had to be at least one mile outside the town walls. The house was demolished in 1906 and when the cottages on the site were built, the excavation for their foundations revealed several thousand skeletons of sufferers who had died there. The leper colony, in the centre of which was the hospital of St Laurence, owned 82 acres which included Spittalrig.

St Martin's Nunnery, Court, Gate. The houses were built on Priory ground in 1978. St Martin's Gate was originally called East End Gate, and its houses were built in the 1800s. St Martin's Kirk, now a ruin, was founded by Princess Ada, daughter-in-law of David I and mother of William the Lion. It was a priory of Cistercian nuns before 1178. After the Reformation in 1560 it was used by Presbyterians for over 100 years. In 1822 the site was proposed for a school, and in 1832 those who died of cholera were buried there. It takes its name from St Martin of Tours (315–397) who was the first saint who was not a martyr. He was a soldier who shared his cloak with a beggar. He was elected Bishop of Tours in 271.

Somnerfield Crescent, off West Road, is named after the Somner family who owned land immediately west of the old railway station. In 1816 Elizabeth Boyd sold 17 acres of St Laurence House to Richard Somner who named the area Somnerfield. Somner Mains appears on the 1854 Plan of Haddington and was demolished to make way for the houses of West Road. Somnerfield Works is shown on the 1892 Plan. Dr Richard Somner was principal surgeon in Haddington whose dispensary was in Fishmarket Wynd (now Cross Lane). He was Provost of Haddington in 1789 and 1793; he resigned his office, never having attended a Council meeting. His son George Somner Esquire, laird of Hopes, was also a surgeon. He was buried at

Old Calton Burying Ground in Edinburgh; he died in 1815 aged fifty-five. Witch burning took place during the seventeenth century in the vicinity of Somnerfield.

Starchmill flats were named in 1991 after the Old Starch Mill at Ford Road.

Stevenson Bridge is a footbridge at West Haugh and is named after David Stevenson who was Provost three times from 1855. He was the proprietor of the George Hotel and an active member of the Volunteer movement from its formation in 1859. His son George H. Stevenson became County Sheriff Clerk and Town Clerk; his grandson also became Town Clerk of Haddington.

Tenterfield at Hardgate was probably named from the tenters which were used by dyers for drying their yarn. Dyeworks were situated in Hardgate adjacent to the King's Arms Tavern, now the Red Cross shop (the old building having been demolished). The Burgh records of May 1897 show 'Tenterfield and garden extending to five and a half acres'. It was the home of the Donaldson family until 1903; the Misses Donaldson entertained Jane Welsh Carlyle there.

Traprain Terrace. See Dunpender Drive.

Vert Memorial Hospital was built from the red sandstone of the demolished Amisfield House and was named after its benefactor John Vert who amassed a fortune in America. He gifted £10,000 towards the building of the Cottage Hospital for Haddington, the town of his birth (1852); he died in America in 1934. His father was Provost of Haddington from 1866 to 1869 and was given the Freedom of the Burgh for his successful campaign to remove the toll roads.

Vetch Park, off Victoria Park, is named after the Vetch family who owned land in the vicinity and between Aberlady Road and Station Road. Two sons, George and James, achieved military distinction. George Vetch attained the rank of Lieutenant-Colonel in India and championed the Rifle Volunteer Movement in Haddington in 1859. James Vetch served under Sir John Moore during the Peninsular War (1808–14) and was a military engineer of distinction. He carried out the first surveys of Orkney and Shetland and the Western Isles. He designed the drainage systems for Windsor Castle and Southwark. He owned land in the vicinity of Vetch Park as well as Hawthornbank which became Caponflat House.

Victoria Bridge was opened in 1900 and named to honour Queen

Victoria. Its cost was shared between the Town Council and the Montgomeries who owned the Bermaline Mill. It gave direct access to Market Street across the Tyne and made the old Gimmer's Mill wooden footbridge redundant; this was demolished shortly after.

Waterloo Bridge was opened in 1871 by the Marquis of Tweeddale on the anniversary of the Battle of Waterloo (18 June 1815). The new bridge gave access to Gifford over the Tyne.

Wemyss Place is a small cul-de-sac off Victoria Road. It is probably named after Francis Wemyss Charteris Douglas, 8th (or 10th) Earl of Wemyss, born in 1818 in Edinburgh. He strongly promoted the Rifle Volunteers from 1859 and gave Haddington its first water supply in 1874; the Town Council paid £5,000 for the reservoir on Wemyss land. He was MP for East Lothian in 1847.

West Road was named from the simple fact that it lies west of the town. Its prestigious houses, with those of Letham Drive, contain in their title deeds a clause of 'Servitude of View', which was included in 1925 in order to preserve the magnificent view to the Lammermuir Hills. No development may take place between West Road and Pencaitland Road.

Whittinghame Drive, previously Park Road (renamed in 1970), is named after the Nunnery at Whittingehame where Princess Thenew, daughter of King Loth, was said to have taken refuge during her banishment to the Lammermuir Hills.

Wilson's Close, off Market Street, gives pedestrian access to car parks and supermarket via the Labour Club and was named after a local grain merchant who owned several buildings in the Close from 1853 previously owned successively by a minister, a millwright, a spirit-dealer and a wigmaker. The two-storey tenement and the stables were sold to the Haddington Co-operative Society in 1884. The buildings were demolished except for the frontage when the supermarket was built.

Yester Place was named after Yester Castle, the seat of the Gifford family, who owned Giffordgate.

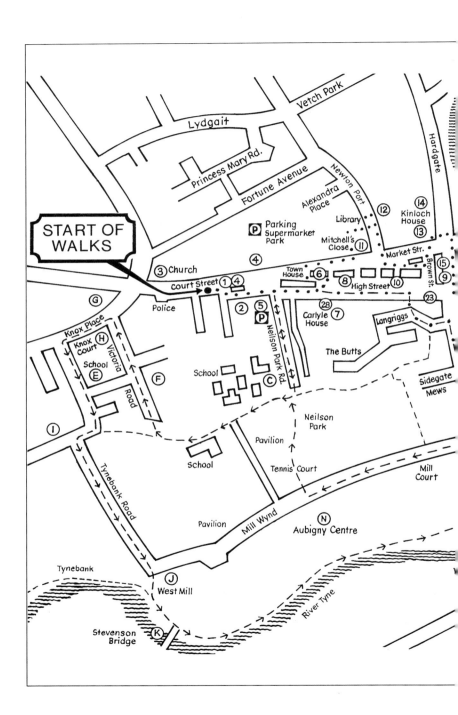

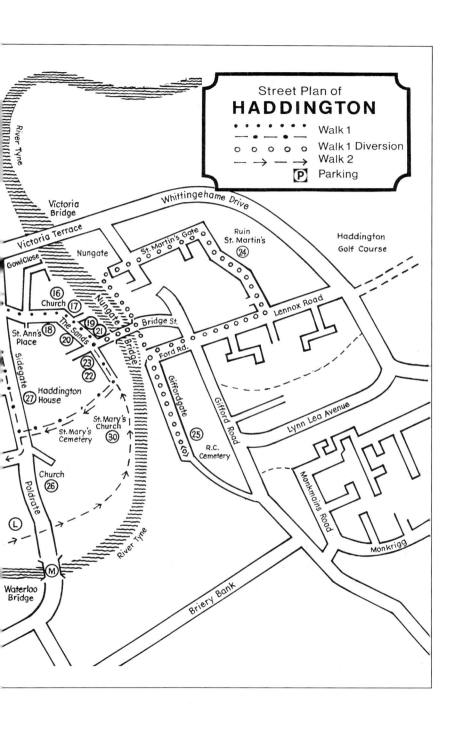

The Tweeddale Monument, flanked by the cannon which stood there for most of this century. (Courtesy Mrs Frank Burnet)

The Bank of Scotland.

Landmarks of Haddington

(References are to Map 1)

Photographs courtesy of George Angus

(1) County Buildings, former site of the Royal Palace where Alexander II, son of William the Lion, was born in 1198.

(2) Tweeddale Monument, erected in 1833 to the 8th Marquis of Tweeddale. Vandalised in 1996, but since restored.

(4) The Bank of Scotland and the Royal Bank of Scotland occupy eighteenth- and nineteenth-century mansions built by wealthy merchants outside the town. Note the urns and sphinx.

(5) Corn Exchange, 1854. Farmers met here weekly and Haddington markets were the greatest for grain. Troops were quartered here in 1914–18 and 1939–45. Now used for social activities.

(6) Town House, built 1748, architect William Adam, Assembly Room added in 1788. Pedimented gable with coupled pilasters on Venetian window in the centre. The steeple, replacing one of Dutch type, is dated 1831 by James Gillespie Graham. The ground floor had a jail with three cells (Jail Wynd) and the Assembly Room upstairs was used for balls, concerts, lectures etc – and still is. The East Lothian Council meet in the large room at street level. An ancient custom still carried on today is the ringing of the town bell at 7.00 am and at the 10.00 pm curfew.

(7) Jane Welsh Carlyle House, situated in Lodge St, down the pend, restored 1981. Authentically furnished and decorated drawing room. Garden laid out in period style. Open April to September Thursday, Friday and Saturday 2–5 p.m. Notice frontage in Lodge Street of one of the first **Masonic Lodges** in Scotland, late eighteenth century. Venetian window and rich Corinthian columns restored in 1960.

Plaque to Samuel Smiles, author of *Self Help*, in High Street (wall of pet shop).

(9) George Hotel. An eighteenth-century coaching inn. Daniel Defoe stayed here: 'the best inn I have seen in Scotland'. Early nineteenth-century tower and battlements added. South side has

Rear view of Carlyle House, with Town House steeple behind.

an elegant tripartite ballroom window. Sadly closed at time of writing but hopefully will be a hotel again.

(10) Haddington Goat (Mercat Cross). The third if not the fourth cross to be erected in ancient Croce Gait. No-one knows the reason for the goat but it is thought to have been adopted as the Burgh arms about 1298. Proclamations were made from the steps of the 'Goat'.

(14) Kinloch House. Early eighteenth century with Dutch gable facing street and crowstepped gables. Formerly the town house of the Kinlochs of Gilmerton. Restored by Campbell & Arnot 1962. Not open to the public.

(16) Holy Trinity Espicopal Church (on the site of the Franciscan Friary known as the Lamp of Lothian, destroyed by the English in 1356). Built in 1769-70 as the 'English Chapel' i.e., for those accepting King George.

(16)–(18) Church Street. The red sandstone building was the new Grammar School built in 1755. Alongside, in 1761, a school for teaching English and allied subjects.

(19)–(23) Lady Kitty's Doocot (23) and Garden (22) in the eighteenth century was occupied by a group of buildings. In 1771 Lady Catherine Charteris was the owner of the property.

The Sands features in the Siege of Haddington of 1548–9 when the French took up a position between Lady Kitty's Garden and the Nungate Bridge.

The Sands. Peter Potter's gallery **(19)** was the original Fire Station with the oldest bowling green in Scotland adjoining **(21)**. Across the road was the 'auld schule' attended by John Knox **(20)**.

(24) Saint Martin's Kirk (ruin). Nunnery said to have been founded in 1178 by Ada, married to Henry, son of David I, in connection with the Abbey of Haddington.

(25) John Knox Tree, planted in 1881 at the request of Thomas Carlyle on the supposed site of John Knox's birthplace.

(27) Haddington House. The oldest house in Haddington dating from the seventeenth century. Notice the balustraded stair and canopied doorway bearing the initials of Alexander Maitland and his wife Katherine Cunninghame, dated 1680, but the rear view shows that this is a somewhat earlier seventeenth-century house on an L-plan with an octagonal stair turret in the angle. Restored in 1969 by W. Schomberg Scott as the Headquarters of the Lamp of Lothian Collegiate Centre and used until 1995

Haddington House, doorway to street.

for art exhibitions, lectures and social activities. Now in use as offices by East Lothian Council. Take the gate on the right of the house into St Mary's Pleasance, laid out in the form of a seventeenth-century Scottish garden: fruit trees, herbs (with notes by Parkinson & Gerard) and laburnum walkways leading into Churchyard or Sands.

(29) Plaques. On wall of Carlyle Cafe to Sir William Gillies R.S.A. On corner to commemorate flood of 4 October 1775.

(30) Saint Mary's. One of the most impressive of the late-medieval Scottish burgh kirks. The roof and vaults were destroyed in 1548 during the Siege of Haddington, and although the nave was repaired for the Reformers, the nave and choir remained ruined for over 400 years until restoration between 1971 and 1973. Much more information can be obtained from a visit to the church. Open April-September 10 am to 4 pm. Guided tours, brass-rubbing centre, tearoom and gift shop.

St Mary's, west door

(31) John Brown's House. John Brown came to Haddington in 1750. His church (the East United Presbyterian – now flats) is behind the manse. John Brown wrote a *Bible Dictionary* and *Self-Interpreting Bible*. He died in 1787 and is buried in the Parish

Churchyard. One of his sons, Samuel, was Provost of Hadding-
ton and began the itinerating libraries; a grandson was John
Brown D.D. of Biggar, the father of the author of *Rab and his
Friends.*

(32) **The Nungate Bridge** was called the 'old bridge' in the
thirteenth century. It was the only crossing of the Tyne until
the Waterloo Bridge linking Haddington with Gifford and the
Lammermuirs was opened in 1817; the Victoria Bridge (seen
downstream from Nungate Bridge) was opened in 1901. Hang-
ings took place on the Nungate Bridge and the hook can still
be seen on the south side of the west arch of the bridge. Nungate
was a suburb and a Barony of Haddington.

Victoria Bridge from the south

(34) **Victoria Bridge** was opened in 1900 and named in honour
of Queen Victoria. The cost was shared between the Town
Council and the Montgomeries who owned the Bermaline Mills
(now Pure Malt). The bridge gave access to Market Street across
the Tyne and made the old Gimmer's Mill footbridge redundant,
so it was demolished soon after.

(G) **Ferguson Monument**, erected in 1843 to Robert Ferguson
of Raith, the first county MP. Notice the wrought ironwork and
blue lamp at the Police Station. Across the road from the Police
Station is the Post Office.

(H) Knox Institute. Opened in 1879 to replace the Grammar School in Church Street. Life-size statue of John Knox represented in Geneva gown with his left hand holding an open Bible. The building has now been converted into flats (Knox Court).

(K) Stevenson Bridge is a metal footbridge at the West Haugh and is named after David Stevenson, who was Provost three times from 1855. He was proprietor of the George Hotel and an active member of the Volunteer Movement from its formation in 1859. His son George H. Stevenson became County Sheriff and Town Clerk, his grandson also became Town Clerk. The existing bridge replaces the one which was washed away in the memorable flood in 1948.

(L) Poldrate Mill. Site of medieval Kirk Mill. Present buildings mainly eighteenth century, with the granary, maltings and workers' houses to the rear. Conversion by the Lamp of Lothian began in 1968 and the nineteenth-century iron wheel and some of the machinery have been preserved *in situ*. The mill is now used for various arts activities and lectures, and the workers' cottages are the Bridge Centre with activities and classes for all ages.

Waterloo Bridge

(M) Waterloo Bridge. Opened in 1817 by the Marquess of Tweeddale on the anniversary of the Battle of Waterloo (18 June 1815). The new bridge gave access to Gifford.

(N) Aubigny Sports Centre. Opened in 1990, 25 years after Haddington was twinned with Aubigny-sur-Nère in France.

❦ 4 ❧

Walks around Haddington

(References are to Map 1)

Walk 1 Basic route tieme 1¼ hour (or + ½ hour)

Meet outside **County Buildings (1)** – *Court Street*
Note Tweeddale Monument (2)
 Council Offices, Sheriff Court etc.
 West Church (3)
 Ferguson Monument
 Bank of Scotland and Royal
 Bank of Scotland (4)
 Corn Exchange (5)
 Spire of Town House (6)

West Church (3)

Continue east via **Lodge Street**
to **High Street**
Note IN LODGE STREET
 Pend to left (Pend House)
 Old Masonic Lodge
 Jane Welsh Carlyle's House (7)
 Facades

 IN HIGH STREET
 Samuel Smiles (plaque) (8)
 George Hotel
 Goat (Cross) (10)

Corn Exchange (5)

Cross towards **Town House (6)**
Note Jail Wynd

Cross into **Market Street.**
Continue along north side to
Mitchell's Close (11)
Note Fire plaque on gable
 Bomb site (open space fenced off)
 'Middle Row' (the houses between Market Street and
 High Street)

Enter **Mitchell's Close.** *Walk to end and look back.*

Royal Bank (4)

Into Lodge Street (4)

Pend House

Jail Wynd

Note Rubbing board
 Crowstepped gables
 Turret stair
 Workshop and houses

Proceed to Newton Port. Continue to Library

Note Former Church buildings
 Town wall (north of supermarket
 car park)
 Old barracks (opposite) (12)

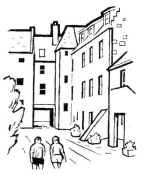

Mitchell's Close

Proceed to Courier printing works. Cross Market Street

Note Gable-ended buildings
 Crowstepped gables

Walk down Kilpair Street
past former lodging houses.
Turn left in Brown Street.

Note Old buildings
 George Hotel again
 Burleigh's Wa's to
 Hardgate

Re-enter Market Street *and*
note **Conservative Club**
building **(13)**

Old Barracks (12)

Continue right to end of Market Street *and look left to*
Kinloch House (14)
Cross Hardgate *at traffic lights (to* **Ideal Garage***)*
Turn right, cross again towards Gowl Close

Note Victoria Bridge
 Present Masonic Lodge
 opposite (formerly Ancient
 Order of Foresters, and
 Knights Templar) (15)
 Customs Stone
 Mitsubishi Goats

Turn left into Church Street
and look along **High Street.**

Note Plaque for Sir William
 Gillies RSA above Carlyle
 Cafe (29)
 Plaque for Tyne flooding level

Kinloch House (14)

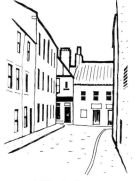

Kilpair Street

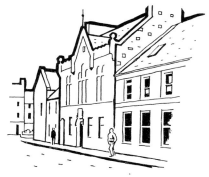

Masonic Lodge (15)

Elm House (17)

Episcopal Church (16)

In Church Street

Note Episcopal Church (site of Franciscan Friary) (16)
Elm House, site of the East Port (17)
Former Grammar, Mathematics and English Schools
(opposite) (18)

Walk into St Ann's Place *and back to* Church Street

Note Old Fire Station
(Peter Potter's) (19)
Site of Old Grammar School (20)
Bowling Green (oldest in Scotland) (21)
Lady Kitty's Garden (22)
Doo'cot (23)
River Tyne

*Diversion here if wished

Cross Old Nungate Bridge (32)
Pause in centre to look at views
along River Tyne

Note NORTH
Victoria Bridge (33)
Bermaline Mill
House – site of former
tannery

Doo'cot, Lady Kitty's Gardens (23)

SOUTH
St Mary's Church (30)
Giffordgate
Waterside Bistro

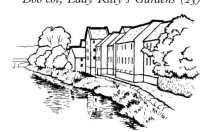

Former tannery

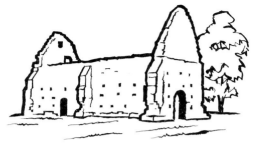

St Martin's Kirk (24)

After crossing bridge turn left alongside river then right (at Robertson's Blacksmiths)
Continue to St Martin's Gate
following the road round to Bullet Loan
Continue to St Martin's Kirk (24)
Turn right at junction into Lennox Road. Cross to Ford Road
Make towards river along Ford Road
Note Former Starch Mill
 (now flats)

At end of Ford Road turn left into Gifford Gate. Continue to John Knox's tree. (25)
Retrace steps until past Waterside Bistro and go back over Nungate Bridge to the Sands

Diversion concluded

Continue through St Mary's Churchyard to Poldrate
Note LEFT
 Site of Poudret House (now R.C. Presbytery)
 St Mary's R.C. Church (26)
 Poldrate Mill Complex

 FACING
 Maitlandfield House Hotel

Turn right into Sidegate. Walk along past
 Haddington House (27) and Garden (Pleasance)
 Summerfield House
 Sidegate Lane (formerly Bedlam Close)

Haddington House

Turn left into **Langriggs;** *note lane to left*
The Butts. *Pass the Old Coach House.*
Turn right through **unnamed close**
into **High Street.**
Turn left past former **Bell Inn**
(Norman Craig, Upholsterer)
Continue to building dividing Lodge
Street *and* **High Street (former Post**
Office)
Note Plaque on wall of Carlyle House
 (28)

Here the walk is concluded.

Former Bell Inn

Walk 2 Basic route time approx 1¼ hours

Leave from **County Buildings (A), Court Street,** *noting*
plaque on wall indicating site of **Palace.**
Walk past **Corn Exchange (B),** *turning right into* **Neilson**
Park Road
Continue past **King's Meadow School (C),** *turn right in*
front of park gates going along the **Butts.**
Pass **St Mary's R.C. School (D)**
Note Plaque with Latin inscription: *Come children listen to me*
 and I will teach you

Turn right into **Victoria Road,** *past Nursery and Infants'*
Schools (E) *on the left and* **Bowling Green (F)** *on the*

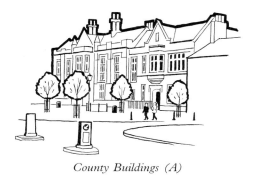

County Buildings (A)

Ferguson Monument (G)

right. At the end of road turn left
into Knox Place

Note Park with Robert Ferguson Monument (G)
 Knox Court, formerly Knox Institute, with statue of
 John Knox (H)

Continue past Knox Court, turn left into Meadow Park
(alongside part of Infant School)
Veer right, then left along walk beside Knox Academy
playing fields (Tynebank Road)

Note Sir William Gillies' family house (Westlea) (I)
 Former West Mills (J)

Neilson Park

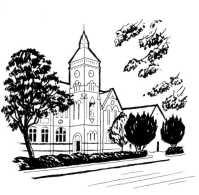

Knox Court (H)

Poldrate Mill (L)

*Where the road turns left, continue straight ahead,
following the path down the side of the* **West Mill** *and
cross footbridge over the mill lade and continue follow-
ing the river downstream*
Pass **Stevenson Footbridge (K)** *(white painted metal)
with right of way to* **Bolton Road**
*Continue along river path with old maltings and sports
complex* (**Aubigny Centre**) *on left to* **Poldrate Mill (L)**
(West Haugh) *and* **Waterloo Bridge (M)** *on right*
The open grassy areas are known as 'haughs'. The **West
Haugh** *has old drying greens which are still in use.*
Plaques indicate trees planted to commemorate:
 Coronation of Queen Victoria 1838
 Coronation of Queen Alexandra and King Edward VII
 1902
 Coronation of Queen Mary and King George V 1911

Look out now for **wild life***: swans, herons, various
ducks, water hens and, if you are lucky, cormorant and
kingfisher*
Cross main road to **East Haugh.** *Continue walk along
riverside to* **St Mary's Churchyard**
Many interesting headstones including that of the victim of the
last duel fought in Haddington.

*Take central path through churchyard to main gate,
emerging into* **Sidegate**

*The Roman Catholic Church and presbytery are on the
left, the* **Maitlandfield House Hotel** *opposite. Cross di-
rectly over Sidegate and continue along* **Mill Wynd.**

St Mary's Roman Catholic Church

Almost opposite Aubigny Centre (N) *(Sports Complex)*
turn right and walk through Neilson Park, *emerging into*
Neilson Park Road

At end of road, turn left into Court Street *and you have
arrived back at the* County Buildings.

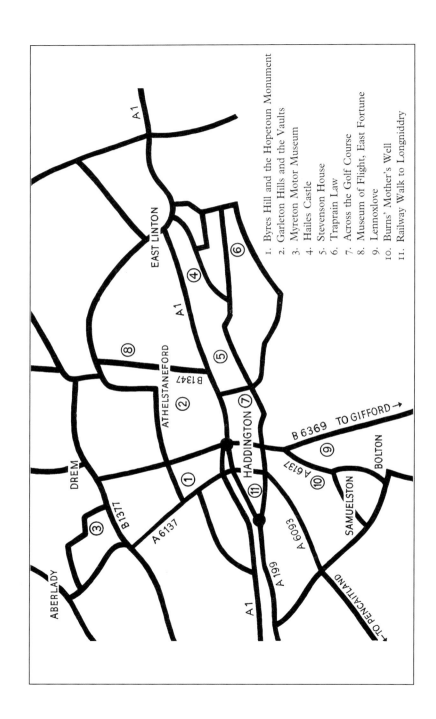

1. Byres Hill and the Hopetoun Monument
2. Garleton Hills and the Vaults
3. Myreton Motor Museum
4. Hailes Castle
5. Stevenson House
6. Traprain Law
7. Across the Golf Course
8. Museum of Flight, East Fortune
9. Lennoxlove
10. Burns' Mother's Well
11. Railway Walk to Longniddry

❧ 5 ❧

Out and About: Walks and Excursions from Haddington

To the North

1. Byres Hill and the Hopetoun Monument
2. Garleton Hills and the Vaults
3. Myreton Motor Museum

To the East

4. Hailes Castle ✓
5. Stevenson House
6. Traprain Law
7. Across the Golf Course
8. Museum of Flight, East Fortune ✓

To the South

9. Lennoxlove
10. Burns' Mother's Well

To the West

11. Railway Walk to Longniddry

1. Byres Hill and the Hopetoun Monument

The Hopetoun Monument is one of the most distinctive features of the East Lothian skyline. A stiff climb is rewarded by a panoramic view of the coastline and countryside.

From the centre of Haddington drive west towards Edinburgh and turn right at the traffic lights by the Railway Hotel. Continue north along Aberlady Road. Take the second exit at the roundabout towards Aberlady on the A6137 and follow this road uphill for about a mile. After the crest of the hill turn right onto the B1343 (signposted East Garleton and Athelstaneford). There is a car park and picnic area with information board on the right at the foot of Byres Hill. A steep path leads up the hill to the base of the monument at 560 feet above sea level.

The monument was built in 1824 in memory of Sir John Hope, the 4th Earl of Hopetoun, by his 'affectionate & grateful tenantry'. A sound stone spiral staircase ascends the tower, lit only by slit windows (a torch would be useful). At the top there is an open circular walkway surrounded by a chest-high parapet which has a series of illustrated panels showing the landmarks in all directions. On a clear day there are magnificent views of the Lammermuirs, Arthur's Seat, Traprain Law, Berwick Law, the Bass Rock, the islands in the Firth of Forth and the Fife coastline.

Sir John Hope, 4th Earl of Hopetoun (1765–1823), was a hero of the Peninsular War (1808–14), taking command at the Battle of Corunna when General Sir John Moore was killed and Sir

Hopetoun Monument

David Baird of Newbyth was severely injured. Hope's successful evacuation of his men earned him a knighthood from George III. He was also a governor of the Royal Bank of Scotland.

THIS MONUMENT WAS ERECTED TO THE MEMORY OF THE
GREAT & GOOD JOHN FOURTH EARL OF HOPETOUN BY HIS
AFFECTIONATE & GRATEFUL TENANTRY IN EAST LOTHIAN
MDCCCXXIV

2. Garleton Hills and the Vaults

An unusual structure, known locally as the Vaults, sits on top of the Garleton Hills to the east of the Haddington to Drem road. It can be seen best from the north near Athelstaneford.

A track which is a right-of-way runs from this road to the east along the Garleton ridge, passing through Barney Mains farm to reach Barnes Castle after about a mile. This track was once the main highway from Edinburgh to London.

The castle was built by Sir John Seton of Barnes but was not completed by the time of his death in 1594. The plan appears to have been to construct a fortified house within a courtyard. The layout was ambitious and advanced for its time in Scotland. Unfortunately the building did not progress beyond the ground floor except for the towers which were carried up to first-floor level. The proportions were generous and the overall site measures some 200 by 150 feet. All the rooms have vaulted roofs. It is possible to continue eastwards along the path and descend to Athelstaneford to the left. Alternatively retrace your footsteps westward to Barney Mains and descend left via the minor road which joins the A1 at Abbey Toll Cottage. Go straight over the A1 and continue downhill to cross the Tyne over Abbey Bridge. Near this bridge lies the site of the former St Mary's Cistercian Abbey. Follow the road to the gateway on the right and return to Haddington by the right-of-way across the Golf Course.

3. Myreton Motor Museum

Cars from 1896; motorcycles from 1902; commercial vehicles from 1919; bicycles from 1880 and World War Two British vehicles.

Leave Haddington to the north by the A6137 Aberlady road. Carry straight on over the roundabout at the junction with the Drem road. Before reaching Aberlady, the road curves sharp left. At this point take a right turn signposted for Gullane. The Motor

Museum is signposted shortly afterwards on the right (approximately 5.5 miles from Haddington).

The collection contains many interesting and rare examples of early road transport vehicles: cars, motor-cycles and bicycles as well as motoring memorabilia. It is privately owned and has been opened to the public since 1966.

Most cars are in running order and many have featured in period films and television series, including *Dr Finlay's Casebook* and *Hamish MacBeth*.

Opening hours 10.00–17.00
Tel: 01875 870 288

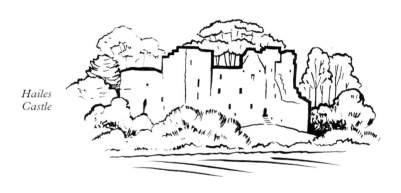

Hailes Castle

4. Hailes Castle

A thirteenth-century medieval ruin in a strong defensive position.

Continue past the entrance to Stevenson House and take the first turning to the left. The castle sits on a rocky outcrop above a bend in the river. It was a stronghold of the Hepburn family for over 200 years and the last Hepburn to own it was the notorious James, fourth Earl of Bothwell, who became Mary Queen of Scots' third husband after instigating the plot to murder her previous husband, Darnley. There are two pit prisons in the basements of the ruined towers. Prisoners were lowered down into the pit through a hatch in the roof.

From the road just after the castle a track on the left leads down to a fine wooden footbridge over the Tyne and there is an excellent riverside walk to East Linton.

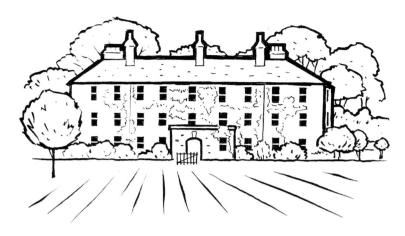

Stevenson House

5. Stevenson House

An unusual seventeenth-century house with extensive gardens.

Stevenson House is signposted on the right from the A1 east-bound about half a mile east of Haddington. It can also be reached by leaving the town by Market Street, straight on at the traffic lights with the Ideal Garage on the left and over the Victoria Bridge. Continue past the golf course; the driveway leading to Stevenson is on the left after one mile.

The present house was built in the early seventeenth century with nineteenth-century additions, although the estate dates from the thirteenth century. The house is unusual in that it is built round a square open courtyard. Both the house and its walled garden were restored in the early 1950s.

Opening Times: House by arrangement: gardens open in summer

Tel. 01620 823 376

6. Traprain Law

A short climb to an ancient hillfort site with magnificent views. Many geological and historical connections.

Five miles to the east of Haddington. Continue straight on instead of turning left to Hailes Castle and park in the car park on the right. There are three information panels near the car park which provide comprehensive information about the site.

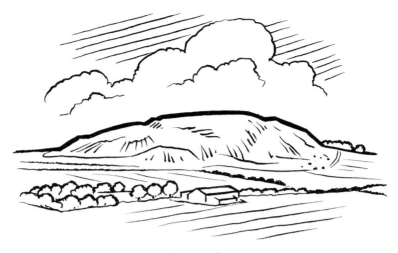

Traprain Law

The unusual whaleback shape of Traprain Law dominates the Tyne valley to the east of Haddington. It was formed by volcanic action and its harder rock core became prominent as the surrounding landscape was eroded by glaciation. It was inhabited from Neolithic times, 6,000 years ago, through the Iron Age and then most notably by the Votadini, allies of the Romans from around AD 80. The Votadini used the fort as their capital and as many as 2,000 of the tribe may have occupied the site. In 1919 the Traprain treasure was excavated. This hoard of late Roman silverware is thought to be pirate loot from Europe, buried in the 5th century AD. It can be seen in the National Museums in Edinburgh.

To climb the hill, cross the stile near the car park and continue westwards following the roadside wall. The path veers left uphill and as it ascends you will cross the ramparts and terraces which formed the early fortification. The top of the hill is relatively flat with views in all directions. The slope to the west is gentler than that to the east and provides an easy descent and loop back to the car park. A longer circuit can be made by descending the steeper east side following the line of the fence bordering the edge of the quarry. This should only be attempted by fit walkers with proper footwear in dry weather. Once at the bottom, it is an easy walk clockwise round the base of the hill below the cliffs on the south side (often used by rock climbers) to return to the car park.

On the way a monument can be seen on the skyline to the south-west. This commemorates Arthur Balfour, the Earl of Balfour (1848–1930), Prime Minister from 1902 to 1906, whose estate was nearby at Whittingehame House.

7. Across the Golf Course

A short walk through the former Amisfield Estate among interesting architectural remains.

The town golf course was laid out in the grounds of Amisfield House. The old estate of New Mills was purchased by Colonel Francis Charteris in 1713 and renamed after his family estate near Dumfries.

Before this date a substantial early industrial venture occupied the site with factory buildings and an associated village. The New Mills Company was founded in 1681 and produced cloth until 1711, employing up to 700 workers at its peak (including outworkers). Many of the employees were English weavers but cheaper imported English cloth proved to be the venture's eventual downfall.

Amisfield House was designed in 1755 and demolished in 1928. It was an important Palladian mansion, and some indication of its former grandeur can be seen from the vestiges of buildings which still remain around the golf course.

The main entrance is from Whittingehame Drive (see instructions for Stevenson). The twin lodge houses are joined by a curved wall with an ornamental gateway. At the eastern end of the estate there is a similar gateway with a lodge in dilapidated condition. Through the west gates a tarmac drive leads through a double avenue of trees towards the car park at the club house. The old house faced north on this site and the stable block still stands nearby. Near the weir (note the fish ladder) on the south bank of the Tyne stands an unusual square ice house built over a former mill lade. Further east a ruined temple built as a landscape feature overlooks the river. Beyond the car park the avenue continues as a pleasant path through mature woodland to the eastern entrance. Just before reaching the main gateway, make a short detour to the right to see the large walled garden with its four round corner towers which are pavilions on the interior. A further landscape ornament can be seen to the south. Return to the car park or continue on foot through the east gateway, turning to the right and following the road along the line of the estate wall back to Haddington.

A further short detour can be made by turning left after passing through the gateway and following the road down to the sixteenth-century Abbey Bridge across the Tyne. Near this spot, on the north bank, downstream from the bridge stood the Cistercian nunnery of St Mary, destroyed in the invasion of 1544.

8. Museum of Flight, East Fortune

East Fortune can be found by taking the A1 from Haddington east towards North Berwick and turning left onto the B1347. The museum is signposted on the right after about two miles. East Fortune was a Royal Naval Air Station during the First World War and the Museum is part of the National Museums of Scotland. Many historical aircraft can be seen in the two massive hangars, and larger planes, including a de Havilland Comet and a Vulcan bomber, are displayed in the open air.

The most famous connection with the airfield was the flight of the R34 airship which completed the first east-west transatlantic flight and the first double Atlantic crossing. It left East Fortune on 2 July 1919 and landed at Mineola, Long Island, New York on 6 July. The return journey finished in Lincolnshire on 13 July.

There is a museum shop with a wide selection of aircraft models and a tearoom (in a Nissen hut) with refreshments and home baking.

Opening hours: April–September: 7 days 10.30–17.00
 October, November, February, March:
 weekdays 11.00–15.00
 Tel: 01620 880 308

9. Lennoxlove

Leave Haddington to the south by the Waterloo Bridge. Turn left onto the B6369 towards Gifford. The stone wall on the right surrounds the Lennoxlove Estate and the entrance is half a mile from the end of the town. The castle itself is a further three-quarters of a mile through the estate from the road.

The ancient L-plan tower of Lethington was built in the fifteenth century by the Maitlands of Lethington who had acquired the estate in 1385. In the late seventeenth century the estate was sold by the Duke of Lauderdale to Lord Blantyre. The money to purchase the estate was supplied by the Duchess of Lennox, Frances Teresa Stuart, a famous beauty of Charles II's court (and the original model for Britannia on the coinage) to her favourite

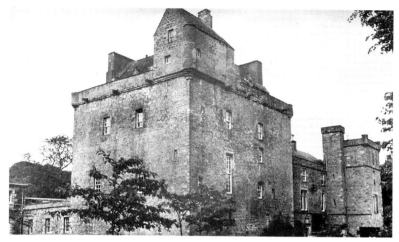

Lennoxlove House

cousin, and the property was renamed Lennoxlove in 1703 in memory of her late husband. The Duke of Hamilton acquired Lennoxlove in 1947 and the family moved there in 1972 (from Hamilton Palace, demolished in the 1920s).

The house was built in three main stages: there is the original fifteenth-century tower (which may incorporate an even older building) with cellar, well, turnpike stair and Great Hall with vaulted ceiling; John Maitland, Earl of Lauderdale, built the main block of the house in 1626; and a further extension was completed in the mid-eighteenth century. Some additional work was done by the architect Robert Lorimer in 1912. Many portraits and other works of art from the Hamilton Palace Collection are displayed as well as older items such as the death-mask of Mary Queen of Scots and the silver toilet service presented to the Duchess of Lennox by Charles II.

There are walks around the gardens and grounds, including the famous Politician's Walk, an avenue of lime trees where William Maitland (1528–73), 'Mr Secretary Lethington', pondered affairs of state while he walked. He became Secretary of State in 1558 and represented Mary Queen of Scots at the court of Queen Elizabeth. He was associated with the murders of both Rizzio and Darnley and helped to indict Mary in 1568. Accused of plotting against his colleagues, he was imprisoned in Edinburgh Castle and died in prison at Leith.

Also in the grounds is part of the Duke of Hamilton's herd of white cattle, descended from the wild cattle which used to roam the Cadzow Forest in Lanarkshire.

The house and grounds are open to the public:

House: Easter Saturday, Sunday and Monday
 May to September 2–5 pm
Tel: 01620 822 156

Grounds and Restaurant: all day

The Garden Room is open for morning coffee, lunches and teas. Tel: 01620 823 720

10. Burns' Mother's Well

A peaceful spot with an interesting historical connection (restored 1932).

By car: Leave Haddington by Sidegate on the Gifford road across the Waterloo Bridge on the A6137. Bear right at the junction towards Bolton. After 1.25 miles there is an open grassy area on the right bordered by trees. At the far end there is a small car park by a memorial with the following inscription: 'Near this spot stood the house in which lived and died the mother, brother and sister of Scotland's National Poet, Robert Burns'.

About 100 yards back towards Haddington on the same side of the road there is a well (restored 1932) with a dedication to Burns' mother Agnes Brown (1732–1820). Burns' elder brother Gilbert moved from Ayrshire to work first at Morham West Mains and then as factor to Lord Blantyre at Lennoxlove. He is buried at Bolton with his family including his mother and sister.

'Drink of the pure crystals and not only be ye succoured but
also refreshed in the mind
1732 AGNES BROUN 1820
To the mortal and immortal memory and in noble tribute to
her who not only gave a son to Scotland but to the whole
world and whose own doctrines he preached to humanity that
we might learn.'

By foot: From the River Tyne Walk across the white-painted metal Stevenson Bridge before the West Mills weir. Follow the right of way up the side of the field to the A6137, turn right and continue as above. For a longer, circular walk continue south, westward from Grant's Braes, crossing the bridge over the Coulstoun Water near where it joins the Tyne, then turn right on to

the minor road towards Samuelston. A few hundred yards on the right there is a footbridge (the earliest reinforced concrete bridge in Scotland) over the Tyne. Cross this bridge and continue north along the right of way bordering the Clerkington estate to the Pencaitland Road B6039. Turn right to return to Haddington (approx 4 miles round trip).

11. Railway Walk to Longniddry

The railway was a spur from the main Edinburgh to North Berwick line. It was closed in the '50s but some traces are left in the names of the Railway Hotel and Station Road. Near Brown's Hotel in Station Road a typical redbrick retaining wall shows where the station stood on its embankment. The railway walk begins at the west end of the town, signposted from the West Road north along Alderston Road. After crossing the old railway line via a stone bridge, the walk is signposted again on the left. The distance to Longniddry is 4.5 miles. Being a former railway line, the gradients are very gradual and it is an excellent safe route for young cyclists. Information panels are provided which describe the wild flowers growing along the verges. As well as cycling or walking there and back a circular route could be followed by leaving the track at one of the many bridges and returning via minor roads. There is a picnic area about halfway.

Further Reading

The Buildings of Scotland: Lothian Colin McWilliam
Charters and Writs concerning the Royal Burgh of Haddington, 1318–1543 J. G. Wallace-James
Discovering East Lothian Ian and Kathleen Whyte
East Lothian C. E. Green
East Lothian Courier Year Books
Farming: Scotland's Past in Action National Museums of Scotland
Haddington Community Council Handbook
The Lamp of Lothian James Miller
Lord Bothwell Robert Gore-Brown
Portrait of the Lothians Nigel Tranter
Proceedings of Haddington's History Society
Royal Burgh of Haddington Guides (1960s–70s)
A Short History of Haddington W. Forbes Gray and James H. Jamieson
Transactions of the East Lothian Antiquarian and Field Naturalist Society

Index